Wildlife Photography
Getting Started in the Field

Wildlife Photography

Getting Started in the Field

by B. Moose Peterson

SILVER PIXEL PRESS®

Wildlife Photography: Getting Started in the Field

Published in the United States of America by
Silver Pixel Press®
Division of The Saunders Group
21 Jet View Drive
Rochester, NY 14624
Fax: (716) 328-5078

ISBN 1-883403-27-8

Design: Buch & Grafik Design, Günter Herdin, Munich
Printed in Belgium by die Keure n.v.

Dedication

To Sis:
Your lessons on life and art will never be forgotten,
your passion for life always treasured.

Contents

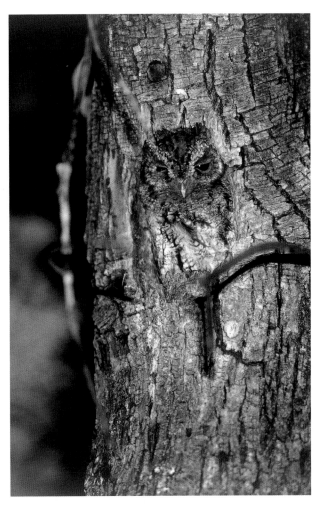

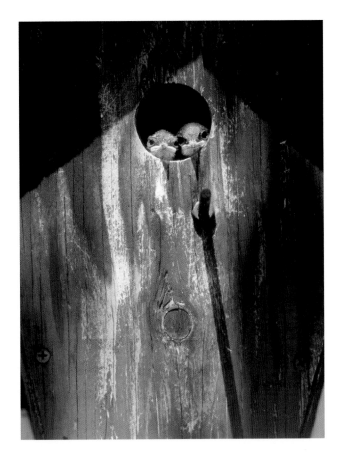

CONTENTS

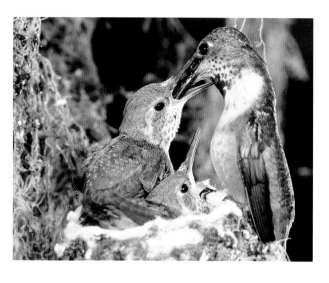

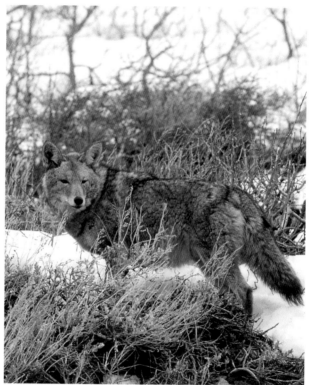

Introduction

I firmly believe that anyone can do what I do; and in most cases, they can do it just as well if not better. That is one of the main reasons that I've written two books on wildlife photography, *Wildlife Photography: Getting Started in the Field* and *Nikon Guide to Wildlife Photography* (hereafter referred to as *NWP*). My techniques and how they are used in concert with sound biological practice are all laid out in these two books. The camera equipment I use is right off the shelf. There is nothing special about it. The same gear is available to anyone who wants to purchase it. The only difference there might be between what I do and my results and how you might approach the same subjects and situations comes down to the compassion and passion I have for my subjects.

My compassion for California's wildlife, its long heritage, and its continuing existence fills my days. My deep concern and genuine desire to understand and preserve this wildlife often consume days of thought on how I can make a difference. I'm incredibly blessed in being able to travel and see for myself any aspect of California's natural heritage so that I can better understand it. Even more, I have the opportunity to witness and take in its wonder firsthand, to be swept up in the ever-unfolding evolution of life and its day-to-day struggles.

And from this comes my passion for wildlife photography itself. Because in having compassion for wildlife comes the desire to share it with others, to communicate to those not as fortunate as I the magnificence that is all of ours to enjoy. Photography has always been the best means for me to communicate that compassion, that love for all living things in our natural world.

It is because of these deep-seated beliefs that I am able not only to succeed in wildlife photography, but also continue on each day with more drive than I had the previous day. Knowing that there is always something new to see, something new to witness and photograph, and always being open to learning a better way to take the photograph—these thoughts are with me every outing I have with my camera.

Many people ask how I manage to get so close to wildlife and what my "tricks" are. I firmly believe the answer to this question can be found right within my photographs. Again, it's rooted in my compassion and passion. Since I carry no magical scent in my pockets, and I don't dress up in special clothing or hide in blinds, I know that wildlife sees me and knows I'm present. I believe their carefree and almost reckless attitude towards my presence comes from their knowing somehow that I mean them no harm. It cannot be documented in any way, but I firmly believe that wildlife senses my affinity

for them and feels at ease. Besides, I'm having so much fun, they must know that anything having as much fun as I am cannot be a threat.

Here, in this book, lies more information on how I go about getting photographs. There is, of course, more soapbox preaching about ethics (something I just can't keep from doing). I've also included more techniques on getting physically close to the subject and solutions to those really difficult problems of getting the amazing photographs we all strive for. I even explain how to work with biologists, get involved in research projects, and how you can make a difference with your photography.

But most of all in this book, my compassion and passion are revealed through my words and photographs. In these two books I have laid before you everything I know about wildlife photography. Every technique and piece of biological trivia I've acquired to date is at your fingertips. You can memorize it all and use it to glorious success, but you are left on your own to find the compassion and passion within yourself. These are things that come from within.

It is with all sincerity that I wish you a long, happy, and fulfilling career photographing our natural world. It is an even greater wish that I hope you experience and acquire the same passion and compassion as I have for our natural heritage and that it grants you a lifetime of pleasure, education, and success!

B. Moose Peterson

Note: Some of the captions include a C or P. This indicates whether the subject was either a captive (C) or a park (P) animal. Both are valid sources for photographing wildlife and provide great educational and photographic opportunities. The absence of a C or P in the caption means that the subject was a wild, free-roaming animal. I believe that photographers should always be up-front regarding the circumstances in which their photographs were taken.

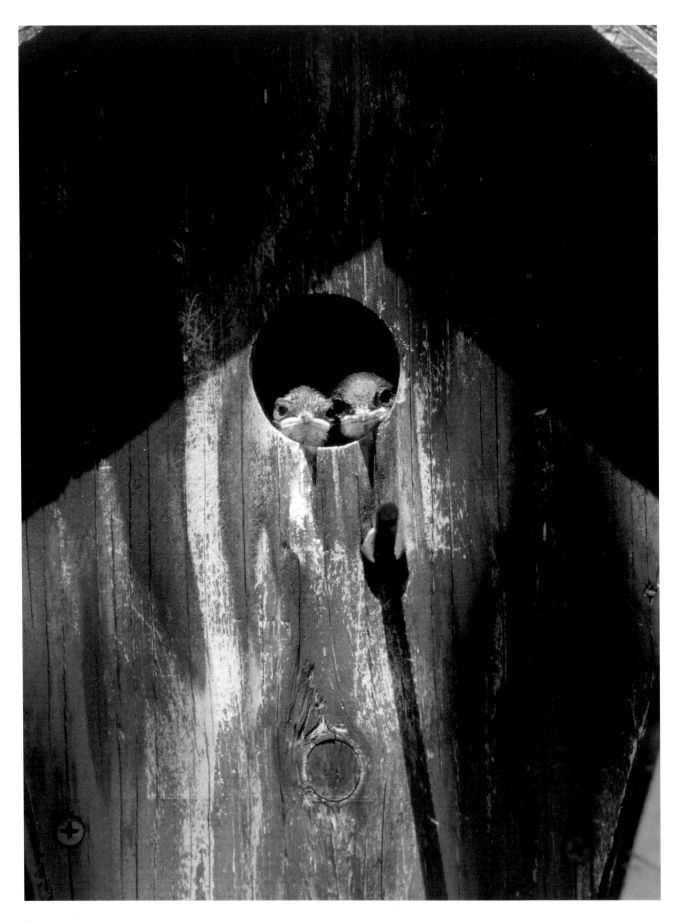

Backyard Photography

Backyard Photography. This concept is as old as the hills and twice as dusty, but it's rarely used by photographers, let alone effectively. Granted, some folks don't have a backyard to exploit, but what's the excuse for the rest of you? Simply put, some of the finest photographs are those taken when the subject comes to you. After working a 9-to-5 job, sitting in the wilds waiting for wildlife to come to you is just not an option the majority of the time. But if you set up your backyard like a shooting gallery (no BB guns, please), you can enjoy your favorite passion when you have only a minute to spare. Backyard photography can be as advanced and sophisticated as you make it. By combining your knowledge of biology and photographic technique you can make the most out of your backyard shooting.

Now, the region in which you live or have a retreat home is the biggest factor in deciding where you place feeding stations and what you offer. The region of the country you're in is also a big factor as to what you can photograph and when. I can only address certain topics in general because of these factors. But you can easily take the suggestions that I offer and supplement and customize them for your own backyard habitat. And that's what your backyard is, a habitat.

Attracting Birds Naturally

Attracting wildlife is, of course, the key to success. Many think that just putting out a bird feeder is all that is required. True, this brings in some birds and is great for pleasure viewing, but it needs to be taken a bit farther to have it be really rewarding for photography. Photographing wildlife in the backyard has two facets: attracting wildlife, and attracting it to the right place for photography. Both topics are simultaneously interrelated and separate.

Birds are the principal subjects that most people are able to attract to their yards. Living in an undeveloped area, as I am fortunate to do, also offers one the possibility of attracting mammals, big and small. But the mammals I attract are simply an added bonus resulting from my efforts to attract birds. I don't do anything special to attract mammals (other than flying

This white-crowned sparrow (below) is safely tucked away in a quail bush. This large bush, approximately five feet in diameter, is only a couple of feet away from two seed feeders and two bird baths. Because of this, the bush is continually jumping with life and activity. It's a great place to focus the lens and just wait for the next photo opportunity.

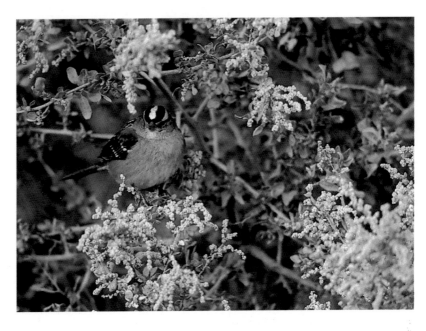

"Where's mom with the food?" Camping out in front of a nesting box with a camera when there are young inside will most likely reward you at some point with photographs that display a little humor. Photo captured with Nikon F4e, 800mm f/5.6 at f/5.6 with a PK-11a attached, on Agfa RSX 100.

squirrels). Actually, I make an effort *not* to attract mammals by taking my feeders in at night because I have bears in my yard (more on that in a second).

The most common way of attracting birds is by putting out birdseed. This sounds simple enough, but there's really more to it than just throwing out a pan of seed. Typically, the birds that come to our feeders are small dickey birds. Sparrows, finches, jays, and the like are those we see most often at our feeders. Attracting them in great numbers along with other more "desirable" subjects while at the same time creating photographic opportunities takes a little forethought.

To attract the greatest numbers, you must make these little birds feel safe. This means providing them with a place to hide quickly if a predator should come around (your neighbor's cat is just as much a problem as the local Cooper's hawk). Typically, a rather dense shrub or tree works great. It should be no more than four or five feet from the feeder. This provides these small birds with a safe refuge.

In a moment I'll talk a little more about photographic considerations, but for now, you might be saying to yourself, "I don't have any shrubs in my

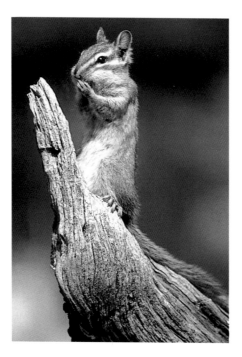

I can't believe I ate the whole thing! Trees not only make great places to put feeders, but they're great for photographs as well. This yellow-pine chipmunk is just one of many that inhabit my yard; each one's a character. I spend hours following them with my lens, as they go up, down, and all around, and wait for moments like this to capture the humor they invariably exhibit. Photo captured with Nikon F4e, 500mm f/4P at f/8 on Fuji 100.

yard," and, "What should I buy?" This question can be easily answered by reading a number of books or visiting your neighborhood nursery (those of you who are on the Internet can also find fast, easy answers in a click). Look for a shrub that not only provides the required protection for your birds, but also is photographically aesthetic. You want one that, when grown, provides perches over the majority of the plant— nice settings for birds to be photographed. You also want a plant that is native to your region if possible and not an exotic one from some far-away country. This is a personal decision, but if you're interested in marketing your image down the road, you don't want the plant to cost you a photo sale.

Planting shrubs for protection is just part of the story. You can attract an incredible diversity of bird species to your yard just by the type of plants that are around. There are many books and articles on this topic that cover the various regions of the country. For example, sunflowers attract seed-eaters, while fuchsias attract hummingbirds. You will have to do some homework to figure out which birds you can attract with which plants. But I've never met anyone who has taken the time to do this and has been disappointed with the results.

Nothing is as good as an old tree. I have 200- to 300-year-old pines in my yard for starters, something you just can't run out and plant. But not having trees doesn't doom you to not having backyard birds. I've planted many aspens that were about five to six feet tall to supplement the big, tall pines. Right under them, on the ground, we put small bird baths. This combo has been incredibly successful in attracting some great birds. So even if you don't have any magnificent old trees, you can make things work by doing some simple homework and landscaping accordingly. See the section "Location, Location, Location" for more tips on effective plant placement.

Since I just moved to a new home and a new area, I've had to do exactly

what I'm suggesting you do. It's been just over a year, and although I have only about 20 percent of my yard planted the way I want for attracting birds, my yard is just jumping with birds. This is partly because of the trees and shrubs I've planted, the water (which will be discussed in a second), plus the seed and suet I put out.

Attracting Birds with Food

Food—we all go for that, but not as eagerly as birds! They will give up almost every inhibition just to grab some quick seed. I've seen Cassin's finches risk being snatched by a goshawk just to grab a bite to eat when the feeder was vacated by smarter birds. There is no reason not to take advantage of this greedy response and capture some great images.

Before I go any further, I want to jump on my soapbox for just a second and talk about feeding birds. Some folks feel that feeding and attracting wildlife is simply not kosher. To a point, I can understand the doubts that are raised in regards to this. But I offer you this story as another point of view to consider.

During the drought in California (1988 to 1992), I was conducting a simple study on white-crowned sparrows. I was capturing and banding two separate populations. One was in my own yard eating me out of house and home. The other was wild, eating whatever they could find. I found that over a couple of years the population that was eating at my home left on migration and returned with a good fat reserve. More of these birds returned each year than those in the wild population. The wild birds returned and left on migration with minimal or no fat reserve.

Of course this makes logical sense, but just think of the implications. So much of our wildlife's native habitat has been altered or destroyed that birds can no longer winter, or nest for that matter, in what has historically been prime real estate for them. We humans have

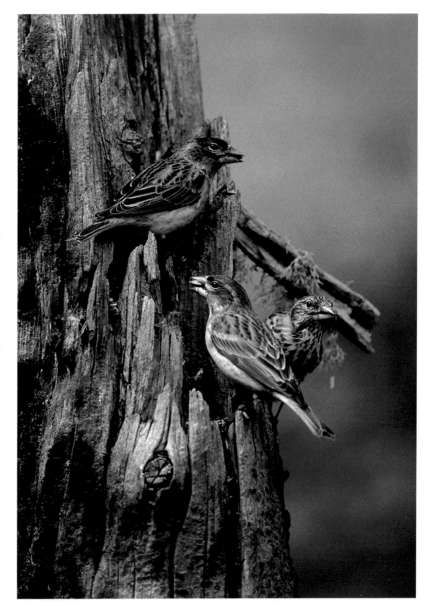

moved in and taken over. So without supplemental feeding, some populations or species might be in trouble. This is just food for thought.

When it comes to seed, there are hundreds of varieties and mixes to choose from. Each and every type and mix attracts certain specific species and not others. What type of seed you should use depends on a number of factors, the first being the types of birds you want to attract. Keep in mind that just because you want to attract a certain species, it might not be possible where you live. You'll have to do a little research to see what birds are known

My friend in Montana has created a bird paradise in his backyard. These Cassin's finches are munching down some of the black-oil sunflower seeds that had been stuffed into a snag that he put out. Sunflower seed is one of the best choices for attracting birds. Photo captured with Nikon F4e, 800mm f/5.6 at f/5.6, with plus 1/3-stop exposure compensation dialed in, on Fuji Provia 100.

Garden Tip

Generally, black oil sunflower seed is unsterilized. This means that if it hits the ground, gets buried even a little, and receives water, it will grow! This can be a gardener's nightmare. This is true for some kinds of generic birdseed as well. Furthermore, only the hearts of the sunflower seeds, not the hulls, are eaten by the birds. These hulls can form large piles under your feeders and will rot if they're not cleaned up. These two things should be taken into consideration when choosing seed to feed your birds.

to visit your area. Here's a basic list of birds with the seeds and foods that tend to attract them.

Chickadees: Black oil sunflower seeds, suet, cups with bacon drippings, chopped peanuts, wild birdseed

Northern Flickers: Suet, chopped peanuts, fruit

Finches: Niger thistle seed, black oil sunflower seeds, chopped peanuts, wild birdseed

Grosbeaks: Black oil sunflower seeds, chopped peanuts, cracked corn

Jays: Black oil sunflower seeds, suet, cups with bacon drippings, peanuts, cracked corn, fruit

Hummingbirds: Sugar-water solution of four parts water to one part sugar (no red food coloring, please)

Juncos: Black oil sunflower seeds, suet, wild birdseed

Mourning Doves: Niger thistle seed, corn, millet, hulled sunflower seeds

Nuthatches: Black oil sunflower seeds, suet, cups with bacon drippings, chopped peanuts, wild birdseed

Orioles: Hummingbird solution and orange halves

Sparrows: Black oil sunflower seeds, wild birdseed

Towhees: Black oil sunflower seeds, milled or chopped peanuts, cracked corn, wild birdseed

Woodpeckers: Suet, cups with bacon drippings, chopped peanuts, fruits

Goshawks and Cooper's Hawks: All the little birds listed above who are feeding on whatever!

This list provides you with an idea of the possibilities that different food combos can attract to your yard. You should also note one common denominator among almost all the listings: sunflower seeds. I use a mix of black oil sunflower seed and sunflower seed hearts. For my location in the Sierras, this attracts more than 30 species of birds and feeds my squirrels and chipmunks. A novel way of presenting sunflower seed is by using complete sunflower heads cut from the stem. This also makes a very photogenic perch for birds that are

feeding. I know some of you are asking yourselves, "When's he going to get to the photography part?" Well, we've got to get the basics out of the way first in order to put everything into action.

There are other foods that can attract birds. Many birds, such as warblers, are insectivorous—they eat insects. They are not at all attracted to seed, but they do like mealworms. Of course, many seed-eaters will also take advantage of a free offering of mealworms, and at their healthy price, this must be taken into consideration.

You can see that fruit is also a popular item on the list of dietary preferences. Oranges are especially prized in the avian world. Orange halves can be hung on trees, sides of feeders, or on a nail or spike, anywhere that photography might be good. Some people fill their orange halves with raisins, hard-boiled eggs, chopped nuts, or peanut-butter balls mixed with birdseed. You can do as much or as little as you desire; however the success of your offerings is related to the amount of effort you put in.

Another excellent and highly effective attractant is peanut butter. Buying this in bulk helps cut down on cost and makes spreading it about not so painful financially. Peanut butter can be applied directly onto a tree or stuffed into a pine cone or any number of other feeders to attract birds. Many folks combine regular birdseed with peanut butter to make it stretch further and attract better. The trick to placing peanut butter for optimum effect is to put it opposite where you want the bird to land. You don't necessarily want to photograph the bird at the feeder, but as it comes to the feeder. Woodpeckers tend to land on the side of the tree opposite where they are going to feed. So place the peanut butter accordingly.

One of the favorite foods of my most popular subjects is suet. Getting suet can be as simple as asking the butcher for meat fat, which would be tossed out anyway. Stuff the fat into a suet holder, hang it on a tree, and watch the birds come. They eat not only

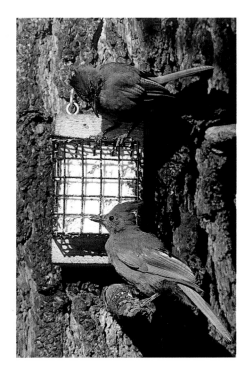

the fat, but the insects that are attracted to the fat as well. Some folks make special suet mixtures.

Here's a sample recipe:

Melt beef suet (fat) over low heat. Add peanut butter and continue to heat until it softens. Mix in chopped fruit, such as unsweetened berries (chopping it when it's frozen makes less mess!) or raisins, cracked corn, and wild birdseed. Pour into small, clean cans (such as cat food cans), and store in the freezer. Take out as needed and place in the suet feeder.

That's not for me though. I go to my local store and buy the suet cakes already made. When I say buy, I mean I buy a case of 36 cakes at a time! I pick the suet cakes with peanut pieces, and the birds just love them. I could go through four cakes a day at my house if I were to give the birds all they wanted. My favorite store loves it too—they see me every week.

Feeders

The system or method you use to deliver seed to your hungry birds is really up to you. You could simply throw the seed on the ground, and the birds will come

to it. Or, you could use one of the hundreds if not thousands of bird feeders that are on the market. You can even go on-line to find plans for making your own feeder as well. But as you can imagine, I have an idea or two about other things you might want to do.

The criteria for feeders are different for each one of us. Part of the fun of photographing birds is finding the perfect feeder. I personally like to find feeders with character that's all their own. In other words, I try to find a feeder that is itself a photogenic subject without any birds added to it. The feeder should be one that you don't mind including in your photographs. If you're always working hard to exclude your feeder from the photograph, then it should be replaced with one that suits your photographic needs.

We have a number of different feeders in our yard. There is one that I call the pig trough, a large one-foot-by-one-foot platform that sits about six inches off the ground. This attracts all sorts of birds, but especially the ground-feeders, which in my case are band-tailed pigeons. This is really only a small step away from having seed on the ground.

Next we have a number of feeders that were hand-crafted by my boys (having that homemade appearance), and they are about two feet off the ground. I learned a lesson from these feeders. My sons put up their works of

Starting right out of the nest, young Stellar's jays learn from their parents where to forage. In this case, it's at one of my suet feeders. There have been times when there are so many birds at the suet, you can't see it. Suet is a great food source for birds and attracts a wide variety to your yard. Photo captured with Nikon F5, 600mm f/4 AF-I with TC-14e at f/8, with SB-24 fill flash with Better Beamer, on Agfa RSX 100.

These two pine siskins are fighting over the best spot in which to sit and eat. This bird feeder is evidently providing the right food at the right place. The feeder adds a rustic feel and a neutral background to support the activity. Photo captured with Nikon F5, 600mm f/4 AF-I with TC-14e at f/8, with SB-24 fill flash, on Agfa RSX 100.

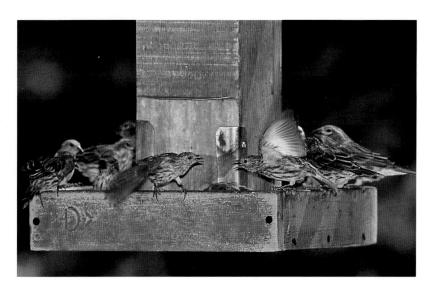

art in locations that they could reach and maintain, in places where they thought the feeders looked good—exactly the opposite of what I thought. The feeders are, like I said, barely two feet off the ground, a natural place cats and other predators could easily snatch an unsuspecting diner. They were also out in the open with only the branches above them providing the birds with any sort of predator protection. At first I thought they would not attract anything different and would just increase my seed bill (about $200 a month). Well, these feeders quickly became the most active in the yard and even attracted a real rarity, a red crossbill. It was only fitting that my son, who built the feeder, was the only one to get a photograph of the crossbill. I, the pessimistic father, got skunked!

We also have some platform feeders that are about six to eight feet off the ground. While these entice some of the same birds as the ground feeders do, they attract a few other species as well. You'll discover that certain species of birds are the first to find a feeder; in my case it's the pine siskin. Other birds key in on the siskins and find the feeder that way. The feeder's location determines who joins the siskins, and it is those other species that become my photographic subjects.

The last type of feeder we have out is a suet feeder. These are semi-home-made in that I buy generic suet cake holders and then attach them to one-inch-thick boards. Since I have to contend with bears where I live, my suet holders can be removed from the tree where they hang during the day (at night we bring them in, along with all the other feeders a bear can reach). I also have one suet holder hanging outside from the rafters of our roof, one foot away from the kitchen window. I can't stress enough the variety of birds and other photogenic subjects the suet feeders attract. Many a workshop participant has been planted in my kitchen for a day (and they weren't raiding the refrigerator) watching visitors to our suet feeder loaded with a Heath-brand suet cake with peanuts.

When in the photographic mood, I often turn to my "custom feeders." These are put out only at those times when I really want to get those once-in-a-lifetime images without leaving the house. My custom feeders are no more than natural logs. I comb the forest

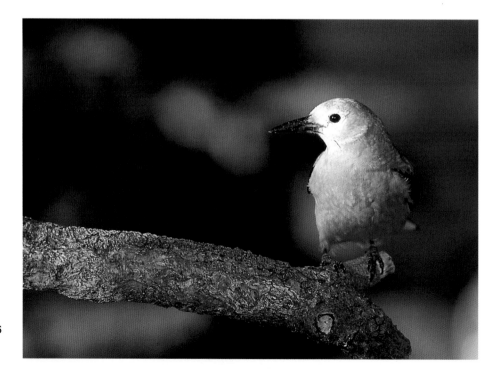

This Clark's nutcracker looks as if it just perched in the right spot at the right time. Actually, on the back side of this branch are small holes filled with suet. The trick in getting this photo was to take it before the bird started to eat. This branch is actually bolted to our deck railing and is a favorite of mine for photography. Photo captured with Nikon F4e, 400mm f/5.6 at f/5.6, with SB-24 fill flash, on Agfa RSX 100.

looking for logs that are 12 to 18 inches in length, have character, and have natural, broken-off branches for perches. Depending on the diameter of the log, I either drill holes to hold seed or use peanut butter to stick seed to the log. In either case, the seed is placed on the back side of the log where it cannot be seen by the camera. The holes are drilled carefully on a slant in the back of the log to hold the seed. Peanut butter is likewise smeared on the back lower side, out of view. The birds land on the top of the log to get their food. Since the food cannot be seen, it simply looks like the bird is perched on a plain old log in the photo. Someone seeing the photo would think you were just really good at stalking, not realizing that the bird came to you.

These custom feeders are placed in strategic locations where the lighting and background are perfect (refer to *Nikon Guide to Wildlife Photography* [hereafter *NWP*], page 91). I then set up on these feeders and wait for the birds to come. I have feeders that are horizontal and ones that are vertical. The side with the most character faces the camera, and the food holes are in the back. Since the birds in my yard are so accustomed to looking around for food sources, it takes them very little time to zero in on these "new" feeders. Shooting is really as easy as sitting in my chair and waiting for the subjects to come to me.

So that I don't have thousands of photographs of the same logs, I constantly search for new ones to replace the old ones. In this way, when I send a submission covering one species to a client, I don't have 20 views of birds all sitting on the same perch, but instead on many different perches.

Attracting Birds with Water

I have a friend who puts a water bath outside his bathroom window to attract warblers when they are migrating past his home. While sitting in his bathroom (no snickering now), he has captured some of the most incredible photographs of subjects that are otherwise nearly impossible to photograph. Water has the power to attract any species and bring them right within camera range.

The actual container you choose can be anything—it can be as simple or

Field Tip

You can take water with you on the road. When traveling to drier areas, I always take my portable water drip. This is especially valuable when going to the desert. My portable water drip is merely a 1/2-gallon plastic milk jug that has a small tube inserted into the cap. In the end of the tube is a small plug that can be pulled out to adjust the frequency at which the water drips. When the full jug is turned upside down, the water drips slowly, bringing the desert's rarest birds to my campsite. A nice thing about this is that the rangers don't get upset by this form of baiting, whereas if you put out seed, they might.

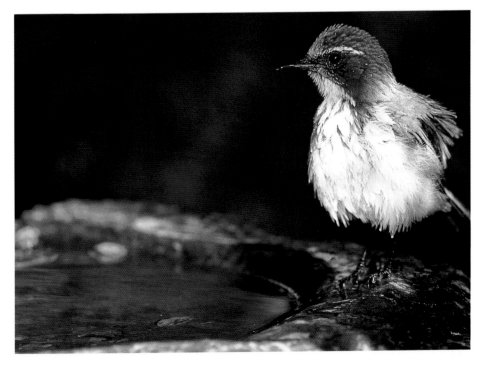

Fresh from its afternoon bath, this western scrub jay is just one of many species that take advantage of an offering of water. This boulder bird bath is a real prize. Its perfect depression makes it a natural bird bath and subject for a photograph. There are bushes practically surrounding the bath so the birds can come and go with a reasonable sense of security. Photo captured with Nikon F4s, 75-300mm f/4.5-5.6 AF at 300mm at f/8, with SB-24 fill flash, on Fuji 100.

BACKYARD PHOTOGRAPHY

Field Tip

Icicles are easy to make and hang in the right spot. You don't have to hope that Mother Nature provides you with one. You can start icicles either in your freezer or outdoors, whichever is colder. Simply keep adding small amounts of water to increase the size of the icicle. Then attach it to the bird bath with nearly freezing water. They attach rather easily and add a very effective environmental element to your photo.

elaborate as you desire. It all depends on how you want to photograph the birds that come to it. If you want to photograph the birds actually taking a bath, the container must be photogenic. What's photogenic in a bird bath? I've seen some that are made of beautiful rock-work that looks like a stream bed. I've seen others that are mere potting bowls that have had rock added around their edges and sand placed in the bottom so they resemble a natural watering hole. Some people line the edge of the bath with sphagnum moss, which looks really sweet. They go so far as to plant a nice flowering ground shrub nearby, which looks smashing in the spring. Personally, I use a rock or boulder that has a natural depression and fill it with water.

I also have simple water baths in my yard, which are merely plastic potting saucers. While I like photographing birds bathing, I'm personally more after the shots of them perching before and after they bathe. Just as with anything that's used to attract birds, the more you have available, the more birds you'll attract. So my three bird baths bring in a constant array of species, which just makes my motor drive sing!

On my advice, some people have put out bird baths, but have had no success in attracting birds. They generally give me a call, sounding rather frustrated, and I give them the following advice: It might take birds a month or so to find your bird bath, or it might be instantaneous. It all depends. I have noticed that sometimes birds have a hard time seeing the water in a bird bath. I don't know if this is because of the reflections or color, but I have found ways to solve the problem. The first and easiest solution is to place a rock in the bath. This breaks the surface tension and provides a perch for the birds. The second and guaranteed enticement is dripping water. A slow drip, say one drip per minute, pulls in birds for miles. They can't pass up such an attractive and powerful invitation.

Water drips and baths work all year round, but many folks take them in during the winter months because they freeze up. If you think about it though, all water sources are frozen during the winter, but a bird's need for water remains the same. Buying a water bath heater (we're not making a Jacuzzi here) for your bird bath can be one of the best investments you'll ever make. The heater keeps the water just warm enough so it won't freeze. The birds flock in by the handfuls to take advantage of the open water. The heaters use very little electricity, take up very little space, and bring in large numbers of birds, which means great photo opportunities. Ever wonder how those great shots of birds perched in winter snow were taken? Maybe there was a heated water bath nearby!

Nesting Boxes

Putting out nesting boxes is also an effective way to lure birds into your yard. Many folks have the impression that since nesting boxes are used only for a few weeks each year, they are not worth the bother for just a few shots. Others believe that since they live in a certain locale, the boxes don't have a chance of attracting any inhabitants.

Well, both might be true, but I've not found it to be so in my travels. A very important thing to remember is that as so many of our natural habitats are becoming developed, and as the dead trees, which provide natural nesting cavities, are being removed, nesting boxes are becoming more and more important to the survival of many species. Also, nesting boxes are used more than you might notice or realize throughout the entire year.

I'm fortunate that in my yard I'm able to have 19 nesting boxes, which provide 20 homes for birds (one box is a double-decker). The boxes themselves vary in size, and more importantly, the sizes of the entrance holes vary as well. These two factors both encourage and eliminate who can nest in each box. Smaller holes encourage birds such as chickadees and nuthatches,

medium-sized holes best suit swallows and smaller woodpeckers, and larger holes accommodate flickers and kestrels. The larger-holed boxes also encourage starlings and house sparrows, which are non-native species that are displacing many of our native species, such as bluebirds, for instance.

Your box selection needs to be based on the types of birds that can be attracted to your yard as well as how photogenic the box is itself. There are hundreds of styles of bird boxes to choose from, including those you can make yourself. The goal is to have one that attracts both birds and your camera lens! I personally like bird houses made from cedar with a natural finish. My friends at Avian Habitats make just such a box. This is the type that fills the trees in my yard. Some folks like the ceramic type, others like the pine version. There are some expensive ones carved out of logs. All of these work well and are equally photogenic.

If you're lucky, you might even find a natural cavity in a fallen tree that you can use. I'm constantly examining downed trees with the hope of finding a natural nesting cavity I can take home and use for a bird house. Finding one is really like having your cake and eating it too, because you can attract nesting birds to your own yard and photograph them in a box that is really a log. The final photograph gives the impression that you took the photograph in the forest rather than in your backyard.

Now, most often nesting boxes don't get used the first year that they are put up. Birds often start scoping out possible nesting cavities (which your box is to them) in the winter. They might even spend some cold nights inside the box. Then in spring they might take up residence. I have found that generally it takes a season or two before the houses I've put out really get used. Don't let the fact that a house wasn't used the first year make you think it won't work or that it's in the wrong location. Be patient, because they will eventually use the nesting box. As the movie says, "If you build it, they will come!"

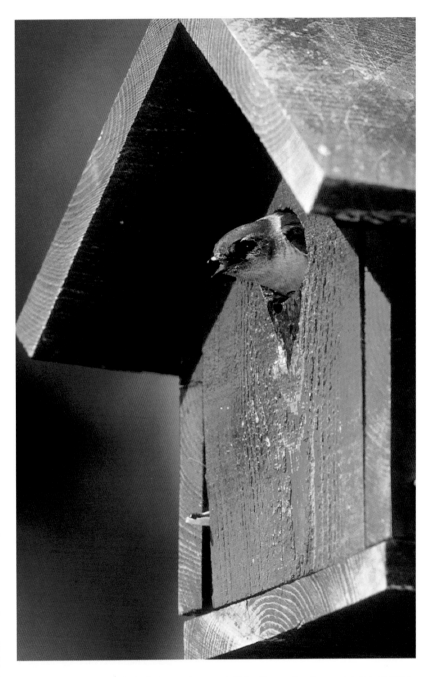

"Harvey, here comes that photographer again!" In the spring I spend a lot of time watching and photographing the inhabitants of my nesting boxes. Over time, they become pretty comfortable with my presence. One of the great rewards of having your yard set up for photography is to sit and watch the animals' activity, even when you're not photographing them. Photo of violet-green swallow captured with Nikon F4e, 800mm f/5.6 at f/8 with PK-11a attached, and SB-24 fill flash, on Agfa RSX 100.

Nesting Material Holder

When they are put out in conjunction with nesting boxes, nesting material holders are a great way to attract birds to your yard and encourage them to nest in it. The holder itself is no more than a little chicken wire attached to a board. This can be hung anywhere as it is really not a subject to be photographed. The holder is stuffed with all sorts of odds and ends that birds can use as nesting material. I stuff mine with wood excelsior, lint from the clothes dryer lint trap, feathers from down vests or pillows, and bits of string. Birds come to the holder and take the materials they prefer to use in nest construction. Making this chore easier for them tends to attract them to the area and encourages them to use the nesting boxes you have provided.

Location, Location, Location

This real estate credo holds very true when it comes to locating our feeders, water baths, and nesting boxes for photography. Yes, I'm finally getting to the photography part. I always save the best for last. You'll read that feeders, water baths, and nesting boxes should be placed in certain locations for the best success. Often this requires having nesting boxes face south and meeting other important biological criteria. Remember that we're not really trying to attract the greatest number of birds, but the greatest number *for photography*.

As I mentioned previously, feeders should be placed where the birds feel safe—that's of primary importance. But when deciding on placement, the photographic goal must be taken into consideration. What are the parameters for placing a feeder, bath, or box that contribute to the photographic process? Well, saying it needs to be photogenic is really an oversimplification. It needs to be placed to encourage optimum photographic conditions. Lighting is a big consideration. Let's look at some examples that might give you some ideas as to where to place them in your own yard.

The feeder needs to be placed such that the lighting is the best it can be at the time you want to shoot. If, as a rule, you tend to have more time to shoot in the morning, the feeder should be placed so it receives morning light. If the evening is the time you're able to shoot, then it should be placed for evening light. And if you can find a spot where light falls naturally most of the day, that's even better. What kind of light are we talking about?

We're not looking for full sun or backlighting. Ideally, I look for light that is partially filtered by branches and shrubs when I place my feeders. I want to be able to use ambient light as my

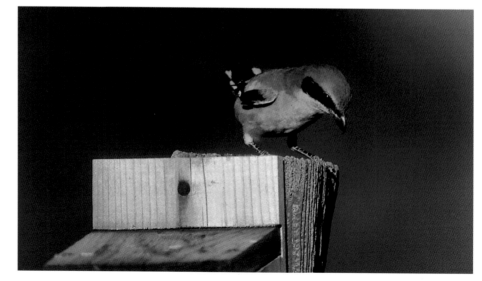

Wildlife action is so unpredictable that it's sometimes hard to capture on film. This loggerhead shrike landed on the nesting box below, and before I knew it, it was trying to get at the young family of plain titmice residing inside. But its head was too large to fit into the hole, foiling its attempt. I would never have thought such an event would occur, let alone be able to to plan ahead to shoot it. Photo captured with Nikon F4e, 800mm f/5.6 at f/5.6, on Kodachrome 64.

main light source and use fill flash only to fill in the shadows slightly. But I'm not talking about the light hitting the feeder. Although I do take photos of birds on the feeder, more important is how the light hits the perches around the feeder!

Perches

In this section we'll tackle the "tricks of the trade," so to speak, that all the previous discussion has been leading up to. The photos, the really great ones, are not taken of birds feeding at the feeders or bathing (though they are not bad subjects), but of birds on perches *waiting* to feed or bathe. These are the situations you must keep in mind and plan for in order to get some really great photos.

What constitutes a perch? Perches can be natural objects found near the feeder, like branches located in and around the area that the birds frequent. I have a couple of locations in my yard where there are natural perches in place. All I had to do was situate the feeders, seed, and suet in the right place and then sit back and shoot.

Some locations have great backgrounds but no perches anywhere in sight, so I simply put some out. When I'm walking through the forest looking for logs for feeders (and nesting cavities, too), I'm also looking for perches. I need a few because I try to change them often to give my photographs some variety. I attach the natural perches to poles that are buried in the ground, duct tape them to my Benbo Trekker (which makes a great portable perch holder), and I even screw them into the railing of my deck. That's just for starters.

Since many of the species of birds that visit my feeders live in habitats that are different than my yard, I collect perches from other habitats. For example, the hairy woodpecker lives in pines as well as in oak woodlands. When I'm in oak woodlands, I look for nice oak branches to serve as perches in my

yard. I strap them to the roof of the car and haul them home. When I get home, I put the oak branch out in the best location to attract and photograph the woodpecker, and then I wait. In this way, from the comfort of my home surrounded by pines, I am still able to take photographs of hairy woodpeckers that look like they were set in oak woodlands.

A very important aspect of all of this is the background. The vast majority of the time my backgrounds are a general blur. Typically, they're dark green foliage or blue sky, colors that would be present in any forest anywhere in the world. This is important when you use, for instance, an oak branch for a perch in a pine forest. Although it may exist somewhere, you really wouldn't want to combine a pine-needle background with a moss-covered oak branch perch. It just wouldn't look natural.

This tree swallow is perched on a cattail wired to a metal post outside the entrance to its nesting box. Cattails grow in the area, but the chances of your getting a swallow to land on one in the right light are slim. By placing an ideal perch in the right location, you can give the bird a place to land and improve your photography at the same time. Photo captured with Nikon F4e, 800mm f/5.6 at f/5.6, on Fuji Provia 100.

Field Tip

Nesting boxes can be homes to animals other than birds. You can easily attract mice, squirrels, chipmunks, bats, and even snakes to your nesting boxes. I've even had chipmunks hibernate in mine. All of these are great photographic subjects and make for extremely marketable images.

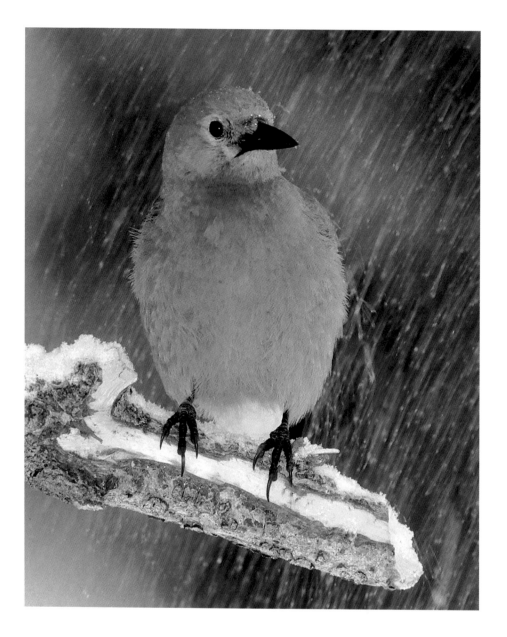

This Clark's nutcracker is perched on what I call the "golden perch." This perch is in a perfect location for the birds to land prior to going to the food. This particular photo was taken during a snow storm; a shutter speed of 1/15 second was required to record the blurred snowflakes. Photo captured with Nikon F4e, 800mm f/5.6 at f/5.6, with SB-24 fill flash with Better Beamer, on Agfa RSX 100.

Always consider the appearance of the ends of your perches. Quite often the length of your perch needs to be modified. Perches that are located naturally where you want them can be pruned so that the birds sit in a specific location, or if you've found a log in the forest, you can prune the branches so you're not carrying back a whole tree. In either case, the ends must be broken, not sawed off. Clean ends are unnatural and hence, undesirable.

You also need to be concerned and aware of other branches that are in the background. The same goes for any branches that are in front of the perch branch. These can be distracting and, if lit by the sun or flash, downright annoying. But don't go around with a saw and hack off every branch you see. The best approach at first is to see which branch the birds prefer to perch on. Then, once that is determined, break off the offending branch, don't cut it. A jagged edge rather than a clean cut is desired. And, once you have everything "cleaned up," don't be surprised if the first time you set up to shoot you find another annoying branch somewhere in your viewfinder just when a bird lands on the perch.

Perches should also be located near

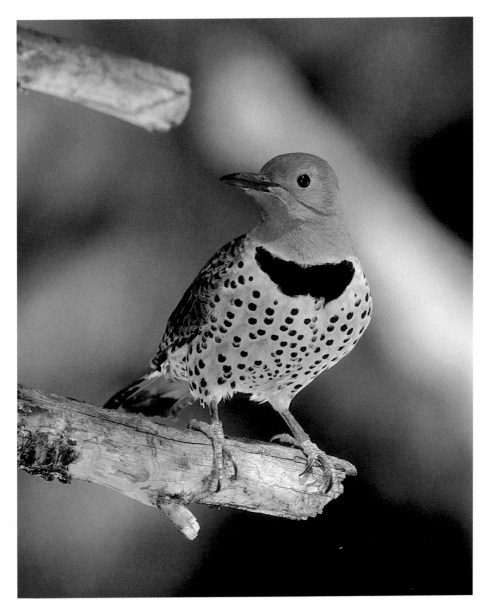

Location, location, location. When placing perches, keep in mind where birds might land while waiting their turn to feed. This red-shafted flicker is on a broken-off limb on a tree near the suet feeder. When selecting a site for your feeders, baths, and houses, consider how the light falls on the perches as well. Photo captured with Nikon F4e, 800mm f/5.6 at f/5.6, with SB-24 fill flash, on Agfa RSX 100.

nesting boxes. A perch does not need to be attached to the nesting box itself, but rather placed within a foot or two of it. Most bird species that are cavity nesters perch, if only briefly, prior to entering the nesting box. This is especially true when they are feeding their young, and one parent is already in the nesting box. This is when the other parent, with its mouth full of insects, perches while waiting its turn to go inside the nesting box to feed the babies. This is the photograph we all want to capture!

If you're using natural perches, you have to go with what Mother Nature

has provided. But if you're putting out perches for the birds to use, select ones with as much character as possible. This includes nice looking bark with curls, twists, and bends that work to enhance the photograph. Avoid perches that are bright with new growth or aspens, which are nearly silver. The grayer and darker the perch, the more the subject will pop in the photograph.

Perches for water baths can be sticks planted in the ground or limbs or bushes located near the bath. Rocks can also be great perches. A rock perch can be placed in the middle of the bath or beside it. Of course, rocks can be

BACKYARD PHOTOGRAPHY

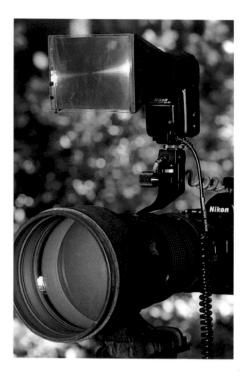

photogenic subjects in their own right. When selecting a rock, take care that it is not one that will fool your meter. Bright, white rocks tend to do this, plus they draw the viewer's eye away from the subject. They will always be brighter than the subject, which is not good. Dark gray granite, black slate, or greenish marble all work great, though. River rocks are naturals, as they tend to be smooth and polished and look like they belong sitting in a pool of water. The rock you use should have as much character as possible so that it enhances your subject.

I want to clarify one point. Always remember that you are not photographing captive subjects. These are wild birds that are drawn into our yards by the habitat we have created for them. By using information about our subject's biology and combining it with photographic techniques, we can achieve outstanding photographs while having fun. It is a win-win situation for everyone!

Lighting and Depth of Field

Let's discuss lighting. As I said earlier, I like to have a mixed lighting source illuminating the perch and the subject. I like to shoot when my perches are bathed in that beautiful, soft afternoon light. At that time of day, the background is dark, and often the bird's head and breast are in slight shadow. I have a single flash mounted on my lens via the Really Right Stuff Flash Arm. This keeps the flash directly over the lens no matter whether I'm shooting vertically or horizontally.

In order to gain a stop or more of depth of field I attach a projected flash unit, the Better Beamer (marketed by Arthur Morris), to my flash. Projected flash or tele-flash units give the light from the flash unit some extra carrying distance, providing up to two stops of increased light.

There are many projected flash models on the market, but I've found that the Better Beamer is really photographer-friendly and one that's worth owning. I wish I could write volumes on it, but it's just too simplistic to take up much discussion. The Better Beamer is a simple design, made of four parts: two sides, an elastic band, and a Fresnel lens. Each side has a wide end that tapers to a narrow end. The narrow end has a rigid support that slides over the flash head, preventing the sides from pivoting. The wide end has a small lip with Velcro that's used to attach the Fresnel lens. It's so simple, it hurts! Just put the elastic band around the flash head, slip the narrow ends of the two sides into the band (one on each side of the flash head), and then attach the Fresnel lens to the wide ends of the sides using the Velcro strips. That's literally all there is to setting up and mounting the unit; it takes less than a minute! All this, and it adds just 2-1/2 ounces to the flash! And when not in use, it folds flat and fits in a vest pocket for easy carrying and storage. It's a big improvement over the bulky milk-container design of the early projected flash units!

Now most flash units, such as the Canon Speedlite 540EZ or the Nikon Speedlight SB-26, are powerful enough to easily reach the required distance with ISO 100 film without a projected flash unit. So then why do we need one? Because it helps increase light reach, thus increasing depth of field by two stops. What do I mean by this? My subject has to be physically close to the camera for it to show up in my viewfinder, it is typically no more than 60 feet away. My single flash can reach that far, but the f/stop required is f/4. This aperture does not produce enough depth of field for the AF illuminator to focus on the chest and have the eyes be sharp as well. But with the Better Beamer, I can close down my aperture to f/8 at that same distance and have a chance at getting those eyes sharp. And as the flash-to-subject distance gets closer, I can close down the aperture even further. The only drawback to the projected flash concept is that the beam of light is extremely concentrated on one area. This is something one must keep in mind when placing the second and background flash units.

Where and How to Sit

Now that you have your feeders bringing the birds in and your perches staked out, just where and how do you sit to capture all the activity on film? There are a number of parameters that determine the answer to this question. The first is the subject. You need to be set up where you can capture the greatest number of subjects at the best angle. Remember, more than one bird will usually fly in at a time, and each is a possible target on which to focus. The second parameter is the background, which is directly affected by where the subject is perched and the focal length of the lens in use.

You must consider both the subject and background in choosing the right lens. I actually have two lenses I prefer for backyard shooting: my Nikon 600mm f/4 AF-I with a TC-14e

attached (extending its focal length to 840mm) and my Sigma 400mm f/5.6 Macro. I use the 840mm for shooting in the backyard, where I am relatively far away from my subjects. I typically have a 27.5mm extension tube (Nikon PK-13) attached to this lens as well to decrease the minimum focusing distance and increase the magnification of smaller subjects. Shooting from locations where I can be physically closer to the subjects, I use the Sigma 400mm f/5.6 Macro. This lens allows me to take advantage of being close to my smaller subjects, because it can focus down to four feet. With subjects that are about that far away, this lens works perfectly.

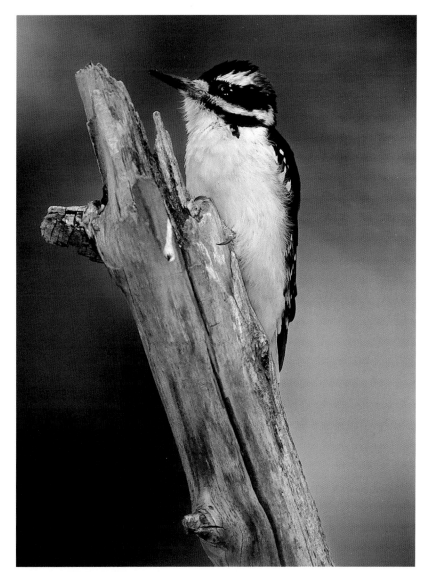

The subject, the lighting, and the background really dictate where you can position yourself. This hairy woodpecker was perched right outside my door. If I had stood a little to the right, I would have recorded a house in the background. A little to the left, and I would have gotten a reflection off a car window. But I positioned myself carefully so that the pine tree was right behind the perch. Photo captured with Nikon F4e, 300mm f/2.8N AF at f/4, with SB-24 fill flash on Fuji Provia 100.

BACKYARD PHOTOGRAPHY

Really Right Stuff Flash Arm

I attach a Really Right Stuff Flash Arm to both lenses, but only the 840mm rig requires a Better Beamer to increase the depth of field. I'm so close with the 400mm that the Better Beamer is not required.

With this in mind, I have basically just a few places I can set up to get the shots I want. Like most folks, we have houses around our home. I don't particularly want our neighbors' blue or brown houses in the background of my photos. I must also avoid the highlights caused by the reflections off their windows. But with careful planning regarding perch placement and focal length selection, I can get the photographs I'm after.

If you have homes or windows in the background of the scene you want to shoot and there is no way to eliminate them, you might consider hanging up an artificial background. Like many hummingbird shooters, I use an old gray army blanket to simulate a distant background. Remember, the background is going to be just an out-of-focus color, not a distinct texture or shape. Of course, these are put up only when you're shooting.

Now, I don't use a blind when I'm shooting in my backyard. I don't even

have a window covered in black cloth with a hole cut out for the lens. Both of these methods are used with great success by some photographers, but they're just not for me. I like to see and hear what's happening around me, and I don't care for blinds (see page 58). Being able to hear and see my surroundings alerts me to what I might expect to appear in front of my lens rather than being surprised when, all of the sudden, something appears. So this, in part, dictates where I sit. This might sound a little funny, but I either sit in the garage with my 840mm rig pointing out or sit or stand right next to my Dutch door with my 400mm when shooting from upstairs (the top half of the door opens, which is great for photography).

When I'm not actually shooting, but plan to shoot sometime soon, I leave my cameras set up. They are pre-focused on the perches I want to photograph, the flash is set on standby to save batteries while providing instant action when necessary, and the camera is left turned on. When I want to shoot, I just ease up to the camera-tripod setup and shoot. With the tripods left in place, the birds get used to their presence and grow at ease with that big front lens element watching their every move. When I approach, much of their fear is already alleviated, so photographing them is much easier and yields more successful results.

Determining where to sit and set up your gear for photographing birds that are bathing is a little more complicated than for birds at perches or feeders. Birds that are visiting water baths tend to be extremely wary of possible threats. Don't take it personally, but that includes us. My bird baths are set up so I can shoot from the front door of the house. I leave the door open with the camera set up and ease towards the camera when a bird I want to photograph is in the bath.

This may sound really silly, but sometimes I use my car as a blind to photograph one of my bird baths. My car is a rather comfortable place to

Field Tip

At times, when I'm eating dinner or doing some other task and can't be planted behind the camera, I leave my camera set up and pre-focused on a particular perch. I leave everything turned on and have either a cable release or remote firing device attached. When I see a bird land at the pre-focused spot, I fire the camera remotely. It's just another way of doing two things at once. One big advantage to this is that birds come in quickly when there is nobody hanging around. You can get outstanding photos this way, whereas otherwise, you might not.

shoot from and it makes a great bird blind without obscuring my view like most blinds do. I park next to the bath and sit in the car, waiting for the subject to show up. My neighbors think I'm a little weird, and they're right, but I get the photograph!

I make sure that I set up to shoot birds at the bird bath in a place from which I can also photograph any that land on my perches. One bath has aspens nearby that provide natural perches. Another bath is somewhat out in the open, and I have buried a few perches around the bath for the birds to use. In either case, from this location I can capture both targets with a simple turn of the camera lens.

Now that you have your camera and tripod strategically positioned, I'll give you a few tips on technique. I typically enjoy a morning or afternoon sitting quietly next to my gear all set up waiting for "the" great subject to appear. I'll be sitting (my favorite way to shoot) when the subject lands on one of my perches. At that point I don't fly up out of my chair to take the photograph. Instead, I ease slowly out of the chair, move up to the camera, and quietly extend my hands to the camera and lens. Once standing, I don't quickly swing the lens over to focus on the subject. This is when slow and steady wins the race. You need to ease up out of your chair and slowly turn the lens, if necessary, to focus on the subject. Remember, the birds have come to feed; they are in no hurry to leave unless you give them a reason to do so.

Hummingbirds

Attracting and photographing hummingbirds is a fantastic pastime for many photographers. I love watching them do their aerial dance around my feeders. There was a time when I really went after hummers. My current home has hummingbirds in the summer only about 45 days a year. But, since we are talking about attracting and photographing birds in the backyard, I would

like to pass on a thing or two I learned when we lived at our old home, since hummingbirds visited there more frequently.

Nowadays hummingbird feeders come in every size and shape. You can use whatever style you like to attract hummers to your yard. The formula for sugar-water used to fill those feeders is simple: one part sugar to four parts water. No food coloring is needed, in fact, food coloring has been proven to cause cancerous growths to form on hummingbird bills.

The more feeders you have out, the more birds you'll attract. Males typically

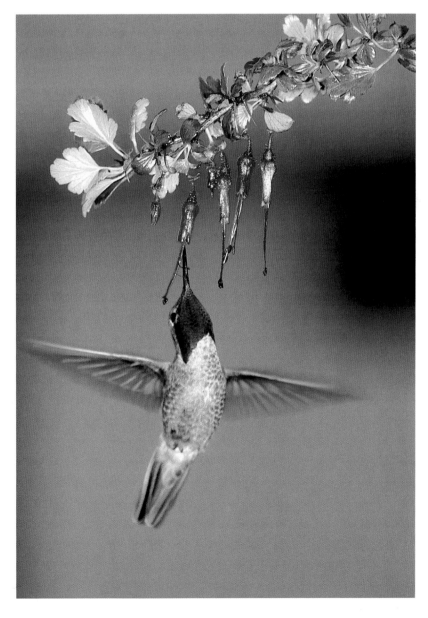

I could spend my lifetime just photographing hummingbirds and be a happy camper. But since they don't frequent my home, I have a "shooting" gallery for them at my in-laws'. This male Anna's hummingbird was kind enough to come to the flowers I put out in place of the usual feeder. My technique is simple: set up the camera and flashes, pre-focus on the flower, attach a remote cord, sit back in my chair, and relax. All photography should be so rough. Photo captured with Nikon F4e, 75-300mm f/4.5-5.6 AF at 300mm at f/5.6, with two SB-24s as main light, on Fuji Provia 100.

BACKYARD PHOTOGRAPHY

This is the same bird shown feeding on page 29. Male hummers need to perch near their feeders in order to defend them. The feeder (and replacement flower) was hung under the eaves in shadow, and this perch was right nearby in beautiful late-afternoon sun. Find a good perch and you're guaranteed good photos. Photo captured with Nikon F4e, 800mm f/5.6 at f/5.6 with PK-12 attached, on Fuji Provia 100.

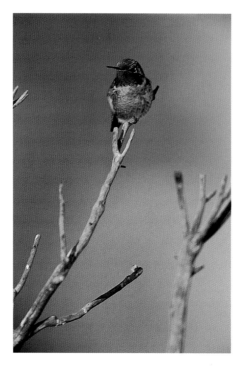

Field Tip

One of the most effective ways to use a second flash for hummers is with the Ikelite Lite-Link. This TTL slave works great for lighting with a second or third flash. Since it is wireless, it can be placed anywhere you desire. Since it's TTL, exposure is taken care of by the camera's computer so you can concentrate on the subject. (There's more information on the Lite-Link on page 71.)

stake out one feeder as their own and defend it with all their might, preventing other hummers from feeding at it. More feeders mean more males, and more males mean more females, and eventually, more offspring.

As with seed feeders and suet feeders, having perches near your hummingbird feeders is essential to photographing your target. Perches for hummers can be any natural or man-made item. Good perches are posts that are located where the birds can watch their feeders and defend them from others. The perches typically have a clear view of the feeder as well as any approach other birds might take to that feeder. Keep in mind that you'll want to photograph visitors to the feeder at some point, so plan its placement accordingly. Keep an eye on the scenery behind the feeder as well as the lighting possibilities when placing it.

When it comes time to photograph the hummingbird feeding, I prefer to remove the feeder and put a flower in its place. I grow native plants that have natural drawing power for hummers. Favorite flowers vary from region to region, so ask your garden center what works to attract them in your area.

Foxglove, hollyhock, and honeysuckle are just a few that might work for you.

I make a simple holder out of a coat hanger and attach the blossoms to it with a binder clip. Then I put the hanger out in place of the feeder and wait for a visitor. To keep the hummer coming back to the flower as if it were the feeder, I put a couple of drops of sugar water in the flower cup or on the pistil using an eyedropper. I refresh the sugar water after each visit.

Actually taking the photo can be as elaborate or as simple as you desire. I like the simple way, so here's how I do it. I place the flower in a shaded location that's surrounded by strong light. You could think of it as hanging the feeder from an umbrella that is out in the middle of a big, sunny lawn. I want to have plenty of ambient light to properly expose the world around the flower or feeder. But the main subject is, of course, exposed with flash. I never do any of the big flash unit setups, but instead stick with my simple Nikon SB-24 Speedlights. I use two or three, depending on the location and how dark it is at the time of shooting.

There is an important lighting rule used in illustration photography that applies to photographing hummers: The angle of incidence equals the angle of reflection. In other words, if you want the hummer's gorget (the brightly colored throat patch) to light up, don't mount your flash units on the camera itself. Place them off-camera at approximately 45° to the hummer when it is feeding. At this angle, the light bounces off the gorget and bounces the magnificent color into your lens to then be captured on film.

This can be difficult to set up at times. Presetting two or more flash units to light the gorget just right when the hummingbird flies in takes a lot of skill and luck. There is another method you might want to try. Take a piece of white board and cut a strip that is approximately eight inches wide and twenty inches long. Bow it so it makes a slight bend (about 20°). Bounce the flash unit's light into the board to light the hummer. Because of the circular

curve of the board, light will always hit the gorget at the correct angle to be illuminated on film.

But if you're a "freeze-the-wing" kind of shooter, this method probably won't yield the results you want. Completely freezing the movement of the wings requires high-powered flash units. This makes the hummer look as if it is suspended in mid-air, and for me, removes the elegance of flight these birds are so blessed with possessing. The simple method I have outlined here freezes the movement of the wings, while recording a slight ghosting to the wing beat. This ghosting suggests the movement the wings are making. This is the way I like to portray the flight of the hummer in my photographs.

Security

An all-too-real facet of backyard photography that many don't think of is personal security. I regret having to introduce this negative thought into this great pastime, but I feel I must. Parading around one's home with big lenses while chasing birds can draw the attention of those who would rather come into your yard for the wrong reasons. When placing feeders, keep in mind how visible you will be to others outside your home when you are shooting.

Keeping a low profile is *always* on my mind. Although I am forced to sacrifice great shots at times, I avoid being out where those I don't know can see me and my cameras. On those long holiday weekends when we have extra time to shoot, keep in mind that others are out as well who are typically not out to take photographs. Big lenses are real eye-catchers, and you really don't want your equipment to be stolen just when the greatest birds in the world start coming to your feeders.

In Conclusion

Fun is where it's at for me, and backyard photography is simply great fun.

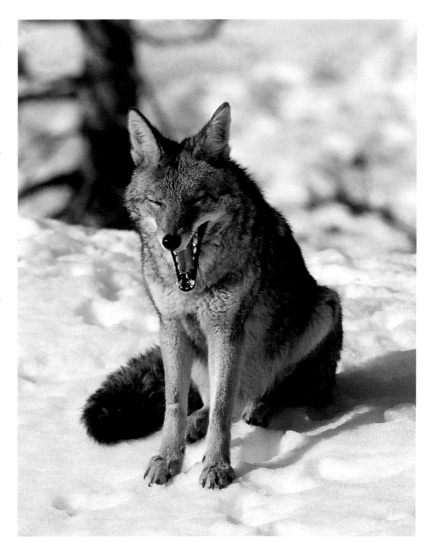

Having my yard full of birds and walking out my front door to hear their songs from every tree is all the reward I need for my efforts. The fact that I can sit and photograph them is really the icing on the cake. It's taken about a year for the birds to get to the point where they are everywhere I point my lens. It's a slow process, but incredibly rewarding. It doesn't matter the season or the time of day. I have a camera set up all the time upstairs for shooting whoever might drop by and another tripod and camera setup in the garage at all times. I simply grab my lens and go. From a marketing standpoint, there is always a need for excellent photographs of "backyard" birds. From a photographic standpoint, life couldn't be any sweeter!

Photographic opportunities in your backyard can be spectacular if you seek them out. I'm fortunate that subjects such as this sleepy female coyote appear in my yard. But then again, I work to make the opportunity happen. There are lots of things you can do to increase the odds of having such photo ops occur in your yard. Photo captured with Nikon F4e, 300mm f/2.8N AF at f/8, on Agfa RSX 100.

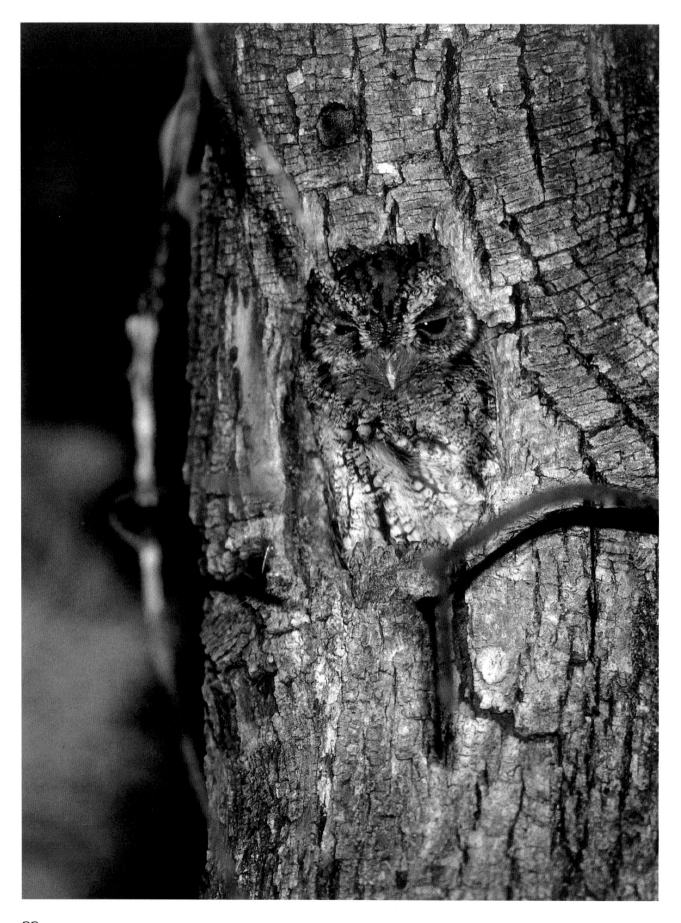

Nocturnal Photography

Some of my absolutely favorite subjects come out only at night! Many photographers fold up their field chairs and call it quits once the sun sets, but that's often when I'm just getting started. Often people don't realize just how diverse a subject base there is to work with when the moon comes out. Most photographers also don't realize just how easy it is to shoot at night. As many as 50 percent of our wild creatures are nocturnal. They spend their entire lives never seeing the light of day. Many are well-known critters, such as owls, but some, such as the northern flying squirrel, are rarely seen, even though they're a common species. I'd like to shed some light on these dark subjects so that you, too, can take advantage of some marvelous photographic opportunities.

You could think of it this way: You work a regular job all day and would like to come home and photograph something—anything. In the winter, the sun has most likely slipped down below the horizon before you leave the office. So normally, you have to wait until the weekend to pick up your camera and go shooting. Well, if you get into nocturnal photography, you can do that any night after work, at least as long as you can stay awake! And you don't have to go to the Amazon or the African plains to find a subject. Most likely, you'll find them right in your own backyard.

Finding Your Subjects

I can just read the minds right now of my urban readers asking themselves, "Who are our subjects?" They are probably coming up with answers like, their neighbor's cat or the undesirable

Norwegian rat! I'm afraid that for some this might actually be the only thing that's available to photograph in their own immediate backyard. But hopefully it's not for the majority of you. What are we going to find to photograph at night? Well, you'd be surprised how many critters come out at night.

And how do you determine if there is anything out there worth bothering to photograph? There are a number of techniques used by biologists when they sample for nocturnal visitors. Most involve using bait of some type. This concept upsets some photographers, which is regrettable. Let me assure you that all the techniques I use and write about have been proven by scientists to be safe and accurate methods of collecting data. And at the beginning, that's what we need to do. We need to determine what lives in our backyards without having to stay up all night with night-vision gear.

Let's start off with small mammals, say, up to squirrel-size. Generally these little creatures enjoy basic birdseed, the same kind you put out during the day to attract birds. You might have noticed that the birdseed in your feeders seems to dwindle during the night. If it has, that's a good sign that you have nocturnal visitors. Determining who these visitors are is simple and can be done by one of two methods.

The first is the old sandbox trick. Fill an old cookie sheet with one-inch sides all the way up with clean sand. Level out the sand so its surface is smooth and even. In the center of this, place a small bowl of seed—basic, generic birdseed. Put this out once it's dark, and then pick it up before sun-up. It might take a couple of nights to get a clean set of tracks. Once you have tracks, use

More than any other, the experience of photographing this flammulated owl changed my perception of night photography. This female was in a nesting cavity that I thought was technically impossible to photograph. Luckily I went for it and returned richly rewarded with one of my personal all-time favorites. Photo captured with Nikon F4s, 800mm f/5.6 at f/5.6 with PK-11a, and two SB-24 flash units, on Kodachrome 64.

33

Field Tip

One of the fun and educational things to do if you find animal tracks is to make plaster castings of them using simple plaster of paris. This is a great way to get to know different animal tracks, which is something that always comes in handy in the field. Hang on to them for future reference.

a reference book to determine what made them.

The second method follows the same principle but uses a different medium. This method requires using finely ground chalk instead of sand. Take a large box and cut out one end. Leave the opposite end closed. On a tray or piece of heavy cardboard sized to fit in the box, make a solid circle of ground chalk that's five to seven inches in diameter, and put a bowl of seed in the center. The circle should be large enough that the critter has to step into the chalk to get to the seed. Place the tray with the seed and chalk circle into the box back against the closed end. Place a long sheet of clean cardboard or colored paper on the floor of the box so that it extends from the edge of the circle out through the box's opening. You now have a box with a long sheet of paper or cardboard on the floor, and the chalk and seed at the closed end of the box. The animal will walk with clean feet into the box to eat (they won't hesitate to do this). While they eat, they'll be coating their feet with the chalk. When they walk out, they will leave footprints on the paper or cardboard, and voilá,

you've got tracks! Once again, compare them to those in a field guide to determine who they belong to.

You can also use either of these techniques with larger mammals, but you just need to change the bait. If you can stand it, raw chicken livers work great. Uncooked ground beef also works very well and is easier to stomach. But most popular of all are hot dogs—non-barbecued, raw hot dogs. Cut these up into small, one-inch lengths. Some small mammals might eat this fare, but more typically it's the larger mammals, such as foxes, that go crazy over hot dogs.

Now, a couple of words of warning about doing this. First, there are some species you may not want to attract to your home. For example, where I live, I have to worry about bears. In some regions of the country, rabid raccoons are a real concern and are not who you want coming to your backyard picnic table. Another concern is local laws. I'm not aware of any place in particular that does not permit the feeding of birds or any nighttime visitor to feeders, but that doesn't mean they don't exist. Check with your local department

You'd be amazed at what's out roaming the neighborhood at night. A bear left tracks in the snow outside my home, and a kangaroo rat left tracks one night in the desert sand. There are many methods of discovering tracks, whether you have natural materials at hand or put out a track station. You just have to get out and look.

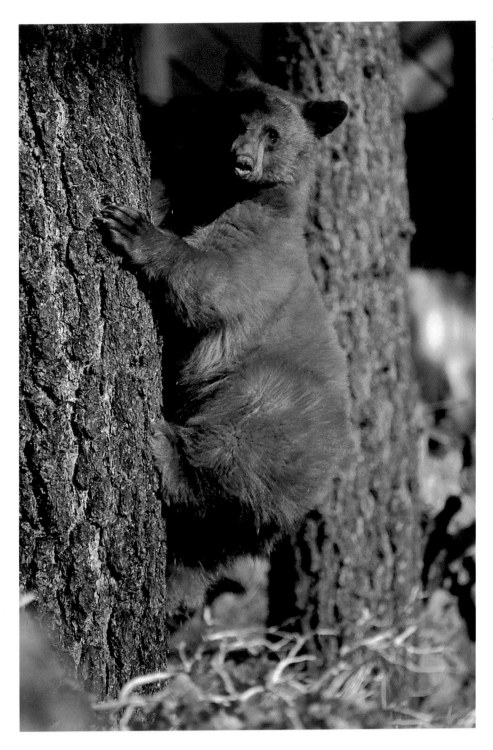

Caught in the act! This brown-phase black bear was caught climbing a tree where I had put suet out for the birds. A great deal of nocturnal wildlife can be spotted during the late hours of the day when they start their evening rounds. Photo captured with Nikon F4e, 300mm f/2.8N AF at f/8, with plus 1/3-stop compensation, on Agfa RSX 100.

of environmental conservation just in case.

Now if some unwelcome nocturnal visitors do show up, it doesn't mean all is lost. There are a number of ways to discourage or make things difficult for them. For example in my case, I simply bring in most of the daytime bird feeders, especially suet, and place my nocturnal animal lures where the bears can't get at them without a lot of effort. A good place is up in the trees or in feeders that they can't easily reach or knock over. Since most of these visitors are looking for an easy handout, they don't bother with the difficult stuff.

Nocturnal Photography

Nighttime Surprises

At my previous home, those horrible Norwegian rats came to our bird feeders frequently at night. There was nothing I could do about them as they are masters of getting around any obstacle. Well, just when I thought I should abandon my bird feeders, one night I heard something marvelous. Calling from a tree in my yard was a barn owl. Checking the next morning under its perch, I found a few pellets. Pellets consist of the fur and bones the owl can't digest, which are coughed up in tight little packages. When I tore these pellets apart they indicated that the owl had eaten the rats that were coming to my feeders. Well, the owl liked the pickings so much that it nested in my yard, feeding its young those disgusting furry things. The photo ops were marvelous, not to mention the entertainment value. After the nesting season, I had great horned owls and screech owls also visiting my yard. The word must have gotten around, as fewer and fewer rats were turning up.

Since then I have moved to a new home up in the Eastern Sierras of California at an altitude of 8,200 feet. Pines abound around my home, providing me with marvelous subjects during the day. I have a number of feeders out for my new daytime friends, such as black-backed woodpeckers and Douglas tree squirrels. At night though, no matter how we watched, only our snoopy bear, curious coyotes, and rackety raccoon family were about. After a few months, as winter set in, we paid little attention to the goings-on outdoors. Then one night my wife looked out the window and said we had a rat in the feeder. Well, I was excited about this because the only rat around is the bushy-tailed wood rat. I turned the deck light on and found to my amazement a northern flying squirrel sitting in my feeder.

I asked around the next day, and no one, even folks who had lived in the area for 25 years, knew that such creatures lived in our trees. Now these marvelously cute little fellows keep me up late at night. They are just like a basic squirrel, cute, cuddly, and playful. They just do their thing at night, which includes gliding from tree to feeder and back again.

The point is, you just never know what might show up in your backyard at night. I have a good friend who spends lots of time with kangaroo rats, and another friend with voles. Both

In the midst of a snow flurry, my wife turned on the porch lights to watch the snow fall. To her surprise there was an unexpected visitor at our bird feeder, a northern flying squirrel. Because my camera was set up by the door for daytime bird photography, I simply turned on the flash and caught a few photos before the squirrel glided off the feeder. (Note the slight red-eye. This comes from not having moved the flash high enough above the lens axis.) Photo captured with Nikon F4e, 300mm f/2.8N AF at f/8, and an SB-24, on Agfa RSX 100.

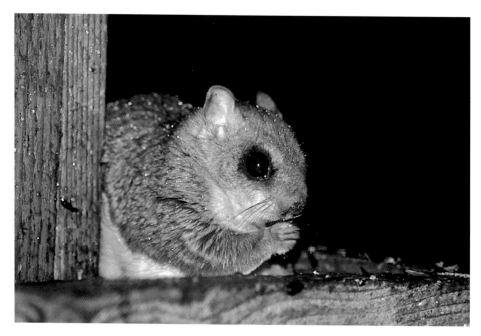

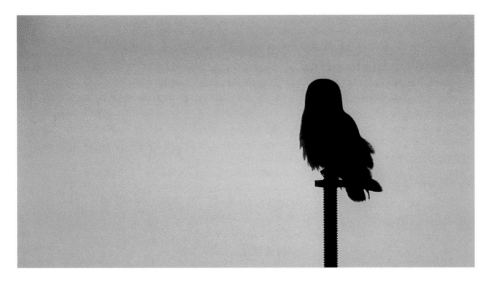

I found this short-eared owl a good 30 minutes after sunset just by listening. While perched, it "hooted" for nearly an hour, defining its territory. The color you see in the sky is not a sunset, but reciprocity failure, I think. The exposure was a whopping 5 seconds long! With such a long exposure, I was surprised that it turned out somewhat sharp and that the owl was not blurred due to movement. Photo captured with Nikon F4s, 300mm f/2 EDIF at f/2, on Kodachrome 64.

types of animals are nocturnal little dudes that visit in order to snatch a small morsel to eat.

But you might have noticed that I haven't really mentioned birds. Owls are the only large group of nocturnal birds whose feeding habits can really be generalized for discussion in this book. And even then, unless you want to raise a huge family of rats in your yard, I don't know of a safe way to determine if an owl is visiting your yard at night. There are other species of nocturnal birds, but their feeding habits cannot be generalized. You'll have to visit your library and do some research to discover those that live in your region.

I will give you more ideas on how to find nighttime subjects in the next section. And I won't leave out bats, even though they give many people the heebie-jeebies when they think of them!

Tools for Finding Nocturnal Subjects

Nocturnal animals have an advantage over us at night. Their eyes have hundreds to thousands of extra cones to help them see in total darkness, whereas ours don't. So we need to even up the score. Night-vision gear has come down in price significantly over the past few years, but it still costs the price of a big telephoto. Since most animals do not like white light, that rules out using flashlights. We need to have a method of seeing them without being seen. The

answer is to create our own red-light district!

If you've ever bought a Mini Maglite (available in most hardware or sporting goods stores), you've probably noticed the accompanying red lens that can be inserted into it. This is perfect for working with nocturnal subjects. Red light isn't visible to most animals, so they don't seem to notice anything that's illuminated by it. We humans, on the other hand, are able to see under red light.

Now, any flashlight can be made to project a red beam. Simply attaching a red gel or a piece of red cellophane over the flashlight works well. (This is a great use for those red filters we've all bought for black-and-white work but never used!) Car headlights can be altered this way as well. You can't do this with your basic Coleman-type lantern though because the gel will melt. But you can make a frame that holds the gel away from the lantern (just watch out for any other "night life" you might attract doing this). There are a number of great headlights (as in, the ones you wear on your head) that can also be altered in this fashion to illuminate nocturnal subjects. I even have a red light bulb in my deck porch lamp so I can watch my flying squirrels.

There are some subjects that won't care if you have an entire city of lights on them. But when you first start out,

Nocturnal Photography

Finding nighttime wildlife is sometimes best done by day. This pile of grass heads is a giant kangaroo rat's "haystack." Four feet in diameter and two feet tall, this might seem to the untrained eye to be merely a strange occurrence of plant growth. However this pile suggests the presence of the giant kangaroo rat and represents a lot of work on the rat's part. Photo captured with Nikon F4s, 20mm f/2.8 AF at f/8, on Fuji 100.

it's best to start with red and then work your way up to white light if the red is too hard for you to work with. And don't worry about the red light affecting the color of your photograph. The flash you are using more than overpowers the red light. And, more than likely, the flash won't bother your subject.

The moon is another excellent light source for finding nocturnal subjects. At night, with a full moon, kangaroo rats and mice can be easily spotted scurrying about on the desert floor. In the forest, those few beams of light that do make it to the forest floor can also be of assistance. But more likely it will be when the moonlight silhouettes a subject up in the canopy that it will be of the greatest assistance. When there's a full moon, it is also a great time to look for owls in flight, whether they're approaching or departing from their roosts or nests. Moonlight is a great, non-evasive tool for watching animal activity or setting up for shooting.

Now you will read many different accounts as to whether moonlight affects the activities of nocturnal creatures. My personal experience is that it does not. I have had just as many

successful evenings out shooting when the moon was out as when it was not. The only evening when my small mammal critters weren't cooperative was in 1992, just 30 minutes prior to the Landers earthquake, which literally shook us all into hiding! It has always fascinated me that 30 minutes before this quake hit, the little mice and kangaroo rats went down into their burrows, plugged them up, and rode it out underground! But these are things you would see only when you're out at night.

Two of the best tools for finding subjects at night are your ears. Whether it's day or night, walking to an area you want to shoot and then just sitting and listening is a great method of finding subjects. This is especially true at night when your ears become attuned to the slightest sound long before your eyes ever adjust. What are you listening for though? Well, that all depends on where you are.

If you're listening for owls flying overhead, you'll almost never hear a wing beat. In the spring though, when courtship is in the air, many owls fly about and call to advertise their

availability. This is the most vocal time for males trying to attract a mate to their territory (or telling another male to buzz off). In the spring, without ever turning on a light, you can find owls with just your ears. Because some owls have as many as 40 different hoots, understanding what you're hearing is an education in itself.

Some people use tape recordings of owl calls to attract or find owls. This is a valid research tool used by some biologists. But using tapes is something I personally don't recommend or encourage the inexperienced to do. In some parts of the country, the use of tapes is forbidden because they disturb nesting birds. Many people are able to imitate the hoot of a particular owl species with their mouth and elicit a response. This is true for locating coyotes and wolves as well. These are valid methods of finding subjects. But caution and expertise must always be used when employing such methods.

When I refer to using sound to locate an animal, I mean listening for the rustling of leaves or scurrying in sand. Hearing these things takes more than just being in the right place at the right time. It takes knowing the difference between the sound of leaves moving because of a slight breeze or because a small vole is scampering by. This is an acquired skill and not something I can describe to help you distinguish between the two. But it's important to learn these nuances in order to be successful in nocturnal critter location.

Many nocturnal creatures use sound to communicate to others of their kind, since sight is not possible. For example, kangaroo rats communicate through drumming their foot. They beat their hind leg on the ground in a very rapid motion, creating drumming sounds that communicate various things. I speculate that these probably include everything from "get out of my burrow," to "photographer topside!" Not that we can ever really understand the foot drumming of kangaroo rats, but we sure can use it to detect their presence.

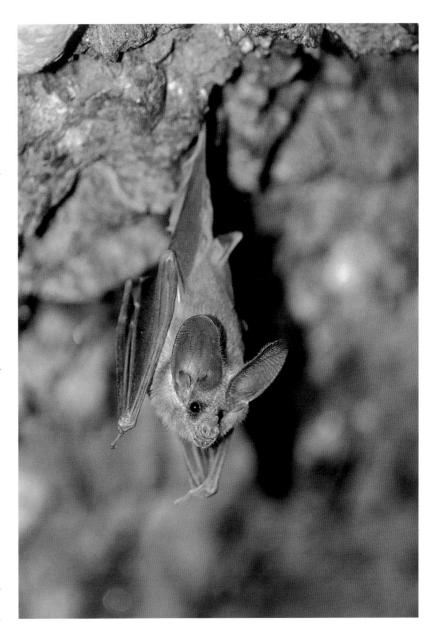

Other animals, such as the grasshopper mouse and owls, likewise have means of communicating that we can use to find them at night. The grasshopper mouse emits a very high-pitched call. Like a wolf baying at the moon, the elusive grasshopper mouse gets on its hind legs and "howls." Listening for this is just one method of finding this elusive mouse.

During the day, we can use visual signs to detect nighttime activity. The prime example again is owls. Their roosts are made apparent by a number

When the subject has the same tonal range as the background, we need to create a small shadow in the background to make the subject stand out. My model for this demonstration is a California leaf-nosed bat I found just hanging around doing nothing, so I put him to work as a model! Photo captured with Nikon F4e, 200mm f/4 IF Micro at f/11, and two SB-24s, on Fuji Provia 100.

If you really want to make life simpler when taking nocturnal photographs, invest in the Really Right Stuff Flash Arm and B89 Extender Post. The benefit of the flash arm is that it permits the camera to be turned vertically (using a lens with its own tripod collar) while keeping the flash above the lens. The extender post works with the flash arm in eliminating red-eye. Both, in my opinion, are indispensable to successful nocturnal photography.

of easy-to-find signs. The first are their pellets, which are coughed up and hit the ground right under their perch. The pellets of great horned owls are about three inches long, while those of an elf owl are maybe only an inch long. Some owls have used the same perch their parents and grandparents used, creating huge piles of pellets that are easy to find. This is especially true for barn owls. Owls also leave whitewash on their favorite perches, another easy way to find their nighttime perches during the day.

Other species also leave visual signs of their nighttime activities. Kangaroo rats, mice, and other small mammals dig burrows. These can be inspected during the day to see if they are in use at night. Typically, those in use will not have cobwebs over the entrance, but will have fresh scrapes in the dirt near the entrance. Wood rat nests, which are large mounds of sticks, are another great daytime find. These industrious animals typically have two or more entrances to their stick lodges, which, like the kangaroo rat's home, show obvious signs of use.

Like everything in wildlife photography, homework is the key to success. This includes finding and understanding the various signs of nighttime activity. There are a number of books that touch on this subject, but there's not one definitive source I can recommend. Your best bet is to be a nature detective, taking the clues presented to you and going from there. If nothing else, when you find a locale with obvious signs, stake out the place at night with a red flashlight to see who is using the area.

There is another way of finding nocturnal subjects—have them come to you. Kangaroo rats are among my favorite subjects, and finding them is really no more difficult than putting out small piles of common birdseed. In the majority of our deserts and Great Basin habitats, these little delights can be found simply by placing a few piles of seed about three feet apart in areas suitable for photography (to be discussed in a moment). Put these piles

out at night (otherwise daytime critters will clean them up). Check the piles 30 minutes later to see which pile has been munched on. Once activity has been found, set up your lens on that pile and have the time of your life photographing the little critters munching on the seed.

Nocturnal Shooting Techniques

The easiest part of this whole adventure is the technical stuff. When I look back at those 1930s images of nocturnal animals in Africa, I can't imagine how they ever got the photos. They took a lot of work, especially compared to now. Actually, with the equipment available to us now, we can just point and shoot and get a great photo. But to get those really incredible photos about which folks ask, "How did you get that?", you need to go beyond the point-and-shoot basics.

The obvious place to start is with flash. For shooting nocturnal subjects, flash is critical! There are a number of techniques that should be thought through, and each solves a problem at hand. At night there is no significant ambient light (an obvious but often overlooked fact), therefore flash must be used as the primary light source. This means that any setting you might have programmed into the flash or camera for fill flash must be reprogrammed. This is critical!

It must be remembered that we're working TTL, a system that can be "fooled" by light that reflects off the pelts of small mammals. You must be in control of the flash exposure! With the Nikon system, this means having the flash set to Standard TTL. Then, depending on your subject and exposure preferences, set the flash accordingly.

For example, when photographing a small mouse with a dark pelt, I typically set my flash so it overexposes the subject by 1/3 stop (plus 2/3 stop for super-dark brown or black pelts). This is because the reflective value of the

dark pelt "fools" my TTL meter into underexposing the subject. If your flash is set for fill flash and minus compensation, you can kiss the exposure good-bye!

Now, believe it or not, our first concern when shooting at night is *shadows*. Even though we're shooting at night when there are no natural shadows created by the sun, shadows are created by the flash. And even with the darkness of night surrounding the subject, we still want to have some visual depth in the photograph. On the other hand, we don't want to eliminate the feeling of night (since we are photographing a nocturnal subject) by lighting everything in sight and turning night into day. This might seem to be a fine but confusing line, however it is actually a very simple technical problem to solve.

Typically, 99.9 percent of the time the main flash is located directly above the lens. (The best way to hold it there is with the Really Right Stuff Flash Arm.) The flash should be above the lens at all times no matter how it's held so that the shadow created by the flash falls directly behind the subject. This is very important because the shadow from the main flash is ink black. You must always keep in mind that because flash is the only light source in nocturnal photography, a single flash creates harsh shadows. The light from the flash falls off so fast that the subject (and part of the immediate foreground and background) is properly lit, and everything immediately behind it goes black.

If the subject is on the ground or against the trunk of a tree, the shadow is hidden behind the subject, unseen. But if the flash is to the left or right of the lens barrel, the shadow created by the main flash would be off to one side of the subject. It would show up as a jet-black shadow on the background. This is because only the area that is the same distance from the flash as the subject is lit with equal intensity. This side shadow is not desirable, but so is a shadowless photo, because without shadow there is no reference point for shape or depth. So how do we light the scene to create visual depth? Use two flash units!

Using a Second Flash

While photographing nocturnal subjects, I hardly ever work with just one flash. More often than not, there are two or three flash units involved in creating the photograph. Two for sure, because the second is required to add visual depth to the subject. Remember, our main concern with all of this is to control shadows. The main flash is placed strategically so as to hide the shadow it will cast, and the second flash is placed to purposely create a shadow. Are you confused yet?

When you work with one flash and successfully hide the shadow it casts behind the subject, the subject does not pop from the background. If the area immediately surrounding the subject (assuming it is nearly the same distance from the flash as the subject) is lit by the same flash intensity as the subject, it blends in. (The size of that area depends on the focal length of the lens and the size of the subject within the frame.) A narrow range in front of and behind the subject is lit by a slightly different amount of light than the subject due to flash falloff. The thing that determines how much of this area is lit by the same intensity as the subject is how parallel the background is to the film plane.

A second flash, set either to the right or left of the main flash, creates a slight shadow surrounding the subject. This shadow appears on the side of the subject opposite the flash (if the flash unit is on the right side of the subject, the shadow falls on the left).

I went fast there, so let me back up and help you think this through for a second. There is a kangaroo rat on the ground and we're photographing it. The main flash, above the lens, is blasting away. With a single light source, the subject is basically lit the same as the rest of the scene. There is no shadow visible because it falls directly behind the subject. The subject isn't popping in the photograph.

Field Tip

With my two-flash setup, both flash units are attached to the camera by brackets and wired to the camera's TTL system. I have a cut-down Nikon SC-17 sync cord going from the hot shoe to the main flash, and then a cut-down SC-18 sync cord going from the main flash to the second flash. This arrangement permits me to move around easily with the lighting without it getting tangled in the bushes.

Now we introduce a second flash to the right of the camera, which casts a shadow to the left of the subject (my typical arrangement). This second flash is working TTL. It is putting out the same amount of light as the main flash in order to produce the correct exposure as determined by the camera's TTL metering system. If used by itself with no main flash, the second flash would create a harsh shadow to the left of the subject. But with the main flash in operation, this shadow is filled in so that less than one stop of shadow rims the subject on one side, giving it form.

Now you're asking yourself, "How can there be a shadow when everything is TTL?" Remember, light falls off very quickly. Even though both the main and second flash units are providing the same exposure, the distance behind the subject, even though just inches, is enough for the light to fall off. So the main flash fills in some of the shadow created by the second flash, but not all. This small shadow not only gives the subject relief from the background by making it pop, but also adds shape and definition to the subject's body.

You can trust that with this technique, you'll be extremely successful in your nocturnal photography (even without understanding the technical mechanics). You could easily stop right here and have the whole thing whipped, but I suggest you read further.

Background Flash

What if the subject moves off the ground and onto a branch far away from the trunk? Right off the bat you no longer have a background that's lit by the flash. Typically when birds or bats are on a branch, there is nothing physically close to them that can be lit by either flash. So the background is just a sea of black, which is not good. We could use the second flash to light the background, but we really need it to light the subject properly and give it definition. What works best here is a third TTL flash unit.

Not so long ago this third light would have had to have been connected to the camera with a sync cord to operate TTL. Now there is the Ikelite Lite-Link, which provides slaved TTL flash operation (see photo on page 71). We now have the freedom to place the third light wherever we desire—but where should that be?

The first requirement is that it be placed in position prior to the subject's arrival. You will rarely find a subject that's willing to let you walk around it to set up lights. This means that you must know where the subject is going to be. It means you'll have to do some homework, though. If it's an owl's nest site or a nighttime roost, this is not a problem. This is also true for a location where the animals are coming to you.

Once you're past this point, placing the flash is rather simple. What I do is to first place the background flash so that the flash-to-background distance provides the desired amount of light. Even though I'm working TTL, I do this so that if I move my camera and the main flash, the background light will remain constant even if TTL metering readings change. The distance required from the flash to the background can be

Looking at this photo, you might think it was taken in daylight. But I overexposed the background in this nocturnal photo of a California vole to emphasize the effectiveness of using a third background flash. By manipulating the background light you can change the photo's message or make the subject pop or not pop from the background. Photo captured with Nikon F4e, 60mm f/2.8 Micro AF at f/8, with two SB-24s and an SB-20 flash in the background, on Fuji 100. (C)

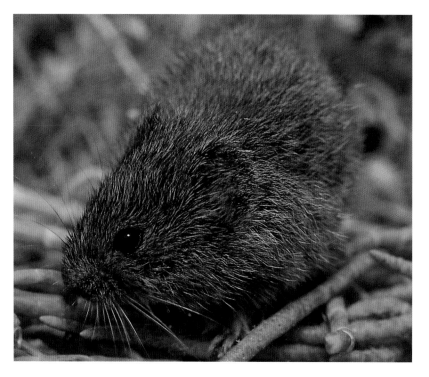

easily determined by using the exposure calculator on the back of the main flash. I normally have the zoom head of the background flash set to wide-angle in order to spread out its light.

You're probably wondering if this third flash unit is going to illuminate the background as brightly as the subject. If the background were flat and consistently the same distance from the flash as the subject, yes it would. But we're dealing with branches and leaves that vary in distance from the flash. Mere inches will change exposure, so that's all that's required to make the background slightly darker than the subject. You have to look very carefully at the background with your "flash detectors" on to see what objects in the background might be closer to the flash than desired. These are things that could appear brighter than desired in the photo.

You should be asking yourself by now how you're going to secure this third background flash. There are actually a number of options available, each one viable, depending on your site requirements. One option is the Magic Arm and Super Clamp by Bogen. This setup provides about a 24-inch boom that can be placed virtually anywhere you need it to be. The Super Clamp can be attached safely and easily to a tripod leg, tree branch, or beam, permitting you to place your background flash exactly where you want it. Another option is the TreePod. This can be secured to a tree or post without causing any harm, providing a secure platform for the background flash (it's even stable enough to support a camera, for that matter). Another option is to use a small tripod such as the Benbo Trekker or a table pod (Bogen and Gitzo make them in many designs), which work beautifully in this type of situation.

My favorite method for attaching the background flash to just about anything comes from the ingenious mind of another photographer. It's so simple! Just attach a length of hook-and-loop tape such as Velcro (whatever length you require) to a small ballhead, such as

those made by Stroboframe (instructions on page 68). Then just loop the Velcro around the tree trunk or branch so the ballhead is where you want the flash, and voilá! The point is that with TTL flash exposure, marvels such as the Lite-Link (which lets you take advantage of TTL) and this simple Velcro strap, working with background flash is really very simple and makes all the difference to your nocturnal photography.

The AF Illuminator

Focusing on the subject can be difficult at night, especially if your eyes are not as young as they used to be. You can easily use a flashlight with a red gel to help you focus. With some subjects, such as campground kangaroo rats, your basic lantern provides you with plenty of light to work by. Even a Mini Maglite or headlight can be used without a red gel. But many forget about the built-in help they have with them all the time.

The autofocus (AF) illuminator gets a lot of pounding from me. The one thing I really use autofocus for is nocturnal work, because the AF illuminator makes life really easy. You can turn the thing on and, at the touch of a button, the subject is sharp even in total darkness (consult the instruction manual for how to operate your camera's AF illuminator). Now when I use the AF illuminator for focusing, I tend to increase my depth of field (DOF), depending on the subject. For mice and other small critters I might increase my DOF by one stop. For bigger subjects, such as squirrels and owls, two stops. This is because the AF illuminator often hits the larger subjects in the chest and focuses on that point, but I want to make sure the eyes are sharp. The extra depth of field helps get them sharp. But by closing down my aperture, I cut down the distance my flash can travel. This is why I use a projected flash unit, the Better Beamer. (See page 26 for more on using the Better Beamer.)

Red-Eye

Nearly all nocturnal creatures have large numbers of cones in the back of their eyes. When animals are photographed with the flash in the camera's hot shoe, these cones are excited by the flash's light and are recorded as red-eye. Now if you want that flying squirrel to appear as if it's off the set of some horror movie, by all means, capture that red-eye. But typically, we want our critters to look cute and cuddly rather than mean and nasty. This requires that we remove the flash from the camera's hot shoe and position it away from the lens axis.

There are many ways of doing this, the least-preferred being the old, "holding it up with the other arm" approach. We want to maintain TTL connection, so use the appropriate cord when you remove the flash from the camera. You can use the Magic Arm-Super Clamp combo to hold the flash up, but you need to make sure that when you turn the camera, the flash turns with you. This can be done by attaching the Magic Arm and Super Clamp to the tripod column and then turning the entire column to follow the subject. This was a method I used for a number of years until

These shots show a dramatic difference between having the flash in the camera's hot shoe (top) versus on the Really Right Stuff Flash Arm and Extender Post (bottom). Note the difference in red-eye and the shadows that are produced in the background. The photo taken using the Extender Post has larger shadows because of the higher angle of the flash. Using a background flash in addition would have reduced the shadows. Photos captured with Nikon F4e, 300mm f/2.8N AF, and an SB-24, on Agfa RSX 100.

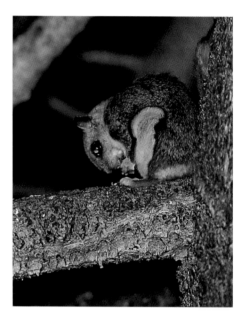

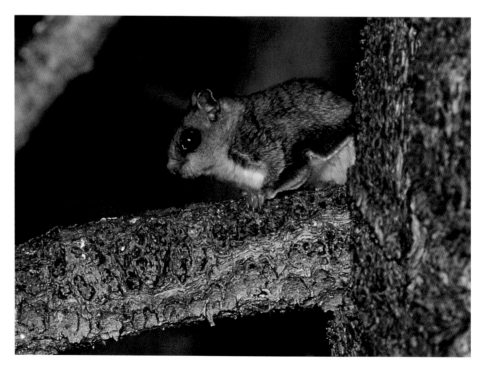

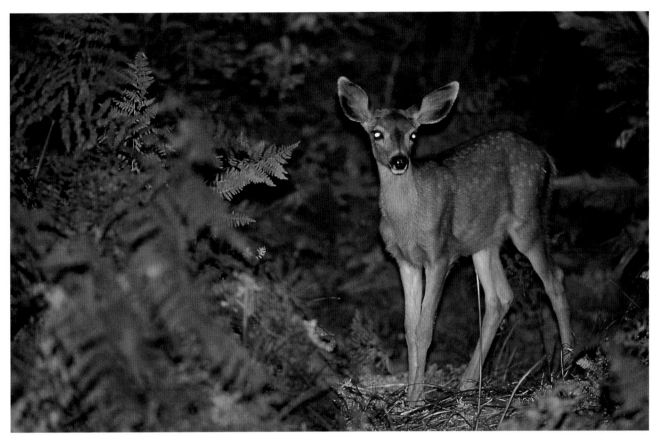

The devil made me do it! The eerie glow emanating from the eyes of this cute little "Bambi" mule deer is a special problem photographers must deal with when shooting animals at night with flash. But red-eye is not always red, as you can see. The subject's eyes can also glow green, white, or purple, depending on the type of animal and how dilated its pupil is. Making sure that the flash angle is different from the lens axis will solve this problem. Photo captured with Nikon F4s, 300mm f/2.8N AF at f/5.6, with an SB-24, on Fuji 100.

Really Right Stuff came out with its flash arm.

The Really Right Stuff Flash Arm works with lenses that have their own tripod collar. The lens rotates in its tripod collar from vertical to horizontal while the flash arm holds the flash directly above the lens. Using the flash arm without any other attachments helps eliminate red-eye in some critters. (It's a matter of physics: adjusting the angle of light so it is not aimed directly into the subject's eye.) But I want to make sure the red-eye is gone no matter what the subject is, so I attach the Really Right Stuff B89 Extender Post (a work of art as well as functional). The extender post raises the flash 18 inches from the lens barrel to eliminate red-eye. It quickly and securely holds the TTL cord to which the flash is attached. And if two flash units are required, both can be used on the flash arm or extender post by using Really Right Stuff's B90 Dual Strobe Bar. The bar permits the two flash units to straddle the center line of the lens axis, or for one of the units to be placed in the center and the other to the right or left of center. This system quickly, easily, and effectively takes all the pain and struggle out of nocturnal photography and eliminates red-eye!

Remote Nocturnal Photography

For most of us, nighttime is for sleeping. I'm the first to admit that I'd rather be inside at night by the fire enjoying the company of my family rather than outside shooting in the cold and dark. When I want the best of both worlds or just need to find out what's out there, I let my camera do all the work while I stay home. This approach calls for the Shutter-Beam.

The Shutter-Beam is an infrared (IR) beam system. In its simplest setup, it emits a beam of infrared light that, when broken, triggers the camera to fire. So in checking to see if someone is at home in a burrow, you can set the Shutter-Beam so that its beam travels over the entrance of the burrow to a reflector, which in turn bounces the light back to the Shutter-Beam. If someone or something breaks that invisible beam (wildlife cannot see the IR beam), the camera fires. When you pick up the camera, all you need to do is look at the frame counter to see if any photos were taken. If the counter has advanced, then you know something went through the beam and into the burrow. This is a quick indication that the burrow is inhabited. Just get the film processed, and you'll know who is using it!

The setup for this, as far as the camera and flash are concerned, is the same as if you were going to be sitting behind the camera. The flash setup, background light, and all the elements in the scene must be considered as usual. All you're going to do is have an electronic assistant do the tedious waiting for you.

You want to be sure to set up the Shutter-Beam so that neither it nor the reflector are seen in the photograph. This really isn't that difficult to accomplish. You will most likely need to manufacture a cord so the Shutter-Beam can be some distance away from the camera itself. This can be done with a simple trip to an electronics store.

You also need to make sure that battery power is consistent and active during the entire shooting session. This can be a tricky proposition if you don't think it through. Since everything is battery-powered, this is very important. First, all the batteries should be fresh in all systems. This includes the camera body, flash, and Shutter-Beam. There are a couple of factors affecting battery life: the temperature, and the Shutter-Beam setup.

The first is rather obvious. Temperature has an effect on battery life, especially when the batteries are housed in a cold metal camera body or plastic flash unit. I always use my Nikon F4e for this type of work because it accepts the MN-20 NiCd battery pack, which to this date has worked perfectly keeping the system powered no matter how cold it is. The flash units, even though they're plugged into a Quantum Turbo and at times set to standby, are kept artificially warm when the air temperature gets below 40° F.

The Turbo doesn't need to be kept warm, but the AA batteries in the flash do. The AA batteries power the LCD and the flash unit's functions, but not the flash capacitor (that's the role of the Turbo). If the AAs go dead, regardless of whether the Turbo has power, the flash becomes inoperative. To keep the batteries warm, I attach a hand warmer to the outside of the flash unit's battery

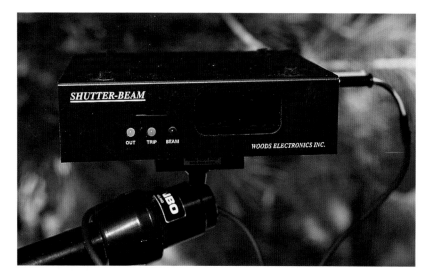

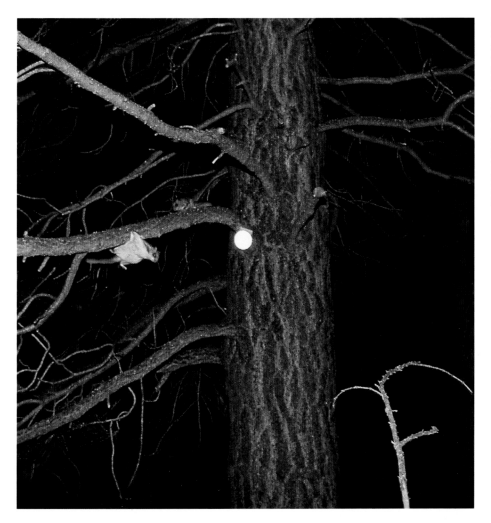

Nighttime can be busy at our bird feeders. I managed to catch these northern flying squirrels as they came for a snack. As one of the squirrels glided in for a landing, it broke the Shutter-Beam's infrared beam and triggered the camera. (The bright spot in the photo is the reflector.) Although I've not yet taken "the" flying squirrel shot, trying to capture these guys on film is incredibly fun. Photo captured with Nikon F4e, 35-70mm f/2.8D AF at 35 mm with two SB-24s, on Agfa RSX 100, tripped by the Shutter-Beam.

compartment door with a rubber band. I use the 10-hour kind—a small packet of material that, when exposed to air and shaken, produces heat (available at most outdoor sporting goods shops). You can also use the battery-operated kind, but that involves more batteries and adds bulk to be carried into the field. These hand warmers keep the batteries warm and functioning even when the temperature drops to 0° F.

So now that we have everything powered, we can just put out the Shutter-Beam and go get warm, right? Well, there is one other detail that needs to be discussed, and that's focus point. When you purchase the Shutter-Beam, you're supplied with a piece of paper to help you figure out the shutter propagation of your particular camera (you probably didn't even know your shutter

could propagate!). Propagation is a big word that means the length of time from when your camera is told to fire to when the shutter actually fires. During this lag time (we're talking 0.085 second with my F4e), the subject could already have moved through the frame. The distance the animal travels during this time obviously depends on its speed. Roughly speaking, to shoot your basic wood rat walking about on the desert floor, you need about an eight-inch lead. This means you must focus the camera so it is focused eight inches past the point where your Shutter-Beam's beam is broken.

Now for the inventor of the Shutter-Beam and other math-wise geniuses who have all these formulas committed to memory, calculating these distances for different traveling speeds is easy.

NOCTURNAL PHOTOGRAPHY

The Shutter-Beam is ideal for capturing shots of shy subjects. It is linked electronically to the shutter's operation and projects an infrared beam to a reflector. The beam is aimed so that it crosses the animal's usual or assumed path of travel. When the beam is broken, the camera's shutter is released, catching the action!

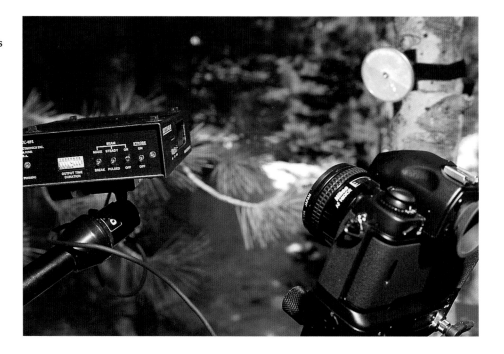

But I'm just a silly photographer, so I don't tend to be as precise from the start. I tend to set up the camera in the beginning with lots of lead room so when the film comes back the first time, I can see more precisely how to set up next time for that particular situation. I constantly fine-tune the system as each roll of film comes back. That is, unless I'm able to watch the Shutter-Beam from a distance while it's at work to actually see if the flash goes off when the subject breaks the beam.

I've had times when I've gotten to the camera and found the whole roll of film had been shot, but got the film back only to find that nothing was captured. This can happen for a number of reasons. The most obvious reason that no subject appears in the photo is because the subject traveled right through the frame before the camera fired. This happened to me when I first started to photograph northern flying squirrels. I had to allow for nearly three feet of lead time in order to capture them on film.

Another reason for not capturing the subject on film can be a misfire. If the Shutter-Beam, its reflector, or both should move, the alignment is broken, and hence the beam, so the camera fires. This is a common occurrence when it's windy. Another reason for not recording a subject in the photo can be that you're shooting a very smart subject. When I was shooting my flying squirrels, I'd see the flash go off and I'd see the squirrels present, but the film came back blank. For a long time, I just thought the squirrels were really flying through the frame. Rolls of film later, I found out that the squirrels were coming to my feeder by running down the pole on which the reflector was mounted. They never broke the beam with their body, just wiggled the reflector, breaking the beam and inadvertently firing the camera.

This is just barely the tip of the iceberg regarding nocturnal photography. If you expand your interest to include insects or herps, or if you go after strange little unknown critters such as shrews and mountain beavers, there is no guessing where you could end up. The point is that here I've provided the basics and some of the advanced concepts necessary for successful nocturnal photography. It's up to you to light up the night and solve some of the mysteries of the world that some of our wild heritage calls home!

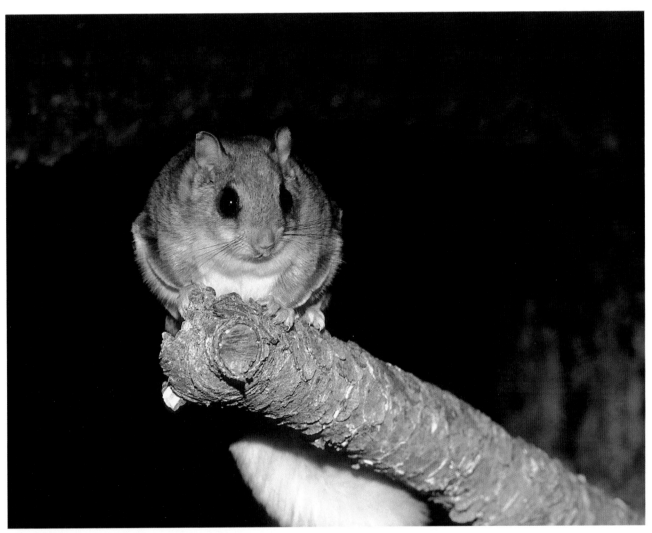

These guys are so cute! Photographing the northern flying squirrel has become one of my favorite projects for a couple of reasons. First because they are so adorable, and second because they are such a technical challenge. Photographing wild flying squirrels that can go wherever they want really keeps you jumping. But just look at that face, wouldn't you like your shot at him? Photo captured with Nikon F4e, 300mm f/2.8N AF at f/8, with an SB-24 on a flash arm and extender post, on Agfa RSX 100.

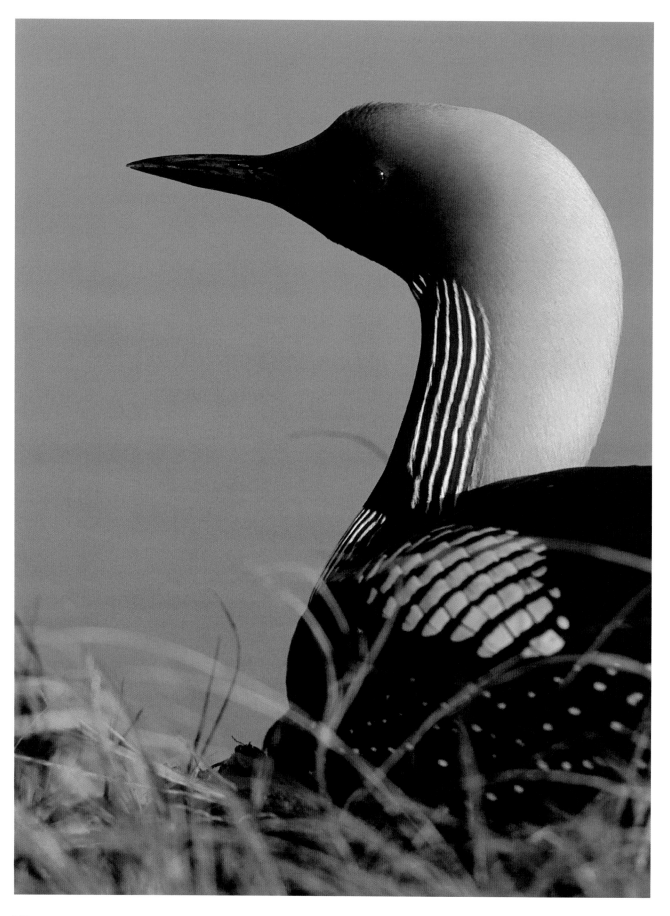

Nesting Birds

It's hard to top the experience of photographing a nesting bird! The rewards of sitting at a nest day after day watching a new generation take flight are what attract many people to wildlife photography. They attracted me! My first nest was that of an Allen's hummingbird. The photographs I took and the lessons I learned from that little mother in those two weeks still influence my shooting today. The balancing act of safeguarding the nest's welfare while still getting great photographs challenges our knowledge of biology and our technical skills to their fullest. But there's no sweeter success than seeing our photographs at the end of the season, knowing that the birds left the nest safely to begin their new lives.

There is a lot of responsibility attached to photographing a nest. The immediate contact we have with the nest puts not only the new generation in the nest at risk, but the parents as well. The slightest wrong move can lead to disaster and possibly death for parents and young alike. But even with all that's involved in photographing a nest, I believe it can be achieved with any species with complete success and safety. What's required is to combine an understanding of biology with the incredible technology available to us today!

Finding the Nest— Pre-Field Homework

When it comes to photographing a nesting bird, the first thing to do is read books. I've always thought that that's what winters are good for, staying in at night and prepping for the upcoming spring shoots. You might find all the prep work I do before going out in the field to be a bit much. But I've yet to have a nest fail (knock on wood!), which I attribute to the preparation and homework I do before entering the field. That zero failure rate is more important to me than getting the photographs! I tend to work mainly with endangered species—a field in which there's no room for the slightest error. But even with common species, there's still no room or reason for errors. This is especially important on your first nest shoot—so before you go out, be sure to do your homework!

The first thing to discover about the species you want to photograph is the time of year it nests. Many believe that just because it's spring, nesting birds abound. In grand generalities this is true. But specifically, it's way off. For example, great horned owls tend to nest very early, in the later part of winter. That's because they don't make their own nests, but use inactive hawk nests from previous years. They nest early because hawks reuse their old nests and don't take kindly to finding an owl in their home! Hummingbirds are another early bird. They can be sitting on eggs before New Year's in many regions of the country. Clark's nutcrackers nest in the dead of winter in the high Sierras. So don't make assumptions about the nesting time or you could be left with an empty nest!

Another important aspect to discover through research is where to look. To be specific, what habitat does a particular species prefer to nest in? You can't always tell by the bird's name. For instance, the mountain plover actually prefers to nest in grasslands. So some research is essential in knowing where

This magnificent Pacific loon sat tight on her nest while I, along with five other photographers on a Churchill photo safari, photographed her. This is a perfect example of the great rewards that photographing birds at the nest have to offer. Photo captured with Nikon F4e, 800mm f/5.6 at f/8 with a PK-11a attached, on Agfa RSX 100.

to find them. Woodpeckers are another good example. You probably know that they nest in trees, but in what type of trees, and at what elevation?

Many bird species migrate to North America in the spring specifically to nest. They're not present for us to observe in winter. Finding them can be accomplished only by determining the correct habitat and then searching for them there.

Researching and discovering the answers to these questions can be frustrating. In some instances, little has actually been published on a species' nesting biology, while the habits of other species are documented in great detail. But for many common nesters, there are no published details about their biology. Finding the information just takes a little detective work.

Published Resources

There are a number of great resources out there to help you start your sleuthing. The first place to take your paper chase is to the public library. Begin by looking at bird identification books. These provide one key piece of information: the species' Latin name. It is often necessary to know this later on when

you're seeking information in scientific sources. Bird identification books also provide range maps. In a quick glance, these provide a rough idea of the geographic region where a species nests. At times the written account provides further insight into the species' nesting biology. The two bird identification books I find indispensable are the *Peterson Field Guides* (either the Eastern or Western guide depending on your locale) and the *National Geographic Field Guide to the Birds of North America*. (These should already be a part of your personal library!)

There are a great number of popular periodicals that contain accounts of bird biology. These articles quite often pertain to a particular species or to some unique characteristic of a genus (genus is a category containing more than one closely related species). In either case, the information is generally transferable to others of the same genus. Magazines such as *Birder's World*, *Bird Watcher's Digest*, and *Natural History*, to name but a few, are marvelous sources of information.

Further information can be found in the *Readers' Guide to Periodical Literature* in the reference section of your

If you were to look up "San Francisco Bay Bird Photography" in the *Readers' Guide to Periodical Literature*, you would find a listing for an article I wrote for *Birder's World* in which this photograph of a greater yellowlegs appears. That article and its photographs offer you information about other subjects you could photograph at this same marsh. Photo captured with Nikon F4e, 800mm f/5.6 at f/5.6, on Fuji Provia 100.

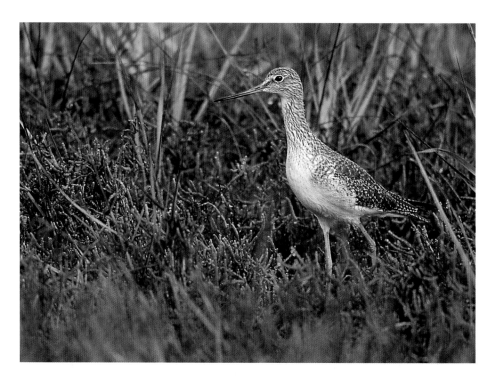

library. Published annually, it lists articles for the year alphabetically by author, title, and subject. Species that are discussed in articles can be found either in this manner or under headings such as "Natural History" or "Wildlife." This makes it relatively quick and easy to find the information. (Not every periodical published is covered by the guide though, so refer to the front index to find out which ones are included in the reference.)

Another resource to check out while at the library are books. If your library is anything like mine, it has many old volumes, some dating back to before World War II. Though old, they often have lavish accounts on species. (You've hit gold if you find one pertaining to the animal you're researching.) These can often solve all of your research needs, as they contain incredible amounts of information. As often happens, though, you might find one or two books that mention your species only in passing, but every little bit helps. (To avoid spending tons of time in libraries, long ago I started my own reference library, which makes research a more pleasant task. If you're serious about documenting lots of nesting birds, you might consider doing the same. There are a number of natural history book outlets that can make finding titles simple.)

The one type of library that's sure to assist you in your quest for information is a research library. These are most often found at universities and museums of natural history. A great treasure chest of information awaits you in the scientific journals housed in these facilities. Many journals are published quarterly by ornithological organizations. They contain collections of papers written by scientists and biologists on a variety of topics. Locating the data you're after is accomplished most quickly by reading through the journal's index, which is often published in the last volume of the year. Here's where knowing the Latin name for the species you're researching becomes invaluable. By searching the indexes of a number of years, papers on the species you're

researching can be found. The one drawback to research libraries is that they usually do not permit you to check materials out.

These papers are generally well written and comprehensible. Yes, some words, concepts, or things like DNA methodology might be more than you want to read. Just remember what you're after—nesting biology trivia. You'll find a "Methods" section in each paper, and that is where the information you're after can be unearthed. Everything from habitat, time of nesting, height of nest, type of nest construction, number of eggs, and incubation and nestling times are often included in this section. This information can make your time in the field one heck of a lot more fun and successful. Journals I most often consult are: *The AUK, The Condor, Conservation Biology, Ecology,* and *The Wilson Bulletin,* to name a few (for more information see Appendix A).

Research libraries also contain stacks and stacks of books. I have found the librarians to be great assets. They typically know all the current books on a

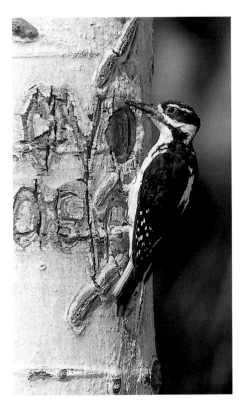

One of the first reference books I purchased was an original copy of Bent's *Life Histories of North American Woodpeckers.* I still credit photos like this one of a male hairy woodpecker to the knowledge I gained from reading that book. Photo captured with Nikon F4e, 800mm f/5.6 with a PK-11a at f/8, and a Speedlight SB-24 on a Really Right Stuff Flash Arm, set to minus 2/3-stop fill flash, on Agfa RSX 100.

Research Tip

When the information you need is unearthed, always document the author, title, publisher (listed on the book's or journal's title page), and take care to note the page numbers of the materials you're using. That way, whenever you are ready to write about your photographic adventure, you'll have all your quotes and notations right at hand. Putting footnote citations in your article will be a breeze. You never know when you might be the first to discover a new aspect of a bird's breeding biology, and you'll need all your support materials in order to write up your discovery.

species, those referred to most often by other researchers, as well as current articles in print. Some librarians are so in tune with the happenings, they can actually refer you to a person locally who is in the field doing research. They are a seldom-tapped resource worth their weight in gold to those willing to do a little digging.

The series *Life Histories of North American Birds* by Arthur Cleveland Bent is a great reference tool. This huge series covers the nesting biology of 85 percent of the birds in North America. It is written in an easily understood format with scientific overtones. It can provide you with tons of information, but you must wade through a lot of text. This series is a great addition to anyone's library. Though the original edition is long out of print, newer reprints can quite often be found at small birding book stores and in natural history-type catalogs. Check in *Books in Print* at your local library.

You might be wondering if there is one definitive source of information. There is one book in my library I rely on constantly in the spring, *A Field Guide to the Nests, Eggs and Nestlings of North American Birds* by Colin Harrison. In this one volume basic information on nesting habitat and requirements; nest type; breeding season; eggs; and incubation, nestling, and nesting periods for each species are listed. (This is the general list of the information you need to find.) Now, not every minute detail is available for every species, but it's pretty darn close. The one drawback to the book is that it covers all of North America generically. You'll need to factor in some adjustments for your region regarding habitat and nesting time of year.

Well, with all this research under your belt, is it time to venture into the field? That all depends upon if it's the time of year to find a nest. If you've done your homework, you'll know when it's right. Well, pretty close. You'll find a slight difference in the start of the nesting season each year due to changes in weather. Weather can direct-

ly affect a particular spring and set changes in motion for seasons to come. Other factors, such as habitat destruction or other natural disasters in a species' wintering ground, can affect nesting times. By keeping good notes every year, you'll become a student of phenology, which puts all these factors into perspective. (Phenology is the study of how climate affects the annual patterns of plant and animal life. To gain a better understanding of phenology and how it can help you capture better photographs, read *For Everything There Is a Season* by Frank C. Craighead, Jr.)

Finding the Nest— In-Field Sleuthing

There are folks who seem to possess a natural sixth sense when it comes to finding nests. They simply walk through a forest or marsh and end up strolling right up to an active nest. Their sixth sense is nothing magical, just an extremely well-honed awareness of the natural world around them. They're able to focus their minds on all the sights and sounds of their environment, soaking up and processing the natural clues being presented to them. Birds make no secret of their activities or where they're nesting (though they'd like to think they do). They tend to put out sign posts, big blatant flags, ones you can find if you know what to look and listen for.

You should start your search in the dead of winter. This may seem like an odd time to start, but it's when the trees and shrubs are bare. Nests of the previous year can be found easily as there's no cover to hide them. Now why would you want to find the nests from the previous year? If you're in the correct habitat for the species you wish to photograph, you'll gain a sense of where to look in the spring. You can see the placement of a nest in a tree or shrub. Is it close to the trunk or out on a limb? Does it hang down from the

limb or rest on top of it? How big is it, and what shape do you look for? What possible technical problems must be solved to get the photograph safely? Take your camera and flash equipment out to these nest sites and take some test shots. This preliminary field work gives you a head start on spring. An immense amount of information can be gathered without endangering anything. It also builds and reinforces your own sixth sense for finding nests. You will also find that many birds are quite site-tenacious, returning to the same locale year after year.

Then Comes Spring

In the spring, trees and shrubs have on their new wardrobes of green. Birds are returning from migration, filling the forests, meadows, grasslands, and marshes with song as males do their best to allure a mate. Most males also use their song to defend their territories from other males that are doing the same thing. These are your first clues that the nesting season has begun in earnest. It's also time to take your first step towards finding an active nest.

Singing males mean there are females about. And where there are two, well you know what happens next. Be aware that with some species, males use more than song to attract a mate. Some birds perform specialized flights and dances in an attempt to impress the opposite sex. Swifts, terns, and shore-birds are just a few. Some species, such as prairie chickens, dance for a mate. Some even have very specialized means of "drumming up" a mate, the ruffed grouse, for example.

Often the reward for the male's efforts is more work. Males are typically the ones that do the nest building (the initial stages, if not all the building). In some species, the male actually sits on the completed nest while singing to attract a mate. If you're after a species that has this habit, all you have to do is home in on the sound, and you're in the nest photography business. But understanding these clues about the species you are after is crucial to your success!

In riparian forests (forests that follow a creek or river), as many as 100 different bird species can be vying for nesting territories and mates. Singling out the species you're after by ear alone can be difficult. You can train your ear to "focus" on the one song you're after by listening to bird tapes. There are a

Field Tip

Learning the calls and songs of birds has a great number of advantages. The most obvious is being able to know which species are around without having to see them. This can help you use your time more economically by focusing your efforts on photographing the "rarer" bird over the more common one. It can also tell you what other birds might be in the area. For example, crows have a distinct call when they're harassing a hawk or an owl. Hearing this call informs the observant photographer of a possible "photo op" of either the hawk or the owl. Learning calls is easiest when a new, unfamiliar call is tracked down to its owner. This in-field work tends to pay off big at some point in the future when you least expect it!

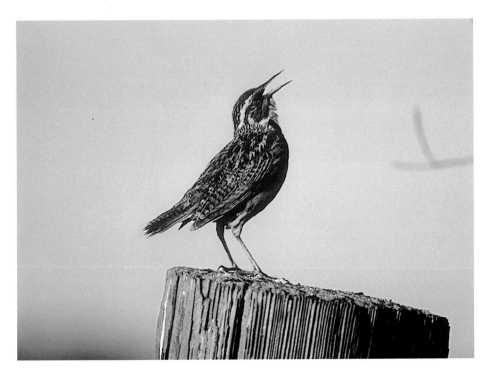

Perched on the highest point, this male western meadowlark sings his all-too-familiar song to attract a mate. Singing posts present you with good photo ops, and seeing one that's active is a sure sign that nesting is underway. Photo captured with Nikon F3P, 400mm f/5.6 at f/8, on Kodachrome 64.

Nesting Birds

This male Smith's longspur was attracted to this perch in response to a tape being played of another male longspur. He flew over to inspect who was in his territory, and when no one was found, he sang anyway just to make sure his territory was secure. Photo captured with Nikon F4e, 800mm f/5.6 at f/5.6, on Agfa RSX 100.

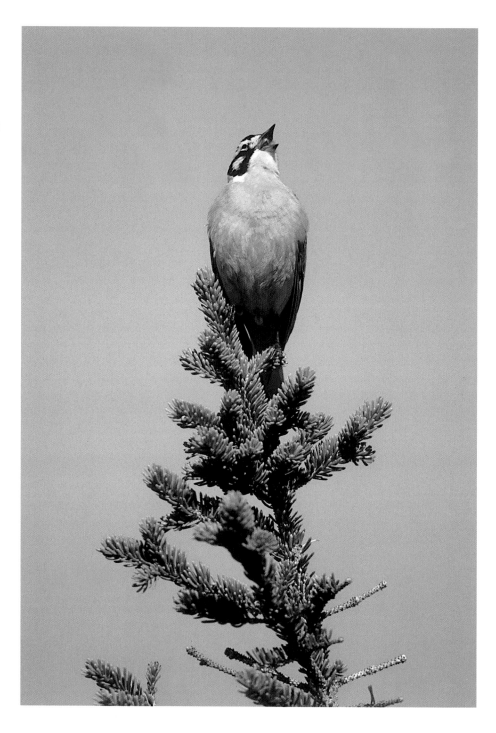

number of excellent tapes on the market that contain the various songs, calls, twits, and tweeters of particular species. There are also a number of excellent CD-ROMs that offer the same thing, providing photos along with the bird's songs. These calls can then be recorded onto a microcassette and taken into the field for review or comparison until you develop an ear for it. But unless you are properly trained, don't be tempted to play the tape aloud in an attempt to attract a bird. True, tapes are a valuable and valid research tool used by biologists. But an amateur not trained in the proper use of tapes can often end up unwittingly harassing the birds. Amateur use of tapes has

been the documented cause of nest failure on numerous occasions and is outlawed in some locales. If you're ready to invest the time into photographing a nest, you'd better be willing to spend a little extra time looking for it.

Males typically have defined "singing posts" throughout their territory, from where they advertise their availability. They'll fly from post to post during the day, singing from each for a period of time. (This in itself is a marvelous photographic opportunity.) These singing posts can aid you in your search. Discriminating observations through binoculars (I recommend using a minimum of 8x) reveal the male's activities and possible success. Males tend to sing *a lot* when they're not paired and mellow out once the female is sitting on eggs. These audible clues are reinforced by sightings of males and/or females gathering or carrying nesting material in their bills.

Signs of Nest-Building
Observing birds with nesting material is the quickest way I know to find a nest. Nesting materials can vary from species to species, so when doing your homework, determine the principal material your species uses in nest construction. For example, hummingbirds wrap spider webs around their bills. Birds of prey often collect dead twigs and branches, and just before laying eggs they collect green boughs for lining their nests. Songbirds often use the natural down of cottonwoods or thistles

for lining their nests. Birds gathering, perched with, or flying with these materials are signals that nest-building is in progress. Nest-building for the majority of small song birds lasts only a day or two. Larger birds, such as crows, hawks, and owls tend to take longer as there is more to construct.

Using binoculars, observe where the bird is taking its nesting material. Now if it's a bird of prey, the nest will be rather obvious. Its very size and placement high in the tops of open trees or cliffs make the nest relatively easy to find. On the other hand, if it's a hummingbird's nest, it can be like finding the proverbial needle in a haystack. Narrowing down the search area from an entire forest, to a corner, to a group of shrubs, to just one shrub, and then finally to a branch, is a chore. It's a chore that's lots of fun, but one that must be done with the utmost care!

Care must be taken when observing a nest site! All preliminary inspections should be done with binoculars and not by foot. The reasons are many, but the main one is to avoid spreading your scent, which can attract natural predators. Foxes, raccoons, skunks, and domestic animals all tend to follow the scent of man. Your actions can lead one of these predators right to the nest. Remember one very important fact. You depend on the welfare and success of that nest! All your efforts in researching, discovering, and photographing a nest can be washed away in a matter of seconds because of a

Field Tip

If in the winter you found nests in a certain area, but on a spring visit you don't hear any singing, don't despair. There could be many reasons. Males quite often stop singing during the middle of the day. Factors such as heat or wind also cause males to stop singing for a period. Quite often when this happens, they seem to vanish, while actually they have just sought cover. A predator in the area, such as a Cooper's hawk, can also cause the male to stop singing and disappear. Your presence could be another reason that the birds are not singing. Biologists typically enter an area and wait 10 minutes before counting on song, letting the creatures become accustomed to their presence. Whatever the reason, a little time sitting and observing will usually provide you with the answers.

NESTING BIRDS

Your passion for wildlife can be addictive. My sons love birds as much as I do. Here my oldest son, Brent, is exploring the possibilities of shooting this nesting hummer with his toy camera. Photo captured with Nikon F4s, 75-300mm f/4.5-5.6 AF at 75mm, with fill flash, on Fuji 100.

careless act. Not only will all your efforts be wasted, but more important, a generation of birds can be lost! If after all this work you cannot go to the nest without leading a predator to it, walk away and photograph the bird another day.

After all of this, you've finally narrowed down your bird's nesting site to a particular bush. What's next? You must first be sure that your activities are not affecting the birds in any way. This can be detected by noticing the birds taking a different flight path back to the nest, slowing down, or changing their routine. If there is a change, you had best find another nest, as you've come across a touchy pair. I've found that every pair of birds is entirely unique when it comes to nesting behavior. I've approached hummingbirds that wouldn't let me get within 50 yards of their nest, and I've had one that let my son stroke its back. Every pair has its own comfort zone. If you observe and detect no change in the pair you're watching, then proceed with caution to the next step—a visit to the nest.

What about Blinds?

I haven't mentioned blinds; have you wondered why? Well, the reason is, I hate using blinds because *they make me blind!* I photograph wildlife because I want to be outdoors. Once you're in a blind, the sights and sounds of the outdoors are muted or lost, and many of the visual clues I depend on to get good photographs disappear. Setting up and taking down blinds also causes damage to the nest site. They beat down the habitat and often create large patches of human scent, attracting predators from miles around. Blinds also create a huge flag for humans, who, being naturally curious, want to see what's going on. This just leads to more problems. So I advise you to avoid using blinds whenever possible.

There are times, though, when I have to use blinds. The most typical is when I'm photographing tern colonies. It's not that my presence is a great concern (though it is a small factor), but I use a blind mostly to keep clean. Keep clean, you ask? Well, terns use two methods to ward off enemies: one is to dive-bomb them, and the other is to defecate on them. Terns eat fish, so their whitewash is not very pleasant. A blind is a good way to keep most of that smelly stuff off of you and your equipment.

Certain species require that you use

a blind in order to photograph them. For instance, raptors are generally more comfortable when they can't see you. I don't presume for a moment that they don't know I'm present. I just think they think that if someone is stupid enough to lug a blind around, set it up, and sit in it, then they must not be a threat. Some small passerines (of the order *Passeriformes*, birds that perch) require blinds as well. The yellow-billed cuckoo, for example, will not go back to its nest if as little as your shoe is sticking out of the blind. Often, the research you do before going into the field will provide a clue as to the sensitivity of the species you want to photograph. Good research will not only get you in close to the nest, but will increase your chances of getting great photographs without harming the subject.

All birds can be flighty when sitting on a nest, but probably the most flighty are shorebirds. This dunlin came off its nest and tried to draw me away by traveling in the opposite direction. Once the bird has lured you a safe distance away, it will "mouse" its way back through the grasses to its nest. Photo captured with Nikon F4e, 800mm f/5.6 at f/ 8, on an overcast day with plus 1/3-stop compensation dialed in, on Agfa RSX 100.

Your First Trip to the Nest

Deciding when the timing is right to make your first visit to the nest can be tricky. If you observe the birds constantly flying with nesting material back and forth to a bush, then the nest is not completed. *Do not proceed any closer to the nest.* During the time that the nest is being built, any disturbance to it can cause the birds to abandon it since they have not developed a strong bond to it or its contents. Come back in a day and check the activity level again from a distance, and wait until the activity seems to have subsided before approaching any closer.

Once the nest is complete and the eggs are laid, the parents' flights to and from the nest become less frequent. Flights take place only when there is a nest exchange—when the partners switch egg-warming duties.

When you believe the pair is on eggs, make plans to make your first physical inspection of the nest site. Give the pair a couple of days' buffer from the time you believe they first started incubating before you make your first visit. Don't take any camera equipment with you this time, just binoculars.

Research Tip

Before approaching or photographing any nest, check the local, state, and federal regulations regarding protected species. Photographing the nests of protected species might have undesired consequences, such as fines. Be aware of species that are listed as endangered by federal law and those that are protected by unique laws such as the Eagle Act, which protects bald and golden eagles. Getting too close to or photographing protected animals can carry particularly stiff penalties. Finding out this information is as easy as making a simple five-minute phone call to the state's department of wildlife.

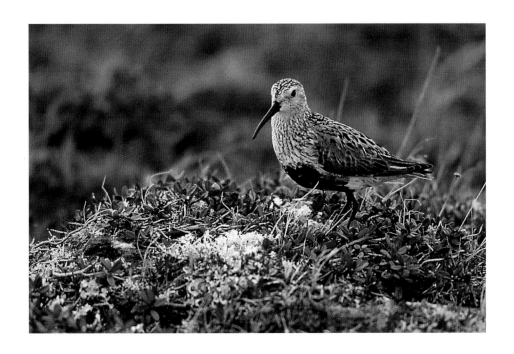

First of all, take care in making your way to the nest. Use large, high steps to avoid beating a path to the nest. We don't have a firm understanding of how birds select their nesting sites, but it's reasonable to believe that the foliage surrounding the nesting site is as important as the actual bush or tree they've selected. If there are any large, downed trees you must cross to get to the nest, do not break off any branches. And if there are branches extending into the nesting bush itself, take great care not to step on them. You could tear the nest by stepping on branches that are attached to it.

Every time you take a step towards the nest, watch to see if the birds flush. They can fly out in any direction from the nest, so keep a keen eye out. Proceed cautiously and carefully, especially if you aren't sure of the exact location of the nest. If you get to the shrub or tree and no birds are observed flushing, you're doing great. If a bird does flush, hold still and wait 20 minutes. If they don't come back within that time, leave the area and watch with binoculars. If it takes them 5 or 10 minutes to come back to the nest after you've left the immediate area, find another nest, as this pair is too sensitive to tolerate your presence. If they come right back after you've left, you're probably going to be OK.

You've successfully approached the bush; now how do you find the nest's exact location? The best method is to use your eyes and refrain from actually touching the bush. If possible, position yourself so the bush or tree is backlit with the light shining through its branches. This sometimes reveals the nest's position by silhouetting it, making it stand out from all the branches. If it's not apparent, slowly move up, down, or sideways to find the nest's location.

But more likely you'll have to pull branches back to peer into the shrub. This must be done ever so slowly and carefully! Nests tend to have a leaf or a twig of the host plant intertwined into their construction. Nests are typically connected to more than one branch.

The one twig or branch you're pulling back could be connected to the nest. Pulling it back and not being aware of this connection could destroy the nest or tip it, spilling the eggs or nestlings out of it. Some branches are brittle, and pulling them back can break them, weakening the nest's support. This process can also create a path to the nest for predators to follow. So with all of this fear of God instilled in you about damaging a nest, if great care is taken, you can move the branches successfully. But if you find you cannot move a branch without risking the nest, it's time to put your energy into finding another one.

Observing the Nest

You've found the nest. Now what in the heck do you do? First, you need to keep an eye and ear out for the adults at all times. If they come, well, watch them and notice their reaction to you. There really is no guidebook for this other than common sense and experience. If they seem to panic, make nervous gestures, or sound chatty, leave. If they just seem to flit from branch to branch watching you, proceed slowly and carefully. And if you're working with a raptor and they start dive-bombing your head, carefully *RUN!*

When investigating the nest, check the status of the eggs. (If it's a cavity nester, a mechanic's mirror can help. See page 75 for more information.) Count the eggs and observe their color, taking notes the whole time. Next, look at the sun's relationship to the shrub or tree where the nest is located. Notice the time of day that the ambient light illuminates the nest the way you desire, even if you're planning to use flash. Remember, background is very important to your photo and must be taken into consideration (see pages 23 and 28). Plan how you are going to shoot the nest when the background is lit or not lit, depending on the effect you want. (I highly recommend using a microcassette recorder for taking notes. It's a much easier and more accurate way of getting back home with the

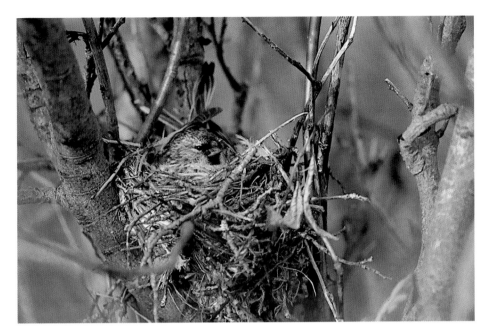

This hoary redpoll's nest was situated in a shrub hanging over a pond. I waited for the redpoll to leave the nest before I went into the water and waded over to the nest to tie the branches back with binder clips. Photo captured with Nikon F4e, 800mm f/5.6 at f/5.6, with a PK-11a attached, on Agfa RSX 100.

facts.) Finally, before leaving the nest, take one last look around for the parents to see if they have flown the coop or stuck around.

Now it's time to depart from the nest site. I know, you've just found it, but carefully put the branches back the way you found them and back off slowly. Again use care in walking back on the same path as you took to approach the site. Keep an eye out for the parents as all the observations you make now about their behavior and their reaction to you will come in handy later. Finally, use your binoculars from a distance and try to determine how long it takes for the parents to return to the nest (the quicker the better). The whole process of inspecting the nest and having the parents return should take no more than 5 minutes.

Lessons from the First Trip

What can we learn from the first visit to the nest? The eggs tell us a lot about what's happening in the life of the nest. We can determine the stage the nest is at by the number of eggs that are present. For example, if you know there should typically be five eggs and you find only two, that's a clear indication that the parents are still in the process of laying eggs. It could also be an indication that you entered the nest too early. (Remember that information gleaned from books is not carved in granite, as nesting times, number of eggs, and conditions can vary.) The goal of all these observations is to calculate the date when the eggs *should* hatch.

What if you're checking on a species such as a hummingbird? Hummingbirds and many other species lay their eggs one day apart. If there's only one egg in the nest, then they've probably just started laying, and the second should appear the next day. (Typically, hummingbirds lay at least one egg before the construction of the nest cup has been completed.)

Egg color can confirm your findings. Eggs usually have a reddish "glow" within the first few hours of having been laid. So finding eggs with this

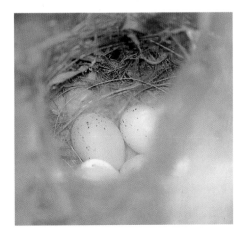

The reddish glow of these least Bell's vireo eggs indicates that they had been newly laid. Within 24 hours, these eggs became pure white with brown spots. Understanding subtle signs like this can help you predict the hatch date. Photo captured with Nikon N2020, 55mm f/2.8 at f/8, and a single flash, on Kodachrome 64.

color is extremely informative, especially if the species is known to lay just two eggs, and one's in the nest. Finding eggs with their "normal" color confirms that the eggs are at least a day old.

Preparing for Your First Shoot at the Nest

Your first visit to the nest for photography purposes could be during the incubation period or coordinated with the eggs' hatch date, depending upon your interest. If you choose to shoot the nest during the incubation period, be prepared to photograph an adult sitting (this can be boring!). The eggs most likely won't be visible except at those times when there is a nest exchange. And even then, they'll be visible for only a short flash of time. Repeated trips to the nest during incubation won't reward you with a great variety of photographs, so I recommend going only once. The longer the adults sit on the eggs and the fewer trips you make to the nest (reducing the chance you'll attract a predator), the better. The more time adults have invested in a nest, the more "emotional" ties they'll have to it, and the less likely they'll be to abandon it.

During the time when the adults are sitting on eggs, check on the nest with binoculars from a distance (without physically going to the nest). Check to make sure that predators haven't followed your path or that you've made wrong calculations about the hatch date. While viewing the nest area, decide where you want to set up your equipment to photograph. You might also want to see if there are other birds nesting in the area. You don't want your activities at one nest to disturb another.

Once you determine how you want to photograph the nest, practice on something else. You can save yourself troubles at the nest by setting up your system and shooting a similar situation at another location in preparation. Check for such things as the physical

distance between the camera and nest to determine image size. And check to make sure you have enough flash power to light the nest at that distance to achieve the maximum depth of field desired. Make sure that the lighting pattern you want to use won't create more shadows than it eliminates. And determine the best time of day for the lighting setup while considering available light levels.

When it's finally time to photograph the nest, you want to head off with a song in your heart and a checklist in your head. Make a mental checklist of *all* the equipment you'll need at the nest (or make a written list, it really helps!). You need to arrive at the nest site ready to go. Once at the nest, you'll need to stay put until it's time to go home. You can't make a couple of trips back and forth from the nest to gather all the necessary equipment. You want to be able to work lightly and quickly. What follows is my checklist of equipment to take for a basic nest setup.

NEST SITE EQUIPMENT CHECKLIST

- ❏ camera bodies (most often two)
- ❏ lens for photographing the nest (see pages 72 and 73 for suggestions)
- ❏ macro lens
- ❏ film (minimum of five rolls)
- ❏ flash unit(s)
- ❏ external battery packs for flash
- ❏ all necessary flash cords
- ❏ flash bracket
- ❏ tripod
- ❏ cable release (minimum 10 feet long)
- ❏ binoculars (at least 8x)
- ❏ binder clip ties (for pulling back branches)
- ❏ rubber bands
- ❏ microcassette recorder
- ❏ chair
- ❏ hat (if sun requires)
- ❏ water and munchies

Your First Shoot

Here it is, the exciting day you've earned with all of your diligent efforts. Now's not the time to lose your cool and go off half-cocked! Assemble your equipment away from the nest. This means not only having film in the camera and the camera turned on, but also having it mounted to the tripod with flash units in place. This also means having all cords attached and ready and the binder clip ties for the branches readily accessible (I will discuss these in just a minute.) The last thing you want to do at the nest is take time assembling your equipment and gathering yourself. Going in unprepared not only limits your productive time at the nest, but also creates unnecessary busyness that can keep the parents away. You want to travel light and work fast when photographing a nest. So, as well as having your equipment assembled, you must have a battle plan for dealing with branches and lighting conditions.

As soon as you've reached the nest site and the adults have left the nest, the clock is ticking. *Your activities should not keep the adults off the nest for more than 20 MINUTES!*

I use three sizes of binder clips with cord attached to tie branches back out of the way and reveal a better view of my subject.

The first thing you'll need to do is pull the branches back out of the way to reveal the nest. This can be a little tricky. You obviously can't hold them with your hands the whole time. *You cannot cut them away either, right?* My method is to utilize some homemade devices made out of heavy-duty binder clips and heavy cord. I attach the cord to two small clips, and use it to tie back a group of leaves or twigs. I can either clamp the two clips together to form a circle, or carefully, without injuring the plant, fasten them to a branch. I have the medium- and large-sized clips set up in the same fashion, but I also carry individual binder clips without any cord attached. I use these to hold back just one branch, if needed. (Remember, when you leave you must protect the

All birds are susceptible to having the eggs in their nests overheat, but none are as vulnerable as ground nesters. In the case of the parasitic jaeger, threats to the eggs include predators as well as heat. This jaeger is flying back to cover her eggs after chasing off a herring gull who had posed a threat to the nest. A bird that is incubating eggs should not be off its nest more than 20 minutes. Photo captured with Nikon F4e, 35-70mm f/2.8D AF set at 35mm and f/11, and fill flash at minus 2/3-stop, on Agfa RSX 100.

NESTING BIRDS

This Anna's hummingbird nest was low to the ground, hidden among some brambles. By using a couple of clip ties to clear the view, I was able to photograph the nest easily. Photo captured with Nikon F4s, 75-300mm f/4.5-5.6 AF at 200mm and f/11, two SB-24 flashes as main lights, and an SB-22 for a background light, on Kodachrome 64.

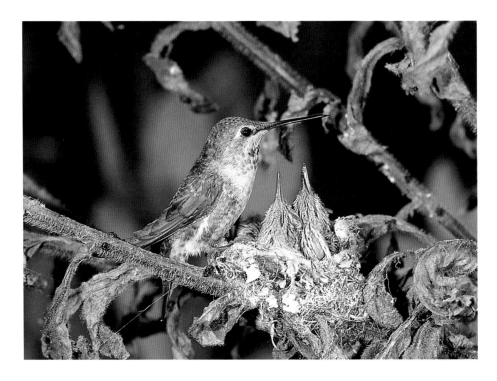

nest by putting all the branches, twigs, and leaves back just the way you found them. When you remove the clips and ties, *do not* let the branches snap back into place, as this could upset the nest! Instead, ease everything gently back into its original position.) Setting these clips up the first time at the nest takes time (meaning minutes rather than seconds), but after the first visit, it will be a snap. You must use great care when moving the interfering branches for the first time because they could very easily be attached to the nest itself. It takes a few minutes to unravel the maze of twigs around the nest, but it can and must be done carefully without causing any harm to the nest.

Setting up the positions of the flash units can take a little while the first time as well. You should already have figured out from your earlier visit which are the best positions for the two flash units. (Refer to *NWP*, page 55.) You must make sure that you are not only compensating for any ambient light deficiencies, but also not creating any new lighting problems. You must make sure that the light path from the flash to the nest is not obstructed by a leaf or twig, which might cause a shadow to be cast on the nest.

Now don't forget, your activities should not keep the parents from their nest more than 20 minutes! If they don't come back to the nest within that time, pull yourself out, but leave your equipment. Go back to the position at which you previously observed the nest with binoculars, and watch the nest. If the adults come back within the next 5 minutes, great. If not, go get your equipment and pull it all out, including any branch ties. (Take care of the path you're creating this whole time. Leave as little trace as possible.)

We have a few scenarios to work through now. Obviously if the adults came in, then skip down a few paragraphs to "You're There!" If you leave the nest with your equipment still set up and the adults come back in 5 minutes, you have a couple of options. Whatever you do, you need to wait a while. If the parents are still sitting on eggs, they need time to tend to the eggs they just came back to incubate. They should have at least 15 minutes to secure the temperature of the eggs and turn them, if required. After this time,

you can slowly approach your gear. The birds will probably flush again, but hopefully they'll return within 20 minutes. If that's the case, you're in like Flynn!

If the parents don't return, attach a cable release to the camera and move back 10 feet from the camera. Remember, you must hold still after reaching your new location. You can't be dancing about from nervousness, the cold, or having to go to the bathroom. If once you've moved back 10 feet the adults return to the nest in 5 minutes, good. If they don't, move back to your previous binocular-viewing position and watch. When they come back to the nest, give them adequate time, then walk back to the 10-foot mark. If they stay with you at this distance, do some remote shooting and try shooting from the camera's position on the next trip to the nest. If, however, at this attempt the adults leave and don't come back within 20 minutes, go get your camera gear and try again the next day.

If you had to pull your equipment out from the beginning, go back to your observation point and watch the birds. When they return to the nest, give them plenty of time, then slowly walk back and place the camera 10 feet away from the nest. Watch their behavior, because if they go back to the nest, you will be able to photograph them following the steps above. But if they don't, you'll need to turn your attentions to another nest. This pair is not going to accept your presence, which is always a real possibility.

You're There!

Wow, you've made it to the nest and you're sitting with camera and flash on, waiting to take that first photograph. The first time the adult returns to the nest, *don't* fry its feathers with a blast of flash! Take a deep breath and soak in the moment; you're sitting next to a wild creature, sharing a very important moment together. You've probably had to work hard to get to this point, and so did the birds. Just sit for a while and take in all that's happening.

I can almost guarantee that the first time you fire the camera, the birds will flush. It's not so much the light from the flash that bothers them as much as it is the noise of all the operations. Generally, they will come back, and within only a few frames they'll ignore the whole picture-taking process. But in the beginning, take it slowly—remain calm,

Photographing this parasitic jaeger sitting on the nest was not really a challenge. With eggs to incubate, she sat tight on the nest, making the variety of photo ops slim. So I took the time to fine-tune the portrait since she was so cooperative. Photo captured with Nikon F4e, 800mm f/5.6 at f/8, shot on an overcast day with plus 1/3-stop compensation dialed in, on Agfa RSX 100.

Nesting Birds

You have to be on your toes when photographing nesting birds. This American avocet was just sitting on its eggs when it suddenly rose to turn them. Capturing this behavior was not easy. Because red fox live nearby, and fox will follow human scent, I dared not approach the nest too closely and used a long lens instead. Photo captured with Nikon F4e, 800mm f/5.6 with TC-14b at f/5.6, on Fuji Provia 100.

making all movements in a very smooth and controlled fashion. This is especially true when focusing the lens. Hand movement around the lens barrel tends to make most birds nervous. (The Nikon F5's autofocus system eliminates this concern. Its mouse pad on the back of the camera lets you select the appropriate autofocus point with just a touch of the thumb.)

The observations that you made of the parents on the first visit to the nest now become invaluable. While sitting at the nest, you tend to grow blinders to the many things going on around you. The direction from which the parents come to the nest, leave the nest, and the duration of their absences are all factors that are important to your photography. These are things you should have observed during your preliminary visits. When either adult leaves the nest, for whatever reason, it's important to be aware of how and when they come back. Each time they return to the nest, it will be like the first time every time. They'll watch you like a hawk! Any movement you make could possibly cause them to stay away from the nest that much longer. Since you want to stay at a nest site for only

a couple of hours, maximum, the time they spend away from the nest means lost photographs.

The activity level on this first shoot will probably be low. More than likely, the adult will sit on the nest and just stare at you the whole time. You might get a shot of it moving about the nest, stretching, or turning its eggs, but you'll probably spend most of the time just watching each other. One thing you don't want to do during these slow times is scare the bird off the nest to get photographs of it coming and going. You'll get enough of these later—don't create stress for the bird because of your boredom or impatience.

Once the birds are used to your presence, a good thing to do during the incubation period is experiment a little with your camera and flash setup. This is the time to fine-tune everything for subsequent visits. Take photos with your primary setup and then move the flash units or camera (very slowly) and try other arrangements. You should also run an exposure test for the flash exposure as well. Close down or open up the lens aperture to compare different depth of fields and their effect on

the flash's recycling time and distance. Remember that flash exposure is affected by flash-to-subject distance and aperture; the light might not expose the background the same with the aperture closed down as when it is wide open. This could dramatically affect your photograph for better or worse!

Try different degrees of underexposure compensation if using fill flash, or possibly try feathering the lights more or less than with the primary setup. All these tests should be noted on your microcassette. Your quiet talking won't bother the birds, and besides, it's a great alternative to getting the film back and not knowing what's what. In this way, when you come back to the nest you'll be able to concentrate just on the birds; the technical stuff will be all set and ready to go.

The Technical Side

For those who have read *NWP*, this section might be a little redundant. But I want to make sure that we're all on the same wavelength when it comes to the technical aspects of taking these photographs. I also want to go over some new advances that, when coupled with old techniques, can make your photography even easier and more successful. You have the basics: the camera, lens, flash, and film. But you're beyond the basics here—you're going for the gold!

Exposing the Nest
The vast majority of the nests you'll photograph will have lighting problems. Those few, rare nest locations where the ambient light does it all are those magical sites where photography doesn't get any better. So how do we deal with exposure and combining light sources without disturbing the occupants of the nest?

Let's start with exposure, truly the most difficult concept to grasp. Except when we're photographing nests out in the open, the majority of nests will be hidden in one way or another by vegetation. This means that ambient light will most likely not be the main lighting source, flash will be. This throws out a number of variables for us to deal with in order to be successful. Thank goodness we have TTL flash technology on our side.

This classic nesting shot of a least Bell's vireo was a learning experience. It set the standard for future nesting shots of mine. The soft-focused, properly exposed leaf helps convey the vireo's environment as well as adding a little atmosphere to the composition. Exposure is critical in a scenario such as this. Photo captured with Nikon N2020, 200mm f/4 IF Micro at f/8, with two Sunpack TTL flash units, on Kodachrome 64.

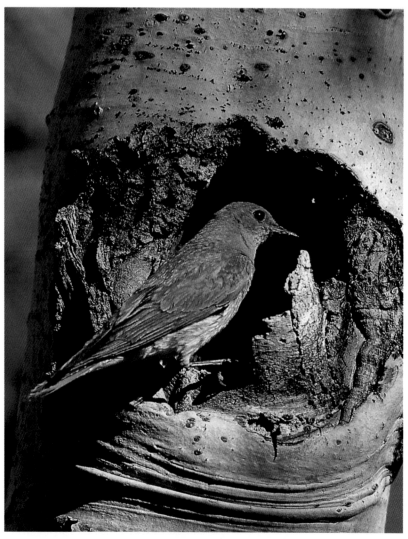

This photo of a mountain bluebird's nest was potentially a winner. It was in a great location—just five feet off the ground—and in afternoon light. But I was so thrilled to find it, I forgot some of the basics. Fill flash would have really helped this photo. Photo captured with Nikon F4e, 800mm f/5.6 at f/8, on Fuji Provia 100.

Field Tip

One method of positioning a secondary flash unit in a desired location I learned long ago from another photographer. You'll need a three-foot length of double-sided Velcro, a 1/4"-20 screw, a Stroboframe Compact Ballhead, and a bar (made of wood, metal, or plastic, approximately 3" x 1") with a hole drilled in the center that accepts a 1/4"-20 screw.

Cut a small hole in the middle of the Velcro strap. Place the base of the ballhead (small little dude) in the middle of the strap, aligning the ballhead's socket with the hole. On the other side of the Velcro, place the bar perpendicular to the Velcro strap, aligning the hole in the bar with the hole in the Velcro. (The bar will give the ballhead stability when this contraption is attached to an object.) Fasten the bar, Velcro, and ballhead together with the 1/4"-20 screw.

This strap and ballhead combination can be attached to any object, square or round (a tree, for instance), without damaging the object. A TTL cord or the Ikelite Lite-Link can be attached to the ballhead. This is a simple, yet effective, method of placing a secondary flash precisely where you need it.

A quick refresher: TTL stands for Through-The-Lens flash metering. When the flash is fired, light bursts from the flash unit, strikes the subject, bounces back to the lens, and is metered at the film plane. When the camera's computer has determined that the right exposure has been achieved, it shuts the flash off.

In manual and automatic non-TTL flash modes, the two variables that must be controlled by the photographer for proper flash exposure are the flash-to-subject distance and the aperture. With TTL flash, the flash-to-subject distance is taken into account by the camera's computer. The only thing you have to do is make sure that the subject is within the limits of the flash unit's range. And TTL gives you more control over the depth of field by allowing you to set a greater range of apertures. (For an in-depth explanation, refer to *NWP*, page 48.) But TTL exposure can be fooled by many variables, and for nesting birds, leaves are the most common culprit.

Leaves come in many shapes, sizes, and textures. Size and shape are not as big a concern as texture (for exposure, that is), which can fool TTL metering. Shiny leaves, for example, tend to reflect back more light than desired, causing the final image to be underexposed. Hirsute leaves (those with small, white hairs) absorb the light and typi-

cally cause the TTL metering to overexpose the image. These generalities apply when the leaves fill approximately 40 percent of the frame. So if your nest is framed by leaves, you must take into consideration what they may be doing to your exposure. That's a good reason for shooting a few frames of test shots the first time you visit the nest with your camera equipment.

Another thing you need to be concerned about when dealing with leaves is how close they are to the flash in relation to the flash-to-nest distance. A leaf that is closer to the camera than the nest and is within the frame can easily ruin the entire photo. How? Flash-to-subject distance. When the flash and nest are within close proximity to one another, exposure changes quickly. The leaf that's closer to the camera than the nest can be overexposed by as much as two stops compared to the nest. In the final image, the leaf ends up looking like a giant searchlight blaring back into the lens. This is obviously not what you intended. So the first thing you need to concern yourself with when setting exposure for these photographs is leaves.

There are three options for solving this problem (which applies to much of our overall exposure solution). The first option is to remove the leaf. This can be done by using my binder clip invention (see page 63) to tie it back out of the

Really Right Stuff Flash Arm and Dual Strobe Bar

way, or clip it directly with a binder clip (not scissors). Of course, there are times when this is not possible because the leaf is connected to the nest in some way. The next possibility is to move the flash to avoid illuminating the leaf. This is often not possible because the flash placement is limited by the need to expose the nest adequately. The third and most practical alternative is to feather or tone down the exposure of the leaf.

Feathering the light is achieved simply by turning the flash so that the main beam of light does not hit the leaf. All flash units have a strong central beam with softer light surrounding it. Turning the flash so that this central, hot beam doesn't hit the leaf can often be enough to keep it from being overexposed. Another way to limit the amount of light is to cut to size a small amount of neutral-density gel and place it on the flash head. This need only be a small piece that reduces the amount of light that strikes the leaf but does not affect the overall burst of light. My preferred method is to physically move the flash away from the leaf.

Remember that exposure is affected by the flash-to-subject distance. If we can keep the flash on the same axis so

that the directional lighting is maintained but we place it farther away from the subject, the amount of light from the flash will cover a broader area and be reduced in intensity as a result. For example, if the distance from the flash to the nest is 10 feet and the distance from the flash to the leaf is 5 feet, the leaf will have two stops more light on it than the nest. But if we move the flash 15 feet away from the nest and hence 10 feet from the leaf, the leaf will have only one more stop of light than the nest. So you see, there are a lot of techniques that can be used singly or in combination to control the light on that one, stubborn leaf.

With the leaf under control, what about overall nest exposure? Since nests generally don't receive full sun, making an exposure using only ambient light requires a slow shutter speed. I've run into speeds as low as 1/4 second, way too slow to freeze any bird activity. So I typically use flash as my key light at the nest. What that means is that the thrust of the exposure comes from the flash (illuminating the subject), and the ambient light generally illuminates the background. (See pages 71 and 103 for more information on background exposure.)

With the camera in manual mode, set the f/stop to achieve the depth of field you desire. Then, assuming you want the ambient light and flash exposure to be balanced, look at the meter and set the shutter speed to the meter's suggested exposure time. To overexpose or underexpose the background, set a slower or faster shutter speed, respectively. I'd like to elaborate more on this, but it really is just that simple. There's only one small catch, and that is ghosting.

Ghosting occurs when the shutter speed is so long that the subject's movement is recorded on film after the flash has gone off. This is typically noticeable starting around 1/60 or 1/30 second, depending on how much and how fast the subject moves. This is a valid effect for conveying movement at the nest, such as the hovering motion of a

Field Tip

Is your setup physically close to the nest, say within four feet? Is there a leaf in the frame that you just can't subdue the exposure on? A quick and effective cure is to modify and diffuse the light of the flash with either the Sto-Fen Omni Bounce or the Photoflex On-Camera XTC II. These diffusers bounce the light everywhere, completely eliminating the main beam of the flash and thus reducing glare on leaves or other close objects. They also bounce light into shadow areas that otherwise wouldn't be affected by bare flash. One problem, though, is that they consume light. The Omni Bounce sucks up two stops, and the XTC II eats up 3/4 stop. They are also rather conspicuous, which can disturb the nest occupants. Despite these drawbacks, I've used both accessories to photograph nests with great success.

NESTING BIRDS

hummingbird feeding its young or a woodpecker drilling on the side of the tree. But ghosting is not something you want in every photograph. So you must be conscious of the shutter speed you've selected and the effect it will have on recording the movement of the bird you're photographing. If it is too dark, you may need to choose between depth of field and ghosting. (This is why it is so important for you to determine the time of day that gives you the greatest amount of ambient light at the nest. The more ambient light there is, the more options you have.)

With ambient light exposure out of the way, all we have left is the flash exposure. Well, you're saying, TTL takes care of that, so we're through. Wrong! TTL makes things easier, but we still need to be aware and in charge of what it's doing. The biggest thing is the overall quality of the exposure. We don't want the photograph to look like it was taken with flash. We don't want our subject to have five gazillion catchlights in its eyes. And we don't want to create harsh shadows around the nest. Remember, this is one of the touchy-feely things where the maternal nest should be surrounded by a soft, spiritual aura.

The quality of light and the quality of exposure are closely connected. Remember, with TTL flash, the flash output is controlled by the set aperture (which in turn, determines depth of field). The quality of the light is determined by the way the flash units are positioned. My methodology for this has changed only slightly since *NWP* was written, and that comes from my good friend at Really Right Stuff. He came out with a flash arm that works with lenses that have their own tripod collar. This flash arm permits the flash to be positioned directly over the lens, even if you're shooting vertically (which is very important if you are taking cover photos). I generally use this arm for mounting the flash unit that provides the main, overall lighting for the nest. My second flash sits on a Really Right Stuff Dual Strobe Bar. It is attached to the top of the flash arm and holds the

flash either to the left or right side of the lens (as determined by the location of the nest in relation to the camera setup).

Right off the bat, having the flash over the lens cleans up any and all shadows that might be caused by the ambient light coming in from above. The flash's placement directly over the lens also creates a natural-looking catchlight high on the bird's eye, like the sun would make if it could. Placing the second flash off to the side provides or creates (however you wish to look at it) an impression of shape.

We're photographing a round, plump bird on a round nest. If we light it with just one flash unit, there will be no visual depth, nothing to tell the viewer that the object in the photograph is three-dimensional. Everything flattens out with just one light. The second flash causes a slight shadow to be created on one side of the subject. Not black and dark, but just enough, maybe one stop, to create depth and texture in the scene.

You might be asking yourself, how can this be since we're working TTL? Doesn't the camera's meter expose everything so the light is even overall? Yes, it does. We count on that. The meter basically exposes for the brightest thing in the photo (which is why we watch for leaves and other obstructions). This is typically the bird's breast and/or the nest cup. Because the TTL sensor is exposing for the highlight, the small shadow (the area where the side flash does not light) goes slightly dark. Still a little confused? Shoot a test with a teddy bear and see for yourself (see *NWP*, page 55).

Now that the quality of the light has a good base, let's improve on it with exposure. I hate to use the word "fooled," which is so often used to describe a meter's "behavior," but the camera's meter can make mistakes in determining correct exposure, especially when photographing nests. I have found that these mistakes typically occur because of the nature of the nest cup itself. The cup is made up of many

Field Tip

It takes practice to use background light effectively. Many times, great nest shots are lost because the background light has been placed improperly. How do you get experience in placing the background light? Find a bush! You don't need an active nest or tons of film. Take a brown sock, wad it up into the size and shape of a nest, and place it in the bush. Set up to photograph the sock as if it were a nest, then place the background light where you think it would be best. Shoot a frame or two, move the light, and shoot again. With just one roll of film you can test the background lighting for sixteen different situations, shooting two frames for each setup.

70

natural materials that all have their own reflectiveness. These materials come in different shades, from dark brown to bright white. Any and all of this can affect TTL flash exposure.

Generally (and this is only a starting point) I set my flashes that provide the key light to underexpose by 1/3 stop. I set this manually on the flash units themselves. This might be in combination with using a Sto-Fen Omni Bounce or Photoflex On-Camera XTC II. These two attachments fit over the flash head to modify the light that's emitted. They increase the quality of the light by mellowing, softening, and spreading it out. But they must be used in close proximity to the nest because of the light loss that's typical when diffusers are used.

There's a product on the market that can make your life at the nest one heck of a lot easier, and that's the Ikelite Lite-Link. In a nutshell, the Lite-Link provides cordless TTL operation. That's right, you can maintain TTL operation without having the flash physically wired to the main flash unit or camera. Now you might be asking yourself, what good is that when the flashes are positioned so close to the camera to start with? Well, there are times when

two flash units are not enough—a third is required to light the background. The ambient light in some instances just doesn't cut it, the background exposure is so low you can't make use of it. The Lite-Link gives you the flexibility to use a flash as a background light without having to mess with wires. This means that you can work at the nest with less disturbance.

Setting the background flash can be tricky though. You'll need experience to get it right. First of all, the background flash needs to eliminate shadows. This typically requires that the flash be set up off the ground. That in itself can be tricky. I have often used either a small, tabletop tripod or the Benbo Trekker to hold the background flash. The Trekker works great because its very flexible design allows me to place the flash exactly where I want it. But care must be taken when placing the tripod in relationship to the nest.

Second, the background flash needs to be aimed correctly to prevent flare. None of the light emitted by the background flash should strike the front element of the lens or else you will have flare problems. Some people point the background flash in the direction of the

The Ikelite Lite-Link

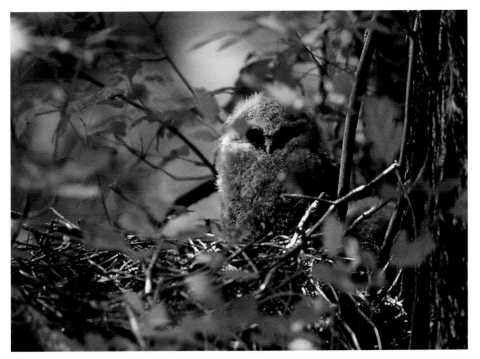

Nests of larger birds such as raptors and owls typically need to be shot with a longer focal length lens. This California spotted owl's nest was located high in a tree, but close to a hillside from where I could shoot. Its location permitted me to use a shorter lens than I would have needed had I been shooting from the ground. Photo captured with Nikon F4s, 400mm f/5.6 EDIF at f/5.6, on Fuji 100.

Some species require long lenses, at least so you'd think. I could have easily shot this whimbrel with my 20mm lens, but I used my 800mm because it has a narrow angle of view. The long lens allowed me to exclude the unattractive fire ring and dirt road that were in the background. Photo captured with Nikon F4e, 800mm f/5.6 at f/8, shot on an overcast day with plus 1/3-stop compensation dialed in, on Agfa RSX 100.

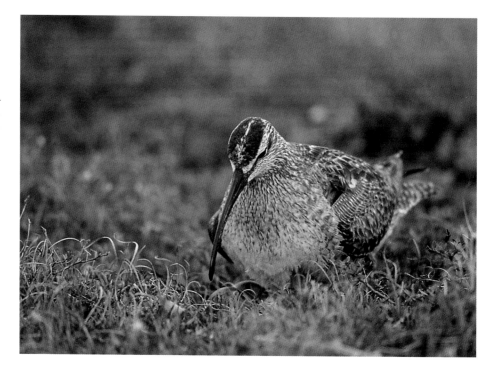

Field Tip

Once you've photographed a few nests, you'll find that you won't be able to remember exactly what you did to shoot any one in particular. My remedy for this is to photograph the camera setup with the nest in the frame at each site. I typically do this after the young have fledged and there is no activity at the nest. This is a quick and easy way to record exactly how I had things set up for future reference.

nest to provide a hair light or rim lighting for the birds. That's determined by personal taste, and if you like it, it's perfectly valid. No matter how you want to use it, a background flash is very easy to use thanks to the Lite-Link.

One other aspect of using flash is battery power. I can't recommend enough the value of the Quantum Turbo Battery for powering flashes. Their incredible recycling time when working TTL makes them invaluable for recording every moment at the nest. Many camera manufacturers state that using these can cause harm to their flash units, so be forewarned. However I can tell you that I've replaced the NiCds in my Turbos four times because of all the use they've received, and they've never damaged my flash units.

One thing you always want to subconsciously keep an eye on is the flash unit's ready light. Since you should try to always be looking through the viewfinder, make use of the ready light in there. If you are working with remote flash, either use your naked eye or binoculars to watch the ready light on the flash unit. The ready light not only tells you when the flash is ready, but also whether exposure was sufficient or

not. Most flash units' ready lights blink rapidly after the exposure has been made if the amount of light was insufficient for good exposure.

For example, you might fire off a couple of frames very quickly with the ready light indicating that everything was all right, only to shoot a third frame and have the ready light indicate that there was not enough light for good exposure. This probably means that the charge in the flash's capacitor is used up and you need to wait for a full recharge (this can even happen briefly using the Turbo). Other reasons that the ready light might indicate that there was not enough light for good exposure could be that a leaf was blocking the flash, the flash moved so that its light did not hit the subject, or the subject itself changed in some way and did not reflect light in the same way as with previous shots.

Lenses for the Nest

I have not mentioned lenses yet, and there's a good reason for that. Your style of photography and the nest itself governs what the best lens would be to use for each situation. Obviously, if you're photographing a raptor's nest, a

200mm probably won't be enough, and if shooting a small hummingbird, a 500mm might be too much. So then, what should you look for in a good "nest" lens?

There are many excellent options available. My favorites are the Nikon 75-300mm f/4.5-5.6 AF and the 80-200mm f/2.8D ED AF because of their incredible flexibility in their zoom range and their close-focusing features. The Canon 35-350mm is a beautiful lens for this as well, providing excellent results at any range. The Sigma 300mm or 400mm Macro lenses are other excellent options, delivering great quality along with incredibly small minimum focusing distances.

What if you don't own one of these lenses, but have a standard telephoto with a large minimum focusing distance? There is no one answer to this question, thank goodness! The simplest answer is to apply an extension tube. This shortens your minimum focusing distance dramatically while causing minimal change in exposure (some compensation is necessary). You can also use close-up filters, which do not require exposure compensation, but at the same time, they do not deliver the quality that extension tubes do.

More than likely, you will find "the" answer for yourself over time. I started out with a 400mm f/5.6 and extension tubes, then went to an older 200mm Micro. I then relied heavily on my 75-300 and now am just starting to use the Sigma 400mm Macro. As you photograph more and more nests, you'll define your own preferences, and lenses will play a big part in your growing proficiency as a nest photographer.

Back to Photographing the Nest

You know, this takes a lot of mental work. What is it all for? Well the best is yet to come, when you actually get to photograph the nest. I have spent thousands of hours watching nests. Much of the time I wasn't shooting, just doing my homework, but I thoroughly enjoyed each and every minute. The time when you reap all the rewards for what you've put into the project is when you're "nestside," behind the camera.

So just what exactly is it you want to photograph? Well, there are certain things that you should try to capture on film. One is the nest and nest site. Many make the mistake of forgetting this small, but important document. You need only a few frames, but having a

Pre-focusing is critical to capturing the action. This female Allen's hummingbird had no sooner landed on the edge of the nest when she started to feed her chicks. By pre-focusing on the edge of the nest I was able to capture this amazing sword-swallowing act! Photo captured with Nikon F3HP, 200mm f/4 IF Micro, with two SB-12 flash units as key light, on Kodachrome 64.

Field Tip

The fast-paced action of this period at the nest requires that you be aware of two important things at all times: frame count and battery condition. Never have your camera loaded with a roll of film that has only a couple of frames left if you're waiting for the adults to return to the nest. Burn up those few frames and reload. And check that Quantum Turbo Battery, too. You get approximately 200 frames per charge; that's fewer than 10 rolls of film. That's why I carry two Turbos with me at all times.

record of the nest and nest site helps tell the story. If you're photographing a hummingbird, you'll find that the nest constantly changes as the nestlings get older. Its unique construction of spider webs allows the nest cup to expand with the growing youngsters. So when the parents are out, grab a shot or two of the nest.

And of course you want to photograph the newborns. You should know when the hatch date is based on your research, so be prepared. When the young first hatch, their activity level at the nest is at its lowest. The adults spend much of their time keeping the babies warm.

Every half-hour or so the parents switch nesting duties. During the nest exchange, the incoming adult will typically have something for the nestlings to eat. This is an opportunity for you to capture a great shot of an adult coming in, hopefully with wings spread, and landing with food in its beak. Shots of the chicks being fed when they are really young are neat because they show size relationships. By this time the adults should be well accustomed to your presence and your shooting. While the adults are coming and going to feed their young, observe where they like to land, and prefocus there every time they leave the nest. This way, you'll be ready to capture the photo when they come back. Depth of field has a big role to play in this. Make sure you have enough depth of field to capture what you want in focus (for instance, the birds and the nest), but not enough to render the background sharply. The background is typically a tangled mess, something you want for general atmosphere, not as additional detailed information.

As the nestlings get older, they become more active and are interesting subjects for photographs. Hummingbirds are a good example of this. Now keep in mind that hummingbird young leave the nest in a little over two weeks, and at this point, they are basically adults. At about five days old, the young hummingbirds first open their eyes. At about fourteen days, they have

most of their feathers and they get the itch to fly. Then they practice and practice until the time that they are finally able to leave the nest. It's really quite funny to watch. The oldest kid sits on the edge of the nest, looking around. All of a sudden it tries to beat its wings. Now, these first attempts are nothing like the way an adult beats its wings, oh no. They are quite uncoordinated, flapping each wing on different beats and slower than at adult speed. A sibling, who is sitting lower in the nest looking on, typically gets whomped in the head a few times in the process. And the elegant hum we all know as the sound of a hummer's wing beat is replaced by what can best be described as an out-of-tune outboard motor. You can't capture the sound on film, but you sure can capture the rest.

Half the fun of photographing any bird is to capture its first wing beats. Remember ghosting? Though troublesome at times, in this instance ghosting can be a friend. By using the ambient light exposure to permit the wings to ghost or blur, you can capture the movement of those first wing beats.

As the nestlings get older, the trips made by the adults to and from the nest become more frequent. You'll know the adults are arriving by watching the nestlings' reactions—they tend to become more excited as the parents get closer to the nest. These are, to me, the greatest moments of all, as the nestlings look less and less like ugly, little, dried-up bugs. When the nestlings look like smaller versions of the adults, the photo ops are simply unbelievable!

The Tree-Cavity Nester

Finding a cavity nester isn't really that much different from finding a cup nester. The biggest difference is that your subject is nesting in a solid object, typically six feet or more above the ground. You use the same techniques for finding and safeguarding the nest, but the techniques used for photographing the nest are quite different.

Many, many species of birds use nesting cavities—woodpeckers, nuthatches, swallows, bluebirds, kestrels, owls, and more. Each species requires a slightly different-sized hole entrance. Generally the smaller the bird, the smaller the entrance, and the larger the bird, the larger the entrance. Many birds adapt and make use of old woodpecker cavities. So it is a good bet that if you find a cavity during the year, it will be occupied in the spring.

But how do you know if someone is in the nest? Of course one of the best ways is to be back from the nest a ways, and watch for activity. Species such as woodpeckers and kestrels are very noisy whenever they come and go from their nests. Inside the cavity, their young are likewise very noisy. You can often find the nest cavity for the first time by just listening for their noise. Other species, such as nuthatches and owls (which are nocturnal), are not so easy to detect by sound alone. A visit to the cavity and a look inside might be required.

Checking the Nest

How do you look down inside a nest cavity? Well, you don't need expensive fiber optics or a video camera, just a mechanic's mirror—a tiny mirror that automotive mechanics use to look around small spaces under the hood. These mirrors come in many sizes, ranging from one-inch circular to three-inch square. (I myself use the one-inch circular variety.) The mirror is attached to a rod with a double ballhead. This should be adjusted so the mirror is at a 45° angle to the rod.

With the mirror and a small flashlight in hand, visit the nest cavity, but only after you're sure that there are no adults around. With the flashlight on, walk up to the cavity, and slowly insert the mirror into the opening. Be sure to keep the mirror at the top of the cavity. *Do not push the mirror down into the cavity.* Shine the flashlight's beam onto the mirror's surface and slowly turn the mirror so you can see the bottom of the cavity. The light will bounce off the mirror and illuminate the bottom of the cavity while the mirror permits you to see what's down there. Quickly determine if there is nesting material (fine grass, wood shavings, sticks, or feathers), eggs, young, or the remains of a successful nesting. Once you have determined the cavity's status, leave.

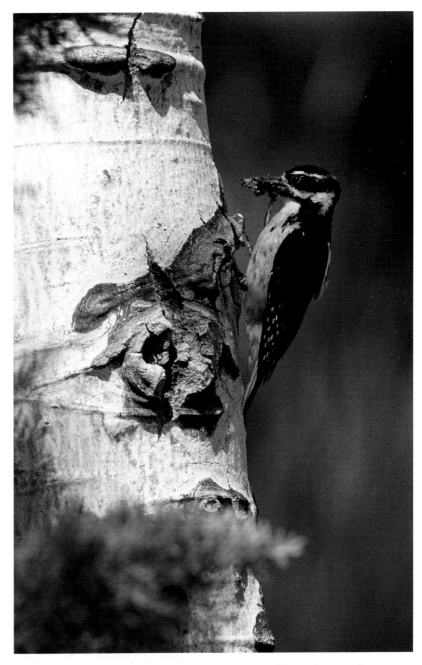

If you see a cavity nester with food, there's a good chance it's tending an active nest. Watch where it lands and particularly what hole it enters. There are often a number of cavities in one tree. Photo of hairy woodpecker captured with Nikon F4e, 800mm f/5.6 at f/5.6, on Agfa RSX 100.

Nesting Birds

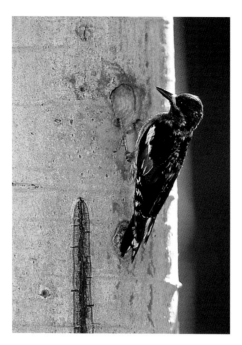 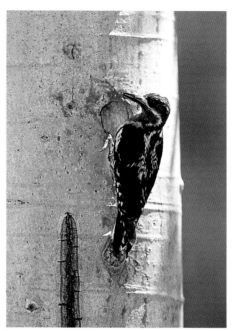

So What Did You Find?

After making your observations, it's time to take the clues and figure out what's going on. If you found eggs or young, it's pretty obvious that you've found an active nest. The only question left is to determine what species of bird is using the site. And if you found nesting material, you also need to determine who's using the cavity. This can be done in a few ways.

The easiest and most obvious method is to watch the nest. If it's a diurnal resident, then you'll be able to see the birds at some point during the day. Now remember that if they are building the nest or are in the process of laying eggs, you won't see lots of activity. But if there are young in the nest, you'll be able to determine in a short time who's making the cavity their home.

However, if it's a nocturnal resident, determining the species might take some nighttime field work. If this is the case, it's best to have a good ear, because you can't light the area with floods to see who is using the nest. You'll need to hear their "hoot" and then go back and listen to tapes to determine the species of owl that's using the cavity.

Another way of determining who is using the nesting site is by examining the nesting material you saw in the cavity. For example, swallows tend to have lots of feathers in their nests, so a cavity found with lots of feathers is probably a swallow's home. Bluebirds use very fine grass material for their nests, whereas titmice use coarser material.

Many natural history museums have displays of birds, eggs, and nests that you can look at to determine the species. But if that's not an option, your local library has many books that will be of help.

It's important to know the species for a couple of reasons. The main one is, of course, knowing what the young will be doing and when. For example, with most cavity nesters, you don't see the young until they are almost ready to leave the nest. The adults dive down into the cavity to feed their babies until the very end, when the babies stick their heads out to be fed. You really don't want to spend weeks sitting by the nesting cavity waiting for this to happen.

But the second reason is so you can select the appropriate lens and flash setup. Your technical and aesthetic approach is very important to

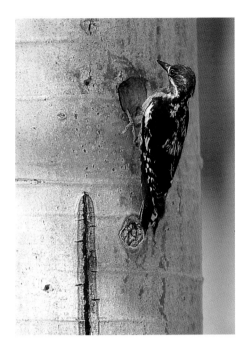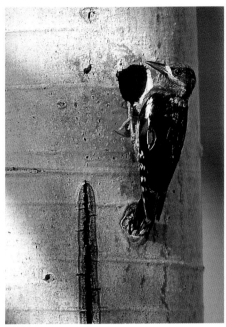

Lighting is critical when photographing cavity nesters. These four images, all taken on the same day, are of the same red-breasted sapsucker nest. They were taken at different times of the day as the lighting changed. The first image was taken in the early morning, with ambient light and fill flash. The second was taken in mid-morning light with fill flash. The third was taken in mid-afternoon light with fill flash, and the last was taken in the light of late afternoon with no flash. They all convey the shape of the tree and the sapsucker is properly exposed. So which one is correct? They all are! You just have to decide which style you prefer and which one expresses what you want to say. Photos captured with Nikon F4e, 800mm f/5.6 at f/5.6, with minus 2/3-stop fill flash (where indicated), on Fuji Provia 100.

communicating that you're photographing a cavity nester. Conveying the size of the occupant relative to the nesting cavity is very important. Selecting the right lens and arranging the flash setup appropriately are crucial to photographing these birds well. It is vastly different from photographing a cup nester.

Photographing the Cavity

With photographing a cavity nest come additional challenges, mainly from the location and shape of the cavity (high and round). Since most cavities are in trees, the photograph must represent both the tree and the activity at the nest. This requires quality illumination and a vertically oriented camera, which can be a challenge.

If you have a flash mounted onto the camera's hot shoe, then going vertical typically presents a problem. As soon as you turn the camera vertically with the flash in the hot shoe, the flash will be at the side of the lens rather than above it. (It is usually desirable to have the flash above the lens so that the shadow that's created falls behind the subject rather than to its side.) There are a number of options that allow you to keep the flash above the lens.

The best solution I know of is the flash arm made by Really Right Stuff. This accessory can be used with any lens that has a tripod collar. The flash arm attaches to the collar and tripod head with an Arca Swiss-compatible quick-release plate. When the lens and camera are turned via the tripod collar, the flash arm does not move; both adjust independently. This accessory keeps the flash above the lens at all times, whether the camera is oriented horizontally or vertically.

Another solution is to take the flash off the camera and use a Bogen Magic Arm or a tripod to keep the flash above the lens. Remember, in nesting photography the adage "less is more" holds true, so you'll need to select the solution that's best for you.

Why do we need to have the camera vertical in the first place? Because we're photographing a subject that lives in a vertical world! In order for the subject to fill the frame and be compositionally pleasing, the camera needs to be vertically oriented.

The cavity into which the bird is flying is round, and the tree trunk itself is curved, so you need to define those shapes and surfaces in your

photograph. That requires a little fore-thought when it comes to lighting. Why, you ask? Well, to illustrate the curva-ture of the tree trunk, you must light it in such a way that one or both sides of the tree are darker than the center, where the cavity entrance is located. If you don't do this, and instead light the tree evenly, the trunk will look like a flat board. Don't forget, the character of the tree is what sets the stage for the activity you're recording at the nest cavity.

Lighting. Well we have one flash above the lens, so what's next? We need to place a second flash unit so that it illuminates the subject and softens the shadow that's created by the main flash (the flash unit above the lens). However it should not over-illuminate and flatten the shape of the tree, which would make it look two-dimensional. We must also avoid adding secondary catchlights, because we don't want to depend on digital imaging software to fix the mis-takes that we can take care of in the field. What follows are just suggestions. Remember, the subject, the cavity, and the tree will dictate the correct solution to each situation.

Always keep one thing in mind when you're photographing with flash—flash-to-subject distance. If you shoot a cavity nester using only one flash located above the lens, the light would fall off from the cavity entrance to the edges of the tree. You would probably end up with a half-stop less light on the tree's edges than at the cavity entrance. This is enough to darken the edges of the tree and convey the trunk's curvature.

But you need to light the subject—the bird! Here's where you need a sec-ond flash. This can be done easily, believe it or not. I typically mount a sec-ond flash to a Bogen Magic Arm and place it off to one side (which side depends on the site). I turn the flash vertically and pull the zoom head out to 85mm. I stick the flash arm out as far as I can and then turn the flash unit so that just the feathered light skims over the bird coming into the nest. This arrangement keeps the light of the

second flash unit from striking the tree and creating a second catchlight. It's simple and effective.

Now if you're lucky, you won't need to illuminate the nest cavity artificially. There is no substitute for beautiful ambient light. If you do require a little fill flash on the cavity, use a simple flash arrangement, such as placing the flash over the lens. Here again, Really Right Stuff's flash arm works the best.

The only other technical thing you need to watch is the depth of field. Typ-ically, you're aiming upward to shoot the nesting cavity. This means that the back of your camera is not parallel to the tree or the bird gripping the tree trunk, so depth of field is the only means you have of getting everything sharp. If flash is your main light source, this can be difficult, as your flash power might be limited. No secrets or tips here, you will have to make the best decision given the equipment you have and the situation at hand. Just remem-ber that above all else, the bird's eye must be in focus!

Framing the Subject

As mentioned earlier, cavity nesters are best photographed in a vertical format. But turning your camera vertically is not all that's required to properly frame your subject. I cannot stress enough how important the background is to a cavity-nesting photograph. I try to set up my lens so that there is some back-ground other than the tree's bark behind the bird when it arrives at or enters the nest hole. This gives the viewer a sense of the bird's location and emphasizes the idea that the bird is hanging on. If only the tree is in the background, the pre-carious feeling that the bird is hanging on the edge of the hole is lost.

If you're using flash as the main light source to illuminate the subject, you have to be careful that you meter and expose for the ambient light that is illuminating the background. Including the background in the frame for visual effect works only if you expose for it. If you're not sure how this is done, refer to *NWP*, page 49.

More Cavity Flash Tips

There are two tools that might make things just a little easier when shooting a nest cavity with flash. The first is a projected flash unit, the Better Beamer. This is a simple tool that increases the flash unit's effective distance by two stops. Using it allows me to set a smaller aperture and thus increase depth of field to get the image I desire. (See page 26 for more information.)

The other tool I'm head over heels about is Ikelite's Lite-Link (discussed more on page 71). In the past, secondary TTL flash units had to be hard-wired to the camera's computer for TTL exposure. This can be difficult at best at a nest site where disturbances must be kept to a minimum. Running wires from the camera to a remote flash unit really doesn't go with this idea. The Lite-Link allows you to place a second TTL flash anywhere that it's required without any wires! This is a must for shooting cavity nests and most cup nests.

The Nesting Box

The nesting box is an important requirement in many regions today because of the loss of so many traditional cavity nesting trees. Though I have pines all around my home, they are all living and provide very little habitat for cavity nesters. For this reason, I have many nesting boxes up for rent. Typically, cavity nesters make their homes in dead sections of standing trees (there are exceptions). The nesting box makes up for this deficiency and provides great photographic opportunities. All the principles are the same as for photographing traditional tree holes, except with a nesting box you know exactly where to look for the subject.

In setting up your nesting box, keep in mind its photographic potential. Pick a location where you will be able to take advantage of the afternoon sun. Look at the background and make sure it's one you like. And don't worry about the

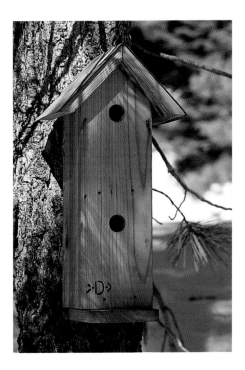

box's height, although a good rule of thumb is to place it around six feet above the ground to keep it out of a predator's reach. If a bird takes up residency, it must mean that its requirements are met and everything is OK!

The Ground Nester

Many species of birds nest on the ground. Terns, shorebirds, gulls, and grouse are just a few examples. I recommend not working with ground nesters until you've photographed many other nests and have a feel for birds and the way they communicate. Without this understanding, there is a real chance that you will chase the birds away altogether. And since the nests of

This double-decker nesting box gives two avian families the opportunity to take up residence in our yard. Not only is it prime real estate for the birds, but it's got everything a photographer could want, too: nice aesthetics, good light (both filtered and bright afternoon sun), and a good background.

A nest no more than a mere depression in the sand is home for these newly hatched black skimmer chicks. The chick on the left is 15 minutes old, the other chick is just hatching. The chicks' feathers are colored so that they blend in with the sand. The eggs are also camouflaged, so they blend in when not attended by the parents. The eggs have a pear shape so that if they roll, they roll in a circle and not out of the nest. Photo captured with Nikon N8008, 60mm f/2.8 AF Micro at f/11 with fill flash, on Fuji 100.

NESTING BIRDS

"Oh mom, he made me do it!" The natural actions of young in the nest can lead to many interpretations. To capture moments like these you need to be on your toes. Photo of California least tern captured with Nikon F4e, 800mm f/5.6 at f/11, with plus 1-stop exposure compensation dialed in, on Fuji 100.

Shorebirds typically perform a "broken-wing" act when you approach their nest too closely. When there are perches nearby, they will fly atop them and scream like this lesser yellowlegs is doing. No matter which ploy they use, their objective is to get your attention and draw you away from the nest. Photo captured with Nikon F4e, 800mm f/5.6 at f/5.6, on Agfa RSX 100.

Finding these nests is by far the most difficult, because these species have adapted and developed incredible techniques for hiding via camouflage. Their nests are often mere scrapes in the ground with just a stone or shell used for decoration. The eggs are meticulously covered with colors and patterns, so when viewed from even one foot away, they disappear into the habitat. You can easily step right on the nest and crush the eggs if you are not careful.

So finding the nest takes a lot of patience and field work. The only way I know of to find it is by watching the adults. The adults can see you all the time, so you just can't hide. Be sure to watch at some distance, because if the adults feel threatened, they perform a "broken-wing" act to lure you (a predator, in their eyes) away from the nest. You'll have to find them when they are actually sitting on the nest and then make a mental note as to where that spot is so you can find it again later.

Once you know how ground nesters communicate, they are technically the easiest birds to photograph. You'll just need a long lens and some film to record all of their fascinating behavior.

ground nesters are exposed to the sun whenever the adults are not there, the eggs could literally bake to death.

The Rewards of Experience

The more nests you photograph, the more you'll be able to develop your own routines and rules for success. I've barely touched on the nesting-bird experience. After 10 years of shooting I still learn something new at every nest. Every bird is a teacher *extraordinaire,* teaching lessons you cannot learn anywhere else in the world. Every time you find a new nest to photograph, new variables pop up. Whether you're photographing a nest over a stream, up in a tree, or in the middle of a pond, each situation presents a different challenge. But that is the great allure of nesting bird photography—there's always something to be learned.

So please, take what's here and build on it! Look forward to each spring, and anticipate each new project. But always remember, no photograph is worth sacrificing the subject's welfare for. You can do anything if you do your homework and learn a little basic biology.

Some birds make it difficult for anyone to photograph their nests. These nesting ospreys are 100 yards offshore in Mono Lake. Their photogenic tufa nesting platform is surrounded by a watery moat, creating a challenge for us to make a stealthy approach. Photo captured with Nikon F4e, 800mm f/5.6 with a TC-14b 1.4x at f/8, on Fuji Provia 100.

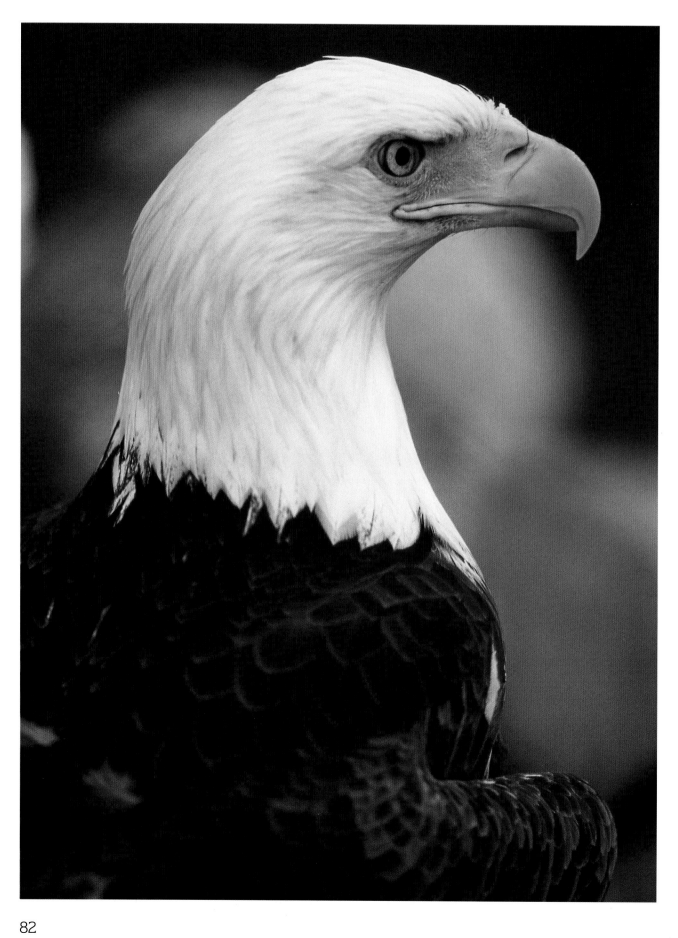

Rehab and Tank Techniques

There is a side to wildlife photography that I, for one, would really rather not have to think about: economics. And something that is painfully true in the business of photography is that time is money. Wildlife photography is a very time-intensive activity. True, you can go to many locations and shoot anything as soon as you leave your car. But when you are going after photographs of one particular species, you need time in the field to get off just one shot. And if you need to capture an in-depth study of something and/or a particular biological event on film, vast amounts of time are often required.

Then there is the expense of wildlife photography. I'm talking about spending money to do some of the simplest things, such as testing new equipment or techniques, for instance. Finding a subject can be difficult enough without having to put such constraints on it as having to hold still for 108 exposures while you test three new brands of film. Or what about trying out the minimum focusing distance of a new lens with an extension tube attached? Finding a subject that lets you easily get close to it for this purpose is just not easy. How about testing a new flash lighting pattern, filter, or tripod head? If you've rented this gear to test it before buying (a very smart thing to do), then time can be costly if you can't find a suitable or cooperative subject. These were the original reasons why I started to work with rehab critters. Some people might see this chapter as a means of justifying photographing captives, such as those at animal parks or game compounds. However that is not my intent. (I must say, though, that I have nothing ethically against such photography.)

When I first started down the path

of becoming a wildlife photographer, I was working 60 hours a week at a regular job and cramming photography in whenever possible. It was obvious to me from the start that I had to do something to cut down on the time I was spending looking for a subject if I was going to get the photos I was after in the scant time available. Using tanks was one of the solutions I came up with (as well as working with biologists, see Chapter V) to get photos of the subjects I wanted within the time and budget allowed. This is the principal reason why I first developed and still depend upon my tanks for photographing small critters.

What follows aren't concepts that I invented, but ones that I customized to work for me and my style of photography. I think you'll find that they will fit in with some of your photographic desires and ambitions, too. And they aren't as cut-and-dried as they might sound, but are a real challenge until mastered. As many of my photo safari participants might tell you, following around a moving kangaroo rat in a tank is not easy. And neither is taking a

My tanks have gone many places and held many endangered species. The tank in which this little kern golden trout was photographed had to be transported into the backcountry along with my photo gear. The trip wasn't that rough, though—a llama carried the heavy stuff. Photo captured with Nikon F4s, 60mm f/2.8 Micro AF at f/8, with fill flash, on Fuji 100. (C)

Getting close to this majestic bald eagle was a real treat. This individual is missing a wing though, having been shot by a thoughtless hunter. By photographing its "good" side, I was able to convey the bird's majesty rather than its handicap. Photo captured with Nikon F4e, 75-300mm f/4.5-5.6 AF at 300mm at f/8, on Agfa RSX 100. (C)

REHAB AND TANK TECHNIQUES

Field Tip

Photographing in game compounds is extremely fun and popular with many photographers today. Though not my "thing," these facilities provide the average hobbyist an opportunity to get photographs that would otherwise be difficult to capture. Besides the photographic opportunity, there is the great benefit of learning about and personally interacting with wildlife. When people share their images and experiences of shooting in a game compound with their non-photographer friends, only good can come from it. When such images go into print, they should be labeled as being of captive animals.

photograph of a captive rehabbed bird sitting on a perch right in front of you. There is a lot that goes into the process that makes it a photographic challenge as well as a reward. Let me open up the doors for you to what I find to be a magical photographic experience!

Rehab and Educational Subjects

Just what am I talking about here? Tragically, much of our native wildlife suffers collisions with civilization. It doesn't matter what state you live in or how populated it may be, wildlife still comes into contact with our mechanized world all too often. The majority of these collisions end in death for the animal—becoming what we know all too well as "road kill." Many of the animals limp away, seldom witnessed, only to die off the road. However some fortunate victims still clinging to life (if you can call it fortunate) are picked up by a good Samaritan and taken to a wildlife rehabber (short for rehabilitator).

Some rehab facilities are one-person shows, while others are extremely

extensive care facilities with a large volunteer network. In either case, these kind people take care of hurt or maimed wildlife. The folks who rehab and care for educational wildlife have obtained permits to do so from their state's department of fish and game. (There are many requirements that must be met to obtain one.) Wildlife that is able to benefit from this care and regain its health is released back into its habitat. This is the ultimate goal of the rehabber—returning wildlife to the wild.

Unfortunately, a high percentage of the injured animals cannot be released back into the wild. Birds of prey are good examples, as many of them never again feel the air fill their wings. Typically, in the early morning or late evening light, birds of prey see a speeding mouse trying to cross the road in the path of a vehicle's headlights. As they dive after it, they come face to face with the auto's grill. Those that survive the collision are often stunned, blinded, or have a broken wing. Those with a broken wing eventually lose it. Such birds cannot be returned to the wild and become what is known as "educational" animals. These are animals that go out into the public for the purposes of education. There are many such birds and mammals across the country.

Finding a Rehabber
The rehabber provides opportunities for people not only to take photographs, but also to get involved with one's neighborhood and have an impact on local wildlife by contributing to educational outreach programs. A phone call to your local veterinarian, Audubon Society chapter, or state department of fish and game is usually all it takes to find out if there are any wildlife rehab facilities in your region. Depending on where you live, you might have as many as five or there may be none at all in your vicinity. Finding a rehabber you can work with may or may not be a challenge in your area. But with a little effort, you will find one.

Your first phone call could be your

This is Aristotle, a great horned owl. He is a magnificent educational bird that I have taken to many elementary school classrooms. Like many owls, Aristotle suffered a collision with a car. You can see the effects of the accident by looking at his eyes. The shattered blood vessels have caused him to be nearly blind, making it impossible for him to be released back into the wild. Here, Aristotle was a perfect model for me to run a film test. Photo captured with Nikon F4e, 75-300mm f/4.5-5.6 AF at 200mm, on Fuji Provia 400. (C)

last if you don't approach it with a little sensitivity and forethought. Many rehabbers who have worked previously with photographers are at times reluctant to work with other photographers because of past experiences. I have run into this myself with a rehabber who once had a bad experience with a photographer and didn't want to take the time or trouble to give another person a chance. I had to have a rehabber friend call on my behalf before he would allow me into the facility. This is an unfortunate but all-too-common occurrence. So the first thing you need to do when you've found a rehabber and are about to make the first call is to be open-minded and thick-skinned.

When you make that call, be up-front about your intentions. If you plan on taking photos of just one subject and want the subject out in the open and not in a flight cage, say so. If you're after numerous subjects, tell them this as well. If it's a one-time thing and you're never coming back, tell them that (but that won't happen; everyone gets hooked after their first visit). Just be honest about everything, including your expertise and the intended use of the photos. I've never heard of a rehabber charging a photographer for his or her time, but at least be up-front with them so they can return the courtesy. (You might offer to contribute a few bucks

towards the feeding of their wildlife. Their food bill can be astronomical!)

You need to know generally what you're looking for as well. Many rehabbers specialize in certain kinds of wildlife. For example, some care for hawks, some for owls, and some for both. Others may be small passerine specialists. There are rehabbers that care just for small mammals, just for large ones, or both, and some rehabbers care for everything. If you're looking for a great horned owl (great subject), then you don't need to bother a mammal specialist. But it can be hard knowing what you're looking for the first time out. If that's the case, tell them you're open to seeing anything they have, and go with a "let's see what happens" attitude.

I don't recommend taking your camera on your first visit, unless something special is happening. If you call up and the rehabber says they just got in a bunch of oil-soaked birds that they are cleaning up, ask if you can bring your camera and photograph the cleaning process (it's a great opportunity). But if only daily cage cleaning is going on, it's best go with empty hands, sharp eyes, and an open mind.

There are a number of things you need to be watching for, looking at, and asking about on your first visit. Rehab facilities can be elaborate buildings with flight cages that put some zoos to

Wildlife Encounter

Rehabbers have amazing stories to tell. While driving across a pass in California, a trucker saw a bird streak in front of his headlights. Being sensitive to collisions with wildlife, he stopped to see if he had hit the bird. He checked his truck, but found nothing. He drove for another four hours until he stopped at a truck stop. When he got out of his truck, he heard a strange noise coming from the back of his trailer. Upon investigation, he found a western screech owl wedged into the hub of one of his wheels. That poor owl had been going around and around and around at 60 miles per hour for four hours. There was nothing medically wrong with it, but to this day it refuses to fly and is being cared for by a wildlife rehabber.

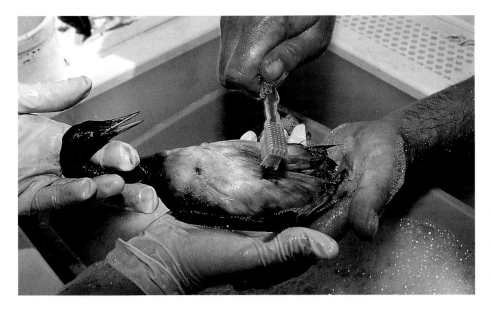

No matter what the subject, always try to find, create, or take advantage of a setting that helps you tell the story. In this case, the background is a bath basin where an oil-soaked eared grebe is being cleaned. Photo captured with Nikon F4e, 35-70mm f/2.8D AF at 35mm and f/8, with fill flash, on Fuji 100. (C)

shame. On the other hand, they can be as simple as a cage in a person's backyard. Watch for locations at the facility where photography can take place. These are generally open places where the background can be controlled and does not pose a problem. And look at the wildlife itself. Ask yourself, how is its condition? If the wildlife seems well cared for and in a clean environment, then the facility is probably a place where you want to become involved and lend your talents. If cages are dirty and the wildlife is not looked after and in sad shape, then you might not want to be associated with the facility (sad, but such places do exist). Another thing you should check out is if the rehabber has educational wildlife. Because these animals are handled frequently by the rehabber and are accustomed to being "on the glove," they are typically the best and most photogenic subjects. Knowing if the facility has such critters and what species they are is of great benefit to you.

And finally, on your first visit, try to get to know the rehabber as much as the wildlife in their care. Ask the rehabber how long they've been doing rehab work, what their specialty is, are they amenable to your shooting on the premises, and if your photography can be of help in their educational programs. If you come away with a positive feeling and answers to your questions, then you're on your way.

WARNING! I'm only going to warn you once. This can be big-time habit-forming! Many a photographer has been lost in the depths of a rehab facility. They are sighted only when making trips to the lab and camera store.

Injured wildlife have an appeal above and beyond their wild counterparts. When they look up at you with their big eyes that cry out "help me," not many people are strong enough to say no. There is no more rewarding experience in life than taking a red-tailed hawk or barn owl that you've nursed back from near death and setting it free. I'm here to tell you, when you see the wind catch its feathers as it wings away from you,

it's hard to keep a dry eye. And when it comes back, circling overhead as if to say, "Thanks" (funny, they always seem to do this, though I doubt it's to say good-bye), your heart beats an extra beat. So don't say I didn't warn you!

The Setting
Aesthetically, very few rehab facilities are set up for photography. You can easily take a photo of a bird's head or wing, but full portraits can be difficult. To take a successful portrait you must create in captivity the conditions in which the subject would be found in the wild. This is actually what I find to be so fun and challenging, more so than the lighting and other technical stuff I'm going to cover later in this chapter.

What we're after is what many people term "nature fakes." Nature fakes are created settings that are biologically correct for the subject. For example, we wouldn't photograph a penguin on a saguaro cactus or a Harris hawk on a snow bank. This would be biologically incorrect as the penguin lives in snow and the Harris hawk in the desert. The first thing then that needs to be accomplished is to determine who the subject is and what setting is correct for it. Typically, rehabbers have only wildlife that is indigenous to the area in which they live. It is rare that rehabbers with facilities in the oaks, 60 miles from the ocean, for example, would be taking care of seals (though I do know of such a facility). So part of the problem is taken care of naturally, right from the start.

Understanding and manipulating a situation to your benefit can be very useful, though. For example, say your subject and rehabber are in an urban environment. The species to be photographed is a great horned owl. Great horned owls can be found in basically any habitat in North America. You could technically set up the same great horned to look as if it were living in the desert, mountain pines, or foothill oaks and never leave the rehab facility. The primary variable here that places your subject in a particular habitat is the branch upon which the bird is perched.

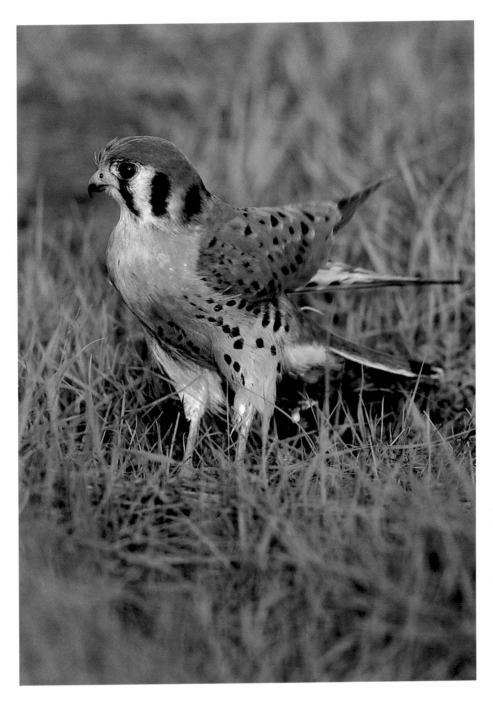

Sometimes all you need is a little grass. Rehab facilities are often not the most picturesque settings. The facility that rehabbed this little male American kestrel has a great grass field behind it where staff are able to flight train and release some recovered patients. This kestrel had just been released when it came back down to catch a grasshopper. Because of this bird's association with people during its recovery, it let me photograph it with ease. The release of rehabbed critters is a great photo op. Photo captured with Nikon F4e, 800mm f/5.6 at f/5.6, on Fuji Provia 100. (C)

The Perch

You might begin to think I have a real perch fetish after reading this book, but I can't emphasize enough the importance of a great perch. If you don't believe me, just start looking at some bird photographs you find in print (or the ones in this book). You'll quickly see that the photographs of birds sitting on perches with character are the ones that are really memorable.

Many factors must be taken into consideration when selecting a perch and its location. The size, character, and placement of your perch are directly affected by the focal length of the lens you're using. These factors also affect the comfort and ease of the birds. And most importantly, you must consider the effect and influence that the background has on the scene. A good perch is required even when

REHAB AND TANK TECHNIQUES

Perches come in many different shapes and forms. This long-eared myotis was at a rehabbers for just a day while it regained some body weight. By doing some quick homework, I discovered that they like to sleep in the bark of trees. So I went on a crazy hunt to find bark I could use as a perch for this neat little mammal. Photo captured with Nikon F4e, 60mm f/2.8 Micro AF at f/11, with flash main light and an Omni Bounce, on Fuji Provia 100. (C)

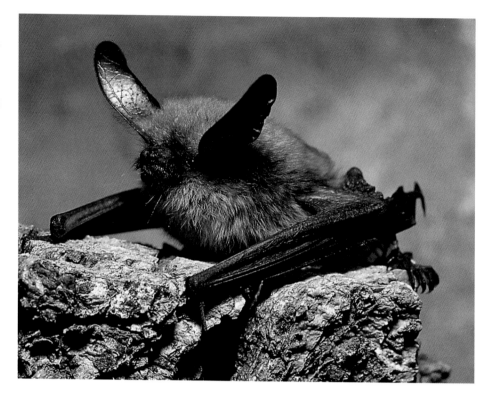

Field Tip

Another reason for having a lot of different perches is variety. You don't want all of your photos of a great horned owl to be of it on the same perch. Having lots of perches is not a problem if you live in or near a forest. But if you live some distance away, you had best keep your eyes open for perches on all of your outings.

photographing rehabbed subjects in someone's backyard.

Where do you find perches? You go out and look for them. Whenever I'm out shooting, I constantly look for perches that have unique character. Character can come in the form of a certain twist in the branch or bark, a knot that is worn from wind and time, mosses and lichens growing in strategic locations, patterns, color, or tone, or a combination of these elements. You want to find branches that you like and that are photogenic subjects themselves. Depending on the size of your subject as well as its size as it appears in the viewfinder, the branch might play an important role in the overall success of your photo. You don't want to take short cuts when selecting a perch.

I collect branches from many different sources: in pine, oak, or riparian forests, and I even collect driftwood off beaches. No place is left unsearched. And I have these treasures stored all over my house, waiting for the day I'll have the opportunity to use them.

I don't cut down green or dead branches. I find ones that have fallen off trees naturally and have Mother Nature's broken-end look. If you must trim a branch to size so you can carry it or load it into your car, then cut it, leaving it long enough to be able to break off the end later on. Depending on the diameter of the branch, you can break off the end with pliers or chip the straight cut into jagged beauty with a hammer. You then need to age the newly broken end. This is a great way to use old coffee grounds. Just soak the end of the branch in a solution of grounds and water until it achieves the desired look.

This tip on creating natural-looking perches originally came from a friend who makes dioramas for museums of natural history. There are many, many more tricks to be learned from these folks. If you run up against a problem in constructing your "nature fake," I highly recommend that you contact your local museum for assistance. Museum personnel are a great untapped resource!

While searching for perches, collect ones of different diameters. Rehabbers have different subjects you might want to photograph, both birds and mammals. A huge branch big enough

to hold an eagle would be overkill for a sparrow. Photographing small mammals, such as mice, requires a curvy branch they can run up on and be easily seen by the camera. A straight one would be best if you are shooting a larger mammal, such as a skunk. (Most skunks that come into rehab are small orphans that don't have scent yet and are awfully cute.)

Why do you need such a variety of branches, especially for birds? A bird's foot closes automatically when its leg is bent while sitting on a perch. This natural reflex varies depending on the species of bird and on its size (birds of prey have a more refined mechanism than gulls, for example). Smaller birds like smaller-diameter branches, bigger birds like bigger branches. Small birds are uncomfortable perching on large branches and large birds on small branches because they can't grip them. In either case, while you are trying to photograph a bird on a perch that it can't grasp, it will constantly be doing a balancing act. This means that it will constantly be moving, hence it will not be very good for photography. The right perch for the right subject makes it feel secure and makes the photo shoot easier for you.

By now you're probably seeing that shooting with rehabbers is not as easy as just showing up. Success does take some time and forethought, but once done, it is fantastic fun!

Some of you are now probably asking yourselves, "What do you attach the perch to, and how?" Well, there are actually a number of methods, but we need one that is portable and flexible to work well in the rehabber's facilities. I do know of some folks who have erected permanent perches at the rehab facility. They work with the rehabber and set up a perch that serves both the educational needs of the rehabber and the aesthetic needs of the photographer. This is rare though, so you might want to come up with a portable perch system for shooting.

One method is just to shove the perch into the ground. The first and

most obvious requirement for this method is to have a perch long and sturdy enough that it can be stuck securely into the ground (remember, the bird requires a secure branch). You don't want the branch to fall over during the shoot; that would be disastrous!

But if the rehabber has cement floors to facilitate cleaning, you won't be able to plant your perch in the ground! In that case, the simple system I use might be right for you, or it may lead you to some ideas that might work

Here's what the scene on page 84 really looked like. As you can see, this is not a wild bird, but you can't tell that from the close-up. These photos were taken in my backyard on one of the oak perches I collected just for this purpose. The oak perch is attached to a tripod via a Really Right Stuff Plate, which is attached to the clamp on the tripod head. (C)

better for you. My perches are generally no more than three feet in length (so they're easy to carry around). I cut one end of the perch off flat, typically the largest in diameter. The cut is made at an angle that best supports the perch as well as works photographically. I attach a Really Right Stuff Plate to this cut end with a wood screw; the plate's size is selected to match the diameter of the branch. With the plate attached, I can mount the perch to my tripod head's quick release. This gives me incredible flexibility. I can adjust the height of the perch in relation to the size of the bird. I can angle the perch any way I want by adjusting the tilt on the tripod head. I can even turn the perch so I can see the bird's front if it gives me its back. Ballheads with panning operation, such as the Stroboframe Pro-3, work great for this (besides holding your camera). More important, this system provides a flexible, portable, and secure perch for your subject. If your tripod can hold a big lens, it can certainly hold this.

But why go to all this trouble just to hold the perch? Remember my saying I have an oak branch, a pine branch, etc.? If you are working with the same subject but want to change the style of perch, using the Really Right Stuff Plate makes changes fast and secure. I've gone the duct-tape route, tried the C-clamp method, and even tried a few other methods I'd rather not mention, but this system works every time.

I'm sure there are a few bright readers who just about now are asking themselves, "What happens if the bird defecates while on the perch?" Well if that happens, your tripod has an official seal of approval! It could be messy, it might even be smelly, but in any case, it does wash off. Actually, this behavior can signal other behaviors, if you know how to read it. Birds generally defecate just before they take flight and when settling down on a perch. Reading this body language can be important to anticipating the bird's next move and getting the photo you desire.

The Portrait Lens

As with any portraiture, you need to make the subject feel secure in its own space. This is where the lens' focal length comes into play. I simply use my 300mm f/2.8 or 600mm f/4. There is a method to my madness. I use my 300mm f/2.8 when I need to produce a very narrow depth of field, and I use my 600mm f/4 when I need a very narrow angle of view. Either lens can work or not work with a particular subject, depending upon the surroundings.

I typically place at least five feet, if not more, between my lens and the perch. The minimum focusing distances of my 300mm and 600mm are far greater than this buffer zone, so I often use extension tubes to decrease the minimum focusing distance of these lenses. This also serves to narrow the depth of field, which is even better.

With larger subjects, such as owls, hawks, and eagles, I use the 300mm lens. I have a couple of reasons for this. The first is personal taste. These large birds have a noble dignity about them and are held in high regard. I like the 300mm because it communicates this regal elevated stature and commands respect more effectively than the 600mm. The 300mm does not compress the subject and background as the 600mm would, giving the subject more dimension. Also, the 300mm allows me to be physically closer to the subject than the 600mm, making lighting with flash a little easier. It also gives me more flexibility in setting the necessary depth of field because a slight change in the aperture has a more dramatic effect on depth of field than the same change made with the 600mm.

I use the 600mm lens for smaller subjects. The little guys tend to become more shy and uneasy the closer you get to them. The 600mm with, say, 27.5mm of extension (Nikon PK-13) covers nearly every small subject I've come up against. The 600mm also lets me control the background better, which tends to be more important with small subjects; they don't dominate a photograph like a hawk. Controlling the

Field Tip

When working around water, use a polarizer to eliminate reflections. Be especially aware of reflections of cage wires. They can cause a very unnatural pattern to appear in the water's highlights. If you are using a lens that takes drop-in filters, you'd best call up Kirk Enterprises and get their polarizer; you'll need it.

background is really the biggest obstacle in this whole "nature fake" business. The lens you use is a big part of this.

The Background

I know of only a handful of rehab facilities in California where you can step right outside of a flight cage and start shooting. Most are chock-full of obstacles when it comes to photographing the subject with a clean background: a flight cage here, a white rod there, a hose rolled up here, and the wooden sides of buildings everywhere. If there are artificial elements in the background of your photos, people will notice and think something is wrong. That's why you must check for these and other obstacles to your photography on your first visit to the facility and find solutions to obscuring their presence in your photos.

For instance, you can control the background by adjusting your lens' angle of view. This is the foremost weapon you have in dealing with horrible backgrounds. If there is natural foliage in the background it can be used as a backdrop, or you can bring some in. It doesn't have to be biologically compatible with your perch because it will be out of focus. It just needs to be green, which will seem natural and correct for all habitats, except deserts.

The next best solution is a dark background. If you use a lens with a narrow angle of view, such as a 600mm, it doesn't take much of a shadowy background to make this work. The shadow's location in relation to the sun and the subject might have some influence on your decision. If at all possible, you want your subject to be lit from the front (with the sun at your back). If the shadow doesn't work with this lighting pattern, you can make it work by introducing flash (we'll get to that in a second).

Another option is to create a shadow where you want it. By hanging a blanket or using a reflector or any other item to block the sun, you can create a dark background wherever you want it to fall. This is a great option when you

have a less than cooperative subject. It also works great when space is limited or cramped at the facility where you're working. In any case, you need a background that makes your subject pop while appearing to be biologically correct (refer to *NWP*, Chapter II).

When you are setting up your camera and perch and are planning the background, make sure you leave enough room for the subject to move

A tempting perch, in this case a rock, was set next to the small wading pool at a rehab facility where sea birds swim prior to their release. I carefully positioned the rock in front of an unobtrusive background. Then I just waited until this gull hopped up on it and got the photo. (Gulls can't resist a rock.) Photo captured with Nikon F4e, 75-300mm f/4.5-5.6 AF at 300mm at f/8, on Fuji 100. (C)

REHAB AND TANK TECHNIQUES

Because his wing did not mend well enough for him to fly, Buster the red bat became an educational animal. Even so, getting him to hang where I could easily photograph him was no simple matter. I brought in a perch, but lighting the scene was nearly impossible. I was lying on the ground shooting upward, while the flash was above the bat, pointing down. Photo captured with Nikon F4e, 60mm f/2.8 Micro AF at f/11, with flash as main light, on Fuji Provia 100. (C)

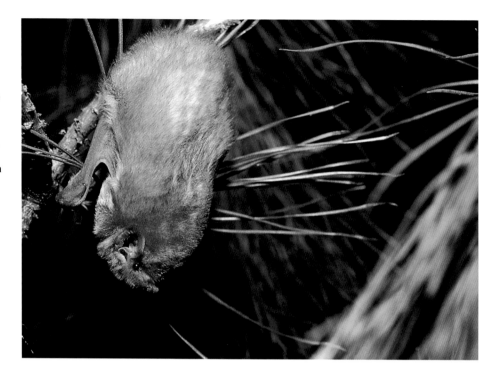

Field Tip

Remember, the comfort of your subject greatly determines the photographic success you enjoy. Most birds and mammals are not keen to sit out in the hot sun any more than you are. If they are in a shaded area, they will feel more comfortable. This in turn provides you with a happier subject, better shooting conditions, and a longer shooting session.

and still have the appropriate background behind it. There is no guarantee the subject will stay where you first place it. It might walk, in its own fashion, up or down the perch. You need enough background to allow for this movement and still be able to get the photograph.

Lighting

Finally, you need to light the whole thing, subject and background. Lighting can be as complicated or as easy as you wish to make it. Remember that you're working in a controlled situation. You know where the subject is going to be, what time of day you'll be shooting, and the lighting that's available, so make the best of it to create an image that fully communicates what you want to say about the subject. We're photographers. That means that we are masters of light. Some of us might be mastering it a little bit better than others, but in any case, I'll start with the basics so we're all talking about the same thing.

First you must determine which light is to be the main lighting source, ambient or flash. The factors that determine this are the quality and quantity of the ambient light itself.

The majority of the time I don't want harsh light of any kind falling directly on my subject. However, if I can get access to the subject in the sweet light of early morning or late afternoon, I'll take advantage of it because the quality of light is so flattering at those times of day. But typically I have access to the rehab animals only after this golden light has passed, so I try to find a location where I have strong, directional (but not direct), ambient light. I diffuse this light and redirect it to softly illuminate my subject. Many rehab facilities have flight cages that have one side made of plywood. I use the plywood wall as a large reflector and try to work with the reflected light. This way I can take advantage of the ambient light while the subject is posing comfortably under shade. If there are no natural reflectors about, I bring some large 32-inch reflectors to accomplish the same thing.

When shooting models at a rehab facility, my basic flash setup is this: I have the flash (not always used as the main light source) connected directly to the camera's hot shoe and positioned directly over the lens. This is held in place by the Really Right Stuff Flash

Arm (permitting vertical or horizontal framing without changing the position of the flash). If the subject is an owl or another nocturnal subject, I use the Really Right Stuff B89 Extender Post to move the flash up 8-1/2 inches to eliminate red-eye. I will typically attach a Promax SoftBox to the flash when I'm using my 300mm lens. When using the 600mm lens, I use the Better Beamer.

If the ambient light is strong enough to be the main light source, then the flash acts as a fill light. This means the main exposure is provided by the ambient light, and the flash is filling in shadows and cleaning up the colors. When this is the case, I usually set my flash at –2/3 stop (underexposure) for basic brown birds. For a subject such as a barn owl, which is basically white, I might set even greater underexposure. I follow these rules of thumb whether I'm using the LumiQuest Promax Soft-Box or the Better Beamer.

When working with the ambient light as the main light, you must be aware of the background exposure. If the background and your subject are both in shadow, then exposure is basically the same. If it's not though, beware. I cannot stress the importance of the background enough because nothing ruins a photograph faster than an overexposed background. The quickest and best way to make sure this doesn't happen to you is to meter the background before the subject is sitting on its perch. With the camera and perch all set up, take a meter reading. Without the subject in the photo, the camera's meter sees the background and meters accordingly. Look at what the meter says; you'll quickly learn if your exposure is OK or not. If not, you need to either change your lighting, the background, or both. There is a way to manipulate this. You'll find the answer in the next section, "Tricks of the Trade."

When flash is used as the main light, at least one other flash is needed to even out the lighting pattern. You could use a bracket of some sort to hold the second flash, but I personally like to use

the Ikelite Lite-Link. It provides me with a second slaved TTL flash wherever I want it, as close to or as far from the subject as I desire. This second light is used to fill in the shadows created by the main light and create the illusion of shape and volume. You must use care when employing a second flash unit so that it does not fill in all the shadows that give the subject shape, thus "flattening" the subject visually.

If you are using flash as the main light source and a second flash as well, the ambient light is likely to be of little assistance. If the background is in shadow, you might want to consider using a third flash unit to light it. You want to avoid having your photo turn out looking as if it were taken at night with an all-black background. This effect is OK for a photo of an owl, but not for the majority of the subjects you'll find at a rehab facility. Don't forget, you want it to look biologically accurate. You must also take care not to overexpose the background or light something that turns out to be distracting in the final photograph. (For more details on using flash, refer to pages 26 to 28 and 40 to 45.)

(For more details on using flash, refer to pages 26 to 28 and 40 to 45.)

> **Field Tip**
>
> When photographing larger subjects, such as owls, hawks, and eagles, I tend to shoot at a slightly upward angle. I do this because I want the viewers to subconsciously put them on a pedestal. I want folks to feel as if they are looking up to the bird. This helps command the respect these masters of the sky have earned. I also use a Tiffen 812 filter. It warms the colors up slightly, making the subject appear to be less forbidding and more cuddly (if you can cuddle an eagle). This helps grab viewers' heartstrings and gets them to relate to the photo on a more intimate basis.

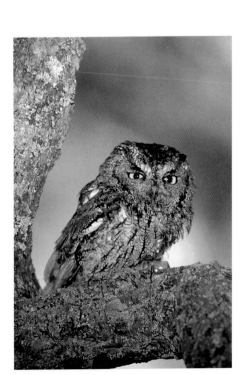

This western screech owl is missing his left wing completely and has one damaged eye. I turned the perch so as not to show the side of his body with the missing wing, and his eye is less noticeable being half-closed. Educational animals tend to be very mellow, often falling asleep on the perch. Photo captured with Nikon F4e, 75-300mm f/4.5-5.6 AF at 300mm, with flash as main light, on Agfa RSX 100. (C)

Tricks of the Trade

When photographing rehab subjects, you may need to pay some attention to hiding the animals' injuries. For example, the western screech owls that are taken in and cannot be released back into the wild are typically missing a wing or are blind. It doesn't matter if these injuries show in photos taken of them when I'm testing out new equipment and new techniques, but it does matter for portraits. There are some basic things you can do to show off a subject and conceal its defects from the camera. Remember that some rehab subjects appear to be physically perfect. These are your preferred subjects. But you should know how to photograph the not-so-perfect ones as well.

Broken or missing wings are common among rehabbed birds. If your perch is attached to a tripod head as described earlier, once the subject is settled you can slowly turn the perch so the bad or missing wing is on the back side, preventing the camera from seeing the defect. When you're doing something like this, it is best to have the assistance of the rehabber so that he or she can turn the bird for you while you're at the camera. Because the bird is more accustomed to the rehabber, it is less likely to turn on the perch and foil your efforts.

If the bird is blind, you have a few options. If the subject is a hawk, there really is no problem because hawks' eyes are so small that the blindness is hard to see in a photo. If the subject is an owl though, their eyes are so large you might have major problems concealing this flaw. Although blind owls might have eyes that look normal (big yellow circles with black centers), they might have ruptured blood vessels that look weird when illuminated by flash, or the blind eye(s) might be a cloudy blue color, totally abnormal in appearance. The easiest way to deal with this problem is to photograph the owl with its eyes closed. If this is your plan, take the photo in the middle of the day when an owl is naturally asleep. To catch it while it is sleeping, you'll need to have it on your perch for awhile and then quietly take its photograph. Typically when in a deep sleep, owls tuck one leg up into their breast feathers. This is a killer photo, and one you're sure to want to capture.

Another way to "hide" the bad or blind eye(s) is to photograph the subject when it's feeding. Birds of prey close their eyes while tearing at or working over their prey. This is a natural defense that protects their eyes from any possible injury inflicted by their prey. If you can, have the rehabber provide the subject with a dead mouse or bird and photograph it while it's eating. As long as it's not a bloody, gory mess, this can make a great photo.

Jesses might pose another obstacle. These are the leather thongs that falconers and rehabbers place on the legs of birds of prey. They provide the handler with a means of controlling the bird if it decides to take flight. You obviously don't want these in the photograph. You can either shoot head shots so the feet aren't in the photo or find a clever perch. If your perch has leaves, you can sit the bird on the perch so the leaves cover the jesses. Some rehabbers

Keep an eye on the man holding the strings! This burrowing owl is out getting flying exercise. Attached to its legs are two strings that can be used to retrieve the owl but give it the freedom to take flight to build up its muscles. Hiding the strings for the photograph was not a problem in the tall grass. Photo captured with Nikon F4e, 800mm f/5.6 at f/5.6, on Fuji Provia 100. (C)

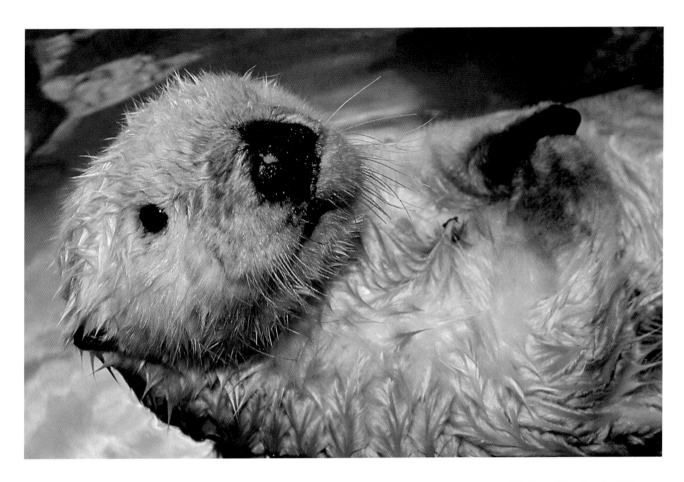

will remove the jesses, so you might request that as well. Just be understanding if they say "no."

The Bathtub

Some rehabbers specialize in water inhabitants such as gulls, pelicans, otters, and/or seals (coastal critters). There is no reason why you can't photograph these as well by just adapting your dry techniques to wet ones. You're going to trade in your branch perches for rocks, so when you're out looking for those branches, you might as well find some rocks as well.

Typically, rehabbers house aquatic critters in a cement-floored pen. The bird or mammal has a small pool within this enclosure that is also (probably) made out of cement. None of this is really conducive to photography. For critters up to the size of an otter (river or sea), working around this is pretty easy. Critters the size of seals are probably not going to be great subjects for full body shots unless the rehabber has

a large pool for them. Head shots can be done, of course, with the head filling the frame and the cement background blurred beyond recognition.

For gulls, ducks, pelicans, and otters, a large washtub can substitute quite nicely for a photogenic lake or ocean. I'm not talking about those little rubber jobs that fit in a kitchen sink, but rather the big, galvanized, silver tubs that hold 40 gallons or more of water. The bigger the tub the better, as it provides you with more of a water background as the subject swims about. You have to constantly keep an eye out for the edges of the tub as you shoot. If your camera has only 92 percent viewing, then you should keep in mind that the edge of the tub could be in the photo without your seeing it.

One way to keep a subject near the middle of the tub and away from the edge is to give it, yes, you guessed it, a perch. A beautiful rock in the center of the tub works well. A branch, when appropriate, works nicely too. You

Is it in the wild or in a tub? The southern sea otter is an endangered species. This unfortunate little guy was the victim of an oil spill off the Central California coast. The oil in its fur prevented it from staying warm, bringing it close to death. Luckily for the otter, it was rescued and taken to a rehabber, who cleaned the oil from its fur and nursed it back to health. At the rehab facility the otter lived in a large washtub around five feet in diameter. It's there that this photograph was taken. Photo captured with Nikon F4s, 35-70mm f/2.8 at 70mm with fill flash, on Fuji 100. (C)

might find this a little restrictive, photographically and compositionally, but you can acquire some marvelous photos of subjects in this manner.

If your rehabber has a lot of aquatic wildlife and photography is really grand, you might offer to build a "swimming" pool. This serves two purposes: first, it can be used to help the critters get better, and second, you can photograph them in it. I made an off-the-cuff remark one time at a rehabber's that it would be nice for the birds and me to have a pool. On my next visit, I was greeted with one that was five times larger than any tub I had and lined with great rock perches! Cruising about in the pool happy as clams were pelicans, loons, grebes, and cormorants. A couple of gulls were perched on the rocks, looking out over their new abode. For the birds and me life couldn't have been any finer.

Taking It One Step Further

Unless I have guessed incorrectly, prior to reading this, many of you had not been aware of rehabbers at all, much less the idea of using them as a photographic resource. You're not alone, as very few people are aware of what rehabbers do for our wildlife. You have the opportunity to change that. Your photographs are one of the fastest and most effective ways to get the rehabber's message out to the public.

Your photos can make a big difference in educating the public, opening up people's eyes about the plight of wildlife and the helping hands that are making a difference. Make prints for the rehabbers to use on Earth Day when they display their educational birds, duplicate slides for their slide shows when they talk with groups, and make copies for them to use in their educational materials. These gestures all have a positive impact on the community at large.

Strictly from a business standpoint, this is an article and photo opportunity screaming to be done. If you've never been published before, here's an opportunity to gain valuable tearsheets and get a tax write-off. All this, and you can have fun at the same time.

The Final Payoff

After all is said and done, is it all worth it? Working with rehabbers is extremely rewarding emotionally. Working with the wildlife that is in their care will change the way you look at and think about rehab facilities. It will open up doors to many more photographic opportunities than I have discussed here. But for me, as I stated in the beginning, the time and economic savings that are involved in trying to find a subject when you want to test out a new piece of equipment or try out a new technique are invaluable. This is the kind of win-win situation that we all try to find in our daily photographic pursuits. Using tanks is just the next step.

The Tank

Did you ever wonder how those photographs of mice in the autumn leaves or the sleeping chipmunk were taken? Well, the photographer more than likely didn't just happen upon those situations while walking through the forest. Just look at the lighting; that's the first hint that the photographs were set up, and more than likely, they were set up in a tank.

If you put your mind to it, you'll probably start thinking of many different situations in which a tank would make an otherwise impossible photograph possible. You can start the gears in motion by just looking through your own magazines or books. There's no need to wonder how those photographs were taken any more. Now you can take them yourself!

A tank is a tool that makes photographing small critters fun, successful, and economical. As with the rehab critters, I did not invent the idea of tank photography. All I've done is refine the technique so it works under any condition and with any critter. Using tanks might upset some folks though because it typically involves catching a wild critter and holding it captive temporarily during the photographic process. Let me explain.

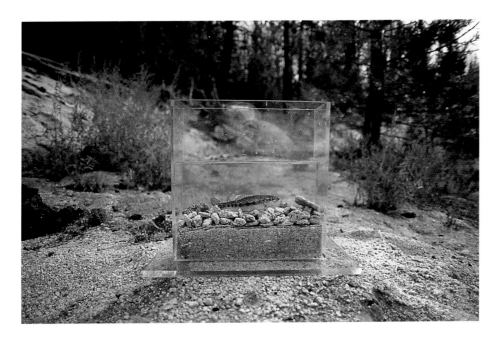

This is a photo of the little kern golden trout in my tank (see page 83). The tank is not set down just any-old-where, but in a carefully selected location where the background blends in with the natural habitat of the subject within the tank.

For many years now, I've been on a quest to photograph all the small mammals in California. Mice, voles, shrews, and especially kangaroo rats have been my main focus. If you've ever spent any time in the wild with these critters, you know how much work it can take to see, let alone photograph, them. Now kangaroo rats are fairly easy to photograph in the wild (see Chapter II) as they will come to an enticement of seed. But voles, shrews, and the like won't come to a bait station. The chances of your photographing one of these out in the wild is minuscule! Hence, the tank comes into play.

I like to work with biologists and visit their study sites at times when they are doing small mammal trapping as part of their research (see Chapter V). Individuals that appear to be suitable for photography (ones that look pretty and aren't bouncing off the walls) are placed in a tank and photographed for a while, maybe an hour. After that, they are released back to the place where they were caught so that they can go on with their lives. With this methodology I maximize my shooting time. My shooting has very little impact on the lives of the critters because I'm not spending days upon days interfering with their routine while

trying to capture them on film. Working in this way, I've been able to photograph an incredibly diverse number of small mammals, many of which had never been photographed before. And what's more important, I can help out the biologists by providing stunning close-up images suitable for scientific documentation. So exactly how is all of this done?

This is the photo that started it all. In a dirty, scratched-up fish aquarium, one of the last living Morro Bay kangaroo rats poses for a portrait. This little fellow inspired me to search for a better solution to capturing photos of this and other endangered species. Photo captured with F4s, 35-70mm f/2.8D AF with a 6T close-up lens, and flash as main light, on Fuji 100. (C)

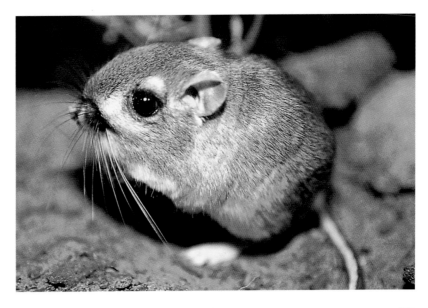

REHAB AND TANK TECHNIQUES

Here you can see the size of my "kangaroo rat" tank (right) compared to one of my "fish" tanks. The fish tank is placed strategically to help diffuse the sunlight coming in from the side. You can see the Stephens' kangaroo rat near the front right of the tank.

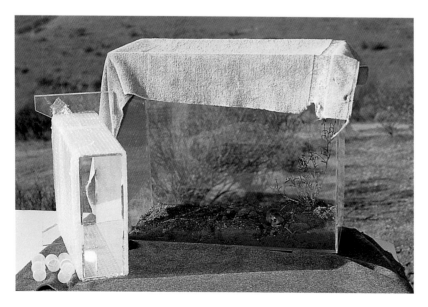

The Conception of the "Tank"

For the purpose of discussion here, a tank is a small cubical used to contain live animals for photography. You could think of a tank as a specialized aquarium. How I came to have my own tanks made and depend on them so much is a sad, but true, tale.

Back in 1989, I was hot to trot to photograph the Morro Bay kangaroo rat. At that time it was considered to be the most endangered mammal in California. It is now extinct. A small population, just a handful of animals, was believed to be living in the wild, but there was no way to photograph them (this was not a technical problem, but a political and legal one). There also was a captive population being kept in a lighthouse in an attempt to breed them and thus prevent their extinction.

With a few phone calls, I got permission to photograph this population, and I established a meeting time with the biologists at the lighthouse. I was as green as they come back then to all of this. I took all of my photographic equipment, but had no idea what or how I was going to accomplish what I wanted to do. I did know that I was going to be working indoors, basically in total darkness, so flash was a must. I also knew I was photographing a small subject, no more than nine inches in length (including the tail). I went inside

and discovered to my horror that the kangaroo rats were living in large plywood homes that were four feet wide, eight feet long, and four feet tall. Even worse was the fact that I couldn't get inside the enclosure to work; there were no doors. Shooting down on a bouncing kangaroo rat was not what you might call ideal. Well, when the biologist asked how I wanted to proceed, the first thing I started to do was stall for time.

I needed a way to have the kangaroo rat in front of me and have the surroundings be biologically accurate and aesthetically pleasing. My eyes searched the room as a cold sweat started to cover my skin. In the darkness my eyes spotted an aquarium. It had sand in the bottom of it, but the glass was a mess—dirty and scratched. But what did I have to lose? So I asked the biologists if one of the kangaroo rats could be put in the "tank" (that's how the name came to be for me). He said, "Sure." We cleaned up the tank, placed the kangaroo rat inside it, and for me, history was made.

But my cold sweats weren't over; I still had to photograph the little dude. I knew I had to have the lens close to the glass or the reflection of the flash would show up in my photograph. But I didn't own a short macro lens at the time, just a 200mm, and that wouldn't work. I did have my trusty 35-70mm f/2.8 and a Nikon 6T close-up lens. That did work. So with a flash on the camera, lens and filter attached, I went to work. As I tried to keep up with the active little guy, focusing and framing was not easy. In fact, it was downright difficult. (I'm not even going to discuss the background problems.) Stimulated by the new surroundings, his activity level lasted for about ten minutes until he settled down and went to sleep. That was it for photography. And after I was done, I realized I had shot the whole thing at f/2.8, giving me extremely shallow depth of field (ideally I would have liked to have shot him at f/11). And sadly, two years later there were no more Morro Bay kangaroo rats to

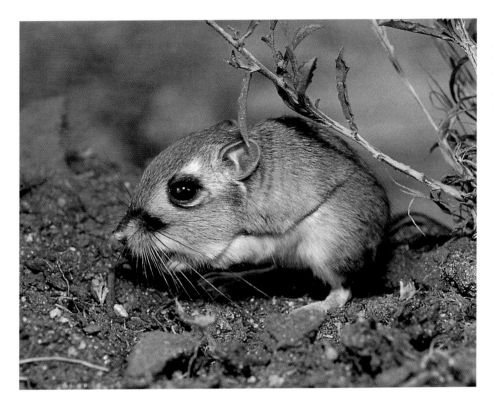

Here's the photo that resulted from the tank setup on page 98. By balancing the exposure from the flash with the ambient light (which is diffused), the subject and the foreground inside the tank blend with the background outside. Photo captured with Nikon F4e, 60mm f/2.8 Micro AF at f/8, with fill flash, on Fuji 100. (C)

photograph. The photographs that I took that day are the record shots for the species. There was no going back, just moving forward.

What Is a Tank and Where Do You Get One?

I traveled back home thinking the whole time that there had to be a better way. Some of the problems that needed solving included slowing down or controlling the subject, creating a clear field of vision for photography, making lighting easier, having the right lens, and having the system be portable and cost-effective. I started searching aquarium shops and catalogs, but couldn't find anything that suited my needs. I was discussing my problem with a friend at the local museum of natural history who recommended I make my own aquarium. Well, this sounded like a simple solution. I got the glass, had it cut to size, and went to a plastic fabricator to have clear plastic joints made, ones that couldn't be seen in the photograph.

Well, John, my soon-to-be good friend at the fabrication shop, thought I was a little off my rocker with my request. He asked a simple question,

"What is the tank for?" After I explained the whole story, he said, "Why not make the whole thing out of Plexiglas? That's when the photo tank was born. My first tank was made specifically for kangaroo rats. From 1/4-inch clear resin Plexiglas a 12-inch deep, 24-inch long, and 18-inch tall tank was created. The tank was light, completely portable, and could be shot through easily. The only catch is that Plexiglas scratches easily whereas glass does not.

It wasn't long after this tank was finished that I was called to photograph a kangaroo rat species that hadn't been seen for a decade and wasn't to be seen again for another decade. I photographed the Fresno kangaroo rat in my new tank with tremendous success. By this time, the new Nikkor 60mm f/2.8 Micro was on the market; its ability to go 1:1 without extension tubes was essential to solving the lens problem. The flash could still be used on the camera with this setup. With the tank on a table in the lab, the kangaroo rat was photographed without a hitch, and the images came out perfectly (I remembered to close my lens down to f/11 this time). The only hitch was that the

REHAB AND TANK TECHNIQUES

Field Tip

I've found knee pads and a THERM-A-REST 12 x 12" pad (available at outdoor and sporting goods stores) make shooting a whole lot more comfortable. As you are constantly moving around to be lined up with the subject, you inevitably find a small rock that sends pain screaming up your knee if you're not using these little creature comforts. Call me an old man, but these things do make life just a little easier.

rat was still constantly moving about the tank. I had made the tank too large. Today, my tank for all my small-mammal shooting is 6 inches deep, 9 inches high, and 12 inches long.

You can either have tanks made for you or make them yourself. The clear Plexiglas is readily available in hardware stores and can be cut to size with a conventional table saw. There is a special glue that you can buy that makes assembly quick and sure. I had John make my tanks because I knew he would take great care in constructing them and would put in special touches such as rounding the edges, making stands and platforms, etc. He ended up making many tanks for me, ones for small mammals and ones for fish.

What You Need in a Tank

Your tank needs to make the subject feel comfortable, restrict its movement to some extent, provide a biologically correct setting, and make photography easy. The first thing to do is make the subject feel comfortable. This can be accomplished by providing a setting that is biologically authentic. I've become quite a master at carving out a small slice of habitat that fits naturally in the tank. With this already in place when the critter is introduced to the tank, familiar smells, textures, and plants make your model feel more at home.

You'll want a tank that is wide enough so that it does not cramp the subject, but simply restricts its movement. You'll also need to provide some sort of "roof." Don't be fooled; no matter what critter you are working with, any of them can easily jump out of these tanks faster than you can say, "Oh ————." I've had kangaroo rats jump out of my 18-inch-high tank from a flat-footed stance! On my current tank, I use a simple, clear plastic celery container lid. It's heavy enough to stay on in a light breeze and can withstand a jump attack from below, plus it helps diffuse the light from the flash and ambient light a tad. Remember that you'll be placing something in the bottom of the tank, so the wall height will

effectively be reduced slightly when the subject is inside the tank.

I always take a shovel on tank shoots for creating habitat within the tank. Now you can't just dig up any old piece of earth and drop it into place; selection, believe it or not, is important. The first thing to remember is, you don't want soil that has rocks in it that can scratch up the inside of your tank. Any grinding noise that you hear as the earth is lowered into place signals that the tank is being scratched and could be scratched later.

You also don't want dirt that is dusty. Kangaroo rats especially like to dig, which creates dust. Plexiglas has a natural static charge that dust just loves to cling to. Wiping off the dust carelessly can scratch the inside surfaces of the tank. Cleaning the inside of a tank takes time, and the critter could jump out while your hand is inside cleaning off the dust. To prevent this whole scenario, the solution is simple: Don't use dusty dirt! (See page 102 for tips on cleaning your tank.)

Finally, you might want to place a small plant in the tank, if it's appropriate. We're not talking big here folks, and it might not be more than a little native grass. Many small mammals eat the plants, so providing the right kind can yield unique photographs. The small plant or grass also provides the critter with a natural place to hide if it feels uncomfortable. Be careful that the plants or grasses you've put inside don't give your critter a handy route for climbing out of the tank.

Setting Up the Tank

If the tank is set on the ground and with maybe an inch of dirt inside, you'll have to dig a hole next to the tank or build a platform to photograph anything inside it. Basically, if the tank is left as is, the subject is a mere 1-1/4 inches off the ground. I don't know about you, but I'm a big guy and I just can't get down that low and work quickly (no jokes now). That's why all my new tanks are built with a slight platform on the bottom, which raises

them up a tad. I have also learned to select sites where I can place the tank so it is raised naturally by something. I also have a small portable table that I can use to raise the tank higher if need be.

As with any photographic situation, background is key. Once again, I cannot stress enough the importance of the background in creating a successful photograph. The best solution is to place the tank and subject within the subject's own habitat. And you need to have a clear field of view. This means that you must not have grasses or plants leaning up against the outside of the tank. You want the back of the tank to be clear of debris, dust, or anything else, so it looks as if you weren't shooting in a tank. You want the background, the world in which the subject lives, to be a part of the photograph. You don't want it to be distracting though.

What's most important is that you avoid having any direct sunlight on the tank. The tank should be in shadow, if possible. This prevents any sunlight from hitting the front surface of the tank and causing a highlight in the final photograph. You also don't want to create an additional highlight (or catchlight) in the eye of the subject. Since flash is used, the sun would create a second catchlight in the subject's eyes.

You also want to set up the tank where you are able to work. I often lie on the ground, eye to eye with the subject, when using a tank. This allows me to have greater control over the background, and it permits me to take it easy; I like working lying down. But most important, it puts me at the same level as the subject. It is only natural for critters to fear anything bigger than it is looming over its head. The last thing you want it to do is perceive you as a predator. Lying on the ground puts you at the same level and puts the subject at ease.

How to Find Subjects

Finding subjects is not as easy as you might think. You can go to your local pet store and buy small mice to photograph. This is a great way to iron out the bugs in your new setup. But remember, you'll have to take care of the mice the rest of their lives. Or, if you're working with rehabbers, they might have small critters for you to photograph as well.

But if the state you're in is like California, you can't just go out and trap small animals to put in your tank. Trapping is a specialized, advanced technique that is best done under an expert's supervision. Trapping small mammals is not done with the traps you set around the house to catch mice. Snap traps kill their victims, and that is not exactly suitable for photography. Specialized traps called Sherman Live Traps are typically what are used to catch small mammals. The critters trapped in these remain alive until they are released. (There are a few things that need to be done to keep critters alive after they've been trapped. These techniques are best taught by an expert rather than by reading about them. Please restrain yourself from trying it on your own.)

Does this mean you should not attempt this type of photography? Not in the least. In fact, I hope it encourages you to read the next chapters and get more involved with wildlife biologists. As I've said many times, *No photograph is worth sacrificing the welfare of the subject.* This is just such a circumstance. Tank photography is a very viable technique that, when done in concert with a biologist, will produce photographs the likes of which you have never seen.

Tricks of the Tank

Like every aspect of wildlife photography, there are certain techniques that will make your life a little easier and your photography more successful. Using a tank is no different, and there are things you can do to achieve success more often.

Small mammals tend to fall asleep when they're in the tank. Unless you're working with these critters during the nighttime when they are active, they will fall asleep. When this happens, don't tap on the glass to get action. It

Shrews never hold still, they just keep on going. Pre-focusing to the desired magnification and image size and then physically moving yourself and your camera to get them in the frame and in focus is the best way I know of to capture the action. Photo captured with Nikon F4e, 60mm f/2.8 Micro AF at f/11, with flash as main light, on Fuji 100. (C)

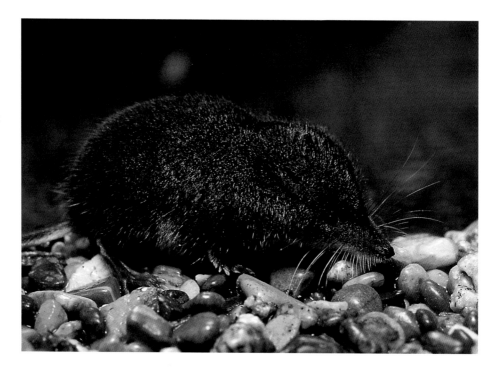

doesn't faze them; they just keep on sleeping. The best thing to do is let in a little air or breeze by moving the lid off slightly. The coolness and smell of the breeze will bring them back to life for a while. Be aware that you probably have only 20 minutes at best with these little creatures before they fall asleep no matter what.

Next is focusing. Now the Nikon F5 might make a difference in this equation, but knowing that few readers have that option, let's stick with the basics. In macro mode, autofocus tends to search too often for the subject. So focus manually. While trying to photograph a small shrew racing around the tank, you'll never click off a photo using autofocus. In the same way, trying to turn the lens barrel to focus won't get you anywhere as well. I know, I've tried and have come back empty-handed all too often.

Using a Nikkor 60mm macro lens, I determine the image size I want and focus on a point that is approximately halfway between the front and back walls of the tank. Then I leave my lens focused at this point for most of my shooting. To focus on the subject as it's moving about the tank, I move myself and the lens back and forth. All I have

to do is move laterally to keep the subject in the finder and then back and forth slightly to focus the image. This is the quickest means I have come up with to focus on these fast little guys. Until you've faced a shrew in a tank, you haven't seen anything fast in your viewfinder!

Cleaning the tank. If dust is kicked up and collects on the inside surface of the tank, don't go crazy cleaning it with a back-and-forth motion. Use a tissue and wipe the glass off in just one direction, one wipe at a time. After each wipe, refold the tissue so you have a clean surface with which to work. If you leave any dust on the tissue when you make your next pass over the glass, you will surely scratch the glass.

If you need to wipe the sides of the tank clean with the critter inside, take care not to upset it. Try not to touch it, especially its tail. Wipe in a direction so the critter sees your hand coming. I realize this sounds backwards, but seeing your hand coming will cause less stress than having your hand surprise it from behind. Predators typically grab these small critters from the backside. That's why many of them have a tail that pulls off easily, so they can escape with their lives. Your touching their tail

triggers the same instinct as if a predator were loose in the tank.

Techniques of Photographing through the Tank

My setup is quite simple now. I have a Nikon F5, a 60mm macro lens, a Speedlight SB-24 directly attached to the camera's hot shoe, and a Sto-Fen Omni Bounce attached to the flash. That's it!

The reason I want the flash attached to the camera is so that when I move to follow the subject, the flash follows accordingly. Because the 60mm allows me to be so close to the subject, the flash provides the perfect angle of light when attached to the camera's hot shoe and I am shooting in a horizontal format. A Sto-Fen Omni Bounce softens the quality of light. It also bounces light in and around the subject, softening the harsh shadows that would otherwise be created by the on-camera flash. None of the flash light is reflected in the tank's surface or seen by the lens. Otherwise, lighting is just that simple.

You have to be careful of exposure when photographing these little dudes. Their pelts are highly reflective. The guard hairs that keep their undercoat sticking up are the worst offenders. This, in combination with the dark coloring of some species, drives the center-weighted TTL metering system loopy. Depending on the subject, I determine the amount of flash exposure compensation necessary. Generally speaking for an off-the-cuff starting point, I set the flash to zero compensation, and then I can vary it from +1/3 stop (overexposure) to –2/3 stop (underexposure). The way to find out your compensation preference is to buy a mouse cat toy, place it in the tank, and do an exposure test on it (such as the test in *NWP*, page 19).

Biologically Correct Lighting and Special Effects

Biologically correct lighting. You must be wondering what the heck I'm about to drop on you this time. Well, hopefully I'm going to open the doors to something you never thought of and show you how easy it is to do. In fact, you can probably do it right now, but don't know it. Defining biologically correct lighting is simple: it's lighting a diurnal subject to look like it's daytime and a nocturnal subject to look like it's nighttime. The amazing part is that you can turn nighttime into day and daytime into night simply by using your flash!

Here's how it goes. The aperture (or f/stop) controls the flash exposure. The shutter speed controls the ambient light exposure. The correct combination of aperture and shutter speed creates a balanced exposure of ambient and

One of the tricks of the trade has to do with exposure. The "night" shot of this female Amargosa vole was actually taken during the day. The only difference between the two photographs is a change in the tank's habitat and the shutter speed. The "nighttime" photo was taken at 1/250 second and the daytime around 1/30. Photos captured with Nikon F4e, 60mm f/2.8 Micro AF at f/11 and f/5.6 respectively, with main and fill flash, on Fuji 100. (C)

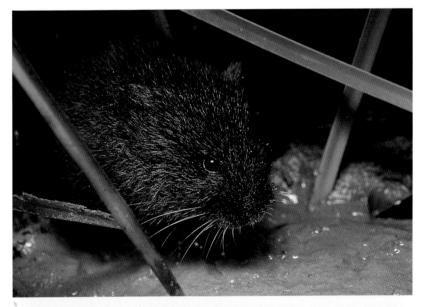

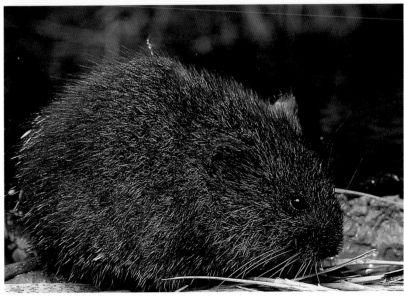

REHAB AND TANK TECHNIQUES

My tanks have been temporary homes for some of the world's most endangered small mammals. This is the Pacific pocket mouse, and at the time the photo was taken, the world population was believed to be just 32. There's no room for error when working with endangered species. Photo captured with Nikon F4e, 60mm f/2.8 Micro AF at f/8, with flash as main light, on Fuji Provia 100. (C)

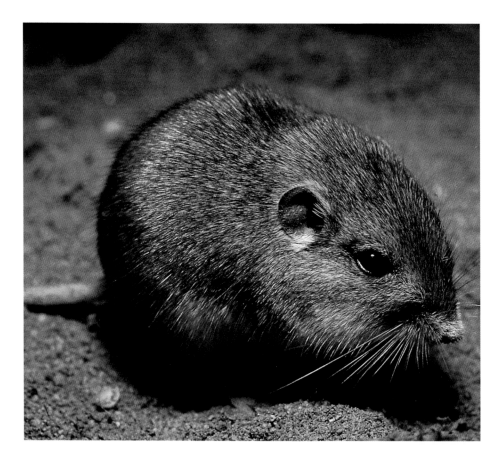

flash light. When both ambient and flash illumination are of equal intensity, the lighting ratio is considered 1:1. When working with a subject at a rehab facility, a 1:1 ratio might be useful, but generally we want the ratio to be a little bit different, say 2:1, which would make the fill light one stop less in exposure intensity than the main light. Whether the source of the main light is flash or ambient makes no difference.

Let's start with a rehab subject on a perch. The background is bright and there is no way to create a shadow to tone it down. We can underexpose the background (lit by ambient light) while properly exposing the subject with the flash. This can be done manually by simply dialing in a shutter speed in manual mode that is one stop less than what the meter is telling you. The flash is not affected by this because its metering is TTL and governed by the aperture and flash-to-subject distance. This method works fine if the light intensity on the background doesn't

change. But there is a better and easier way to do this.

You can set the camera to underexpose the ambient light while properly exposing the subject with the flash. It's this simple (honest): Set the exposure compensation on the camera body to minus one stop (underexposure). Next, set the flash unit's exposure compensation dial to plus one stop (overexposure). You now have a perfectly underexposed background and a perfectly exposed subject. I know, you're probably saying, "Wait a second here!" So let's go over that again so you understand what's taking place.

When you set the exposure compensation dial on the camera body to minus one stop, it underexposes the ambient light by one stop. It also underexposes the flash by one stop as the body's exposure compensation affects both flash and ambient exposure. However, when one stop of plus exposure compensation is dialed into the flash, this neutralizes the minus one stop dialed

into the body so the flash is exposing at zero compensation. Since the flash exposure is controlled by TTL metering, the subject is properly exposed.

The only dicey thing in all of this is that you may need to dial in some more exposure compensation for the subject. When this is required, first set the flash and camera exposure compensation as described above. Next, dial in the appropriate compensation that is required for the subject into the flash (not the camera body), whether it's plus or minus. Pretty neat, eh?

Want to know about turning daylight into night now? That's a piece of cake. Whether you're working with a subject that's in a tank or on a perch, this works every time. If you remember that the aperture controls the flash exposure and the shutter speed controls ambient light exposure (based on the selected aperture), making day into night is as simple as turning the shutter speed dial.

Let's say your meter reads that a setting of f/11 and 1/30 second would produce proper exposure for the ambient light (background). If shot with flash, the subject will be exposed for whatever aperture you set via TTL metering. If you were to take the exposure now, both the subject and background would be lit evenly. But wait. We want the background to look like nighttime. That means you'll have to set the ambient light exposure down three stops or more from the meter's suggested settings. So you have to reduce the meter's suggested exposure of f/11 and 1/30 second to any combination of shutter speed or aperture that produces

a three-stop reduction in exposure. Be careful, though, not to set a shutter speed faster than the camera's sync speed. Stopping down the aperture will shorten the flash distance and ensure that your flash does not illuminate the background. This will not affect the flash exposure since TTL flash metering compensates as long as you are close enough for the flash to provide proper exposure of the subject.

If you thought that was easy, turning night into day is even easier. All you need are about four flash units, three of which are hooked up to Lite-Links and one that is attached directly to the camera's hot shoe, and the camera's computer does the rest. TTL metering takes care of the exposure for you. Placing the flash units takes a little skill, but it's nothing you can't do.

Well there it is in a nutshell. That is how I've been able to photograph so many small mammal species in such a short time. These biological and technological concepts and techniques were developed to maximize every shooting minute. It is while working with rehabbers that I have tested all the equipment I have written about. Using tanks and working with rehabbers gives me the opportunity to refine old methods and test new ones. There are no hidden tricks or secret magic potions involved. This is simply good old solid biology combined with camera technology. Use these techniques to expand your photography and make the most of every shooting minute. They are integral elements to being a successful wildlife photographer.

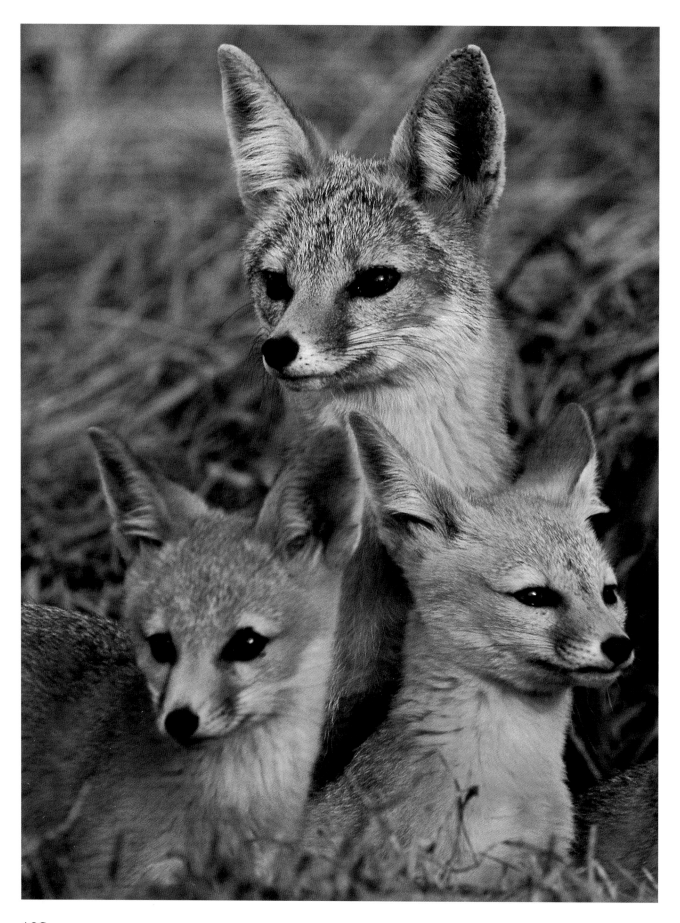

Working with Biologists

The year was 1983, and we had just moved to a new town so my wife could finish her college degree in business. My goal was to be a "wildlife photographer." Within the first month, my wife had heard of a grad student on campus who was a nest-watcher for The Peregrine Fund. I thought it sounded like this guy might open the door to a great opportunity, so the hunt was on to track him down. We searched for two weeks with no success; it seemed as if we were always a moment too late to catch up with him. One day my wife went to work at the university library and told her tale of woe to a fellow worker. After she finished he said, "That's me!" And that's how my association with wildlife biologists began.

The grad student was very kind and intelligent and took me under his wing. Besides spending the next two springs with him at a peregrine aerie, we went birding together all the time. At that time I knew very little about the mechanics of birds (their biology, physiology, habitat, etc.) and even less about identifying different species. He helped me become a proficient birder. He made me learn birds not by looking through binoculars and ID books, but by observing silhouettes, habitats, and sounds. And, as if he hadn't already given me an incredible start on birding and wildlife photography, he invited my wife and me to join him in his work, as he was part of the photographic survey team for the California condor. Because of him, we were fortunate to spend many summers with the condors prior to their all being brought into captivity.

The goal of the California condor photographic survey project was simple: to photograph the condors in flight with their primary feathers extended.

Every condor molts its primary feathers differently, so individual birds can be identified by their molting pattern. I played no significant role in this project, having contributed only a few photographs. But I saw very quickly how photography can be an important and useful tool in the collection of biological data. I also experienced my first great depression over the plight of an endangered species when we witnessed the last free-flying California condor being brought into captivity. (This was nearly a decade ago when there were fewer than ten birds left in the world. Now the population is more than one hundred, and the condors fly once again in the wild.)

So this would-be wildlife photographer (me, that is) went instantly from nowhere to working with biologists and endangered species. It became obvious to me that, at that time in California, only one or two other photographers were doing vaguely the same thing. It also became clear that the critters I was photographing needed to be photographed more extensively than any one-day outing could accomplish. So from that one chance meeting in the library, my life's work was laid out before me.

The LBV Story

A short time after that, we moved. A friend, who knew of my desire to get involved with endangered species, volunteered me to do survey work for the U.S.D.A. Forest Service on the least Bell's vireo (LBV for short). One of three remaining populations was in a little-known spot called Mono Basin near Santa Barbara, California. At the time the LBV was a candidate species,

Without the aid of biologists, I would never, ever have had the opportunity to work with my favorite subject, the San Joaquin kit fox. The assistance that biologists have given me in photographing my endangered species subjects and getting me to the right place at the right time has been crucial to my success. Photo captured with Nikon F4e, 800mm f/5.6 at f/8, on Fuji Provia 100.

WORKING WITH BIOLOGISTS

Working on a survey for the Forest Service literally changed my life. The time I spent with the least Bell's vireo, the trust I developed with the biologists in charge of the project, and the influence my photography had on the species affected my life forever. Photo captured with Nikon N2020, 200mm f/4 IF Micro at f/11 with two Sunpack TTL flash units, on Kodachrome 64.

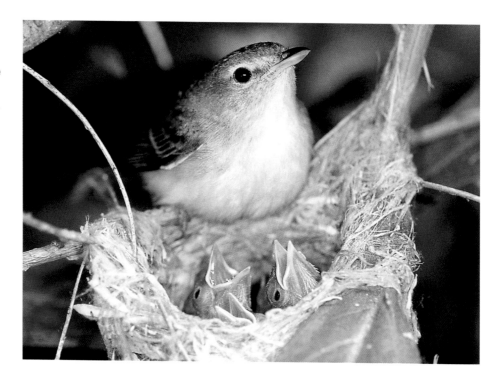

meaning that it needed attention and protection because its numbers were dropping. I was amazed when I was accepted for the job, as I had no biological education or training (I have still never taken a biology class; I've learned what I know from biologists and by doing fieldwork). I worked for a biologist who was extremely generous with his knowledge (as many are), taking me under his wing, and teaching me the methodology needed to get the job done. My duties for the Forest Service were simple: find and count territories, nests, eggs, nestlings, and fledglings of the species. The area I was to cover was two miles long and about one hundred yards wide. It was a beautiful riparian forest corridor with as many as 66 nesting species, so every moment of every day was a feast for the ears and eyes.

I had done all the reading I could prior to starting my survey work. In the mornings, when it was still cool (it got up past 100° F on most days) I walked my rounds, checking on territories and nesting progress. In the afternoon I tried to observe one nest to get a better understanding of the vireo's nesting biology. In personal communications with those who had worked with the species, I was informed that approaching the nest, let alone photographing it, was nearly impossible. Yet in my research I found accounts all the way back to Audubon himself (who gave the bird its name) that these little birds were very tenacious on the nest. Since I was working with a species that was up for federal listing as being endangered, I had to proceed with great care.

These little birds were very tenacious indeed. I had to pick them up from the nest to look in to see if they had eggs and then place them back on the nest! This wasn't true for every nest, but for many. Many nests were never checked physically because walking to the nests was risky. The habitat was just too fragile. But then one weekend the Forest Service had a controlled burn that went out of control and ended up going slightly into the riparian zone. In the process of containing the fire, a bulldozer created a cut about four feet away from an active nest. With the habitat as flat as it could possibly get, my sitting there to photograph the nest wasn't going to do any harm. So for the next two weeks, I sat next to that nest in the afternoons.

It was a wonderful experience! The male and female allowed me to sit out in the open just two feet away and photograph them without a blind. Other than the heat and the biting flies, it was incredible! It was magical to sit there so close to the birds and their young and watch them go through their daily routine. It's hard to imagine or describe how much work those birds do to raise their family and in such a short time. What was even more amazing was that once this pair had finished raising and fledging this brood of young, they started all over and raised another new family. Called double clutching, this behavior is very typical for vireos and some other small passerines.

This was back in 1985, when I was shooting with a Nikon FE2 (the next year I used an N2020), a simple Nikkor 200mm f/4 IF Micro, and two Sunpack 422D (I think?) TTL flash units. I had to really think about what I was doing, because TTL was still a new thing. I kept a constant eye on the shutter speed in order to properly expose the ambient light. That is very important to working successfully with flash so that it doesn't look like flash is being used.

Well, I got the photos, and what's more important, the fledglings made it on to migrate later that summer. A favorite photo from this project is on page 67. The leaf on the left accidentally blew in as I was taking five frames. But that accident "made" the photograph and is why it's been published more than 300 times. But the story behind the photo goes beyond what you see captured on film.

A year later, the least Bell's vireo was listed as an endangered species by the federal government. The very same month the bird was listed, my article on the LBV, my very first ever, was published. It was read by an elderly gentleman in San Diego, California, who walked every morning with another gentleman. The morning after reading the article, the gentleman told his friend that the funny little gray bird they had seen on their walk was the least Bell's vireo and that it had just been listed as

endangered. His friend told him that he had recently seen a bulldozer at that forest, mowing it down. They immediately called the U.S. Fish and Wildlife Service, who fortunately put a stop to the destruction.

One photograph in one small publication made it possible for a single species to live out its simple life. Thus, very early on in my career, I saw firsthand the power that photography has, not only to teach the public about their natural heritage, but also to get them directly involved with it. This photo and the opportunity that led up to it changed my life. I saw the importance of working with biologists, tapping into their knowledge, and being part of a research team. Because a biologist not only took time to teach me what I needed to know, but also trusted that I would get the job done, my photographic career was born. Just imagine what you could accomplish working with biologists! Imagine what you can do with your images! This is why I credit biologists with my success.

My work with the least Bell's vireo led to my being asked to participate in this Nelson's bighorn sheep capture and translocation. It was fun, a lot of work, and photographically rewarding. These bighorn sheep have been captured and looked at by the vet and are ready to be airlifted by helicopter to trailers waiting to drive them to their new home. I've lost count as to how many captures I've done in the past decade, but I've loved them all. Photo captured with Nikon F3HP, 20mm f/2.8 AF at f/16, on Kodachrome 64.

WORKING WITH BIOLOGISTS

The Mohave ground squirrel is an endangered species that lives in the deserts around Death Valley. Over the years, this project has uncovered much new data. The biologist in charge is an amazing source of information. He is incredibly generous in sharing his knowledge with me as well as with students he takes in the field while conducting research. Photo of biologists captured by Nikon F4e, 20mm f/2.8 AF at f/16 with fill flash, on Fuji Provia 100. Photo of squirrel captured with Nikon F4e, 800mm f/5.6 at f/5.6, on Fuji Provia 100.

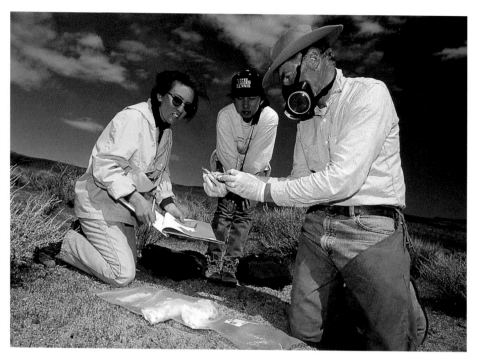

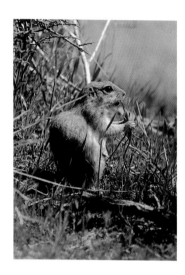

Finding a Biologist

You're probably asking, "Where do you find a biologist to work with?" You might find a biologist at the corner donut shop, but I wouldn't count on it. Actually, finding them isn't that difficult. In fact, they tend to have their names out there for everyone to find, if you know where to look.

Tracking down a biologist to work with can be as simple as going to a state or national park and asking a ranger. But the best source I know for finding biologists is publications. Most biologists come from academia, where there's pressure to "publish or perish." Biologists are scientists, and communication with others in their field is important. Peer review and discussion are an important part of validating their own findings while learning from others. This is great for wildlife photographers, because by reading biologists' accounts, we can learn about their methodology on how they collect data, and we can apply it to our photography.

The best places to search for biologists are in scientific journals, which are typically published on a quarterly basis (see Appendix A). These journals go back decades, so be sure to look at current issues. Some popular publications, such as *Birder's World*, often reference or quote a specific journal. That's another resource for finding a biologist.

Where do you find these journals? The best source is a research library. You can find these in local universities and natural history museums. Private foundations often have extensive journal libraries as well. And in some towns, there are companies set up that will actually do the research for you for a small fee.

The articles in these journals discuss research that has been conducted and information that has been learned. Biologists, researchers, scientists, grad students—whoever did the research and wrote it up—all have their names and addresses listed prominently in these articles. This makes it really easy to find them. Some biologists, when first starting their careers, travel from project to project a bit, so you might have to do some legwork to catch up with them. Often you'll find that they are no longer working on the particular project discussed in the article. But I've never come into contact with one who didn't furnish me with information on the

researchers who are currently involved with a project.

There are other means of finding biologists as well. One of the best ways is on-line. I learned about e-mail many years ago from biologists, who have been using it for years as part of the government's computer and communication system. Now, many journals are on-line and come via e-mail to your home or office. There are also many web sites where this information, plus much, much more, can be found and downloaded. (See Appendix A.) This is a great resource for many people who don't have extensive research libraries in their own town.

Other resources are newsletters and bulletins. Many small wildlife research facilities publish their own newsletters. These feature articles that are written by the biologists who have come to the facility to conduct research. Research facilities are all over the country, and a call to your local Audubon Society chapter will probably produce at least one near you. Many government agencies, state and federal, publish magazines, newsletters, and bulletins about wildlife. For example, the U.S. Fish and Wildlife Service publishes the *Endangered Species Bulletin*. This bimonthly publication has loads of biological information as well as information on biologists.

Finding a biologist is really the easiest part of this whole equation. Once you've found one, you might only want to tag along to photograph the work they do. But you might have something more specific in mind. Now before I go further, let me illustrate this point with a story.

The biologist with whom I was working on the least Bell's vireo project was also involved with other species; one was the Nelson's bighorn sheep. Because of our past association and friendship, I was asked to be a part of a bighorn sheep capture, a really incredible event. It was from this invitation that I met another biologist who also became a friend. His well-recognized specialty is bighorn sheep, and that is how I thought of him for many years. When I wanted to photograph another species, the Amargosa vole, I did a literature search. Low and behold, there was the name of the bighorn sheep biologist; he was also the expert on this species! I knew from some of our conversations that he had done small-mammal work, but I didn't know that he had worked with this particular one (see photos on page 103).

The point is, keep an open mind, and ask questions. The community of biologists is a very small one. If the biologist you know hasn't worked with other species prior to his or her current research work and cannot be of direct assistance, he or she probably knows someone who can.

Just finding any old biologist might be putting the cart before the horse. Deciding on the subject you want to photograph is part of the process. What if the biologist you find is a fisheries biologist and you want to photograph snakes? Or maybe you need a botanist, not a biologist. I found the first biologist I worked with because I had an interest in the species he was working with—the peregrine falcon. The journals I mentioned earlier have indexes that are listed by the species on which the research was conducted. This makes it easy to look up the species you would like to photograph, locate that article, and find the name and address of the researcher or biologist. You will have to decide for yourself which comes first in the process: finding the biologist or deciding on the subject. Finding a biologist by selecting the species you want to photograph first is a logical approach for someone who's just starting out.

Choosing a Subject

Deciding on a subject involves a number of factors: experience, time, money, and equipment should be the top considerations. For example, at this time in my career I would hesitate to commit myself to a project that requires a large expenditure of time and money or

This biologist and his wife work as a team collecting data about the endangered giant kangaroo rat. Here, late at night, they are in the process of measuring and tagging an individual before releasing it back into the wild. These folks greatly influenced my career. Their knowledge and passion for small mammals inspired me to document the state's small mammals for three years. Working with them on the giant kangaroo rat set the stage for perfecting my tank and nocturnal techniques. Photo of biologist and his wife captured with Nikon F4e, 35-70mm f/2.8D AF at 35mm with flash main light, on Fuji Provia 100. Photo of kangaroo rat captured with Nikon F4e, 75-300mm f/4.5-5.6 AF at 300mm, with two SB-24s on a bracket, on Fuji Provia 100.

doesn't fit within my current goals and plans, like working with the whooping crane. I also wouldn't agree to photograph the life history of beavers because I have no experience in underwater photography. In the process of selecting a species, be honest with yourself about your abilities and limitations.

Decide on what you want to come away with. Do you want to document the entire life history of a subject or take portraits? A long-term project documenting an animal's life is best done relatively close to home so you can make many visits to the site without incurring costly travel expenses, whereas the cost of making a single trip to take a species' portrait is not such a great financial hardship.

Every project has its own life span. I have worked with some biologists for only a day on a project to get one photo, and I've worked with other

biologists for over a decade from the beginning of a project. It really depends on the species and the project.

The knowledge you gain from reading books, field experience, and working with biologists and wildlife are also important to selecting a subject. So select one that meets your criteria and provides you with enough challenge to encourage growth in your field of interest.

Prior to Making the First Call

Once you have the name of the biologist and you know the subject you're going after, there are a few things to think about before you make the first call. The first is, take a reality check. Taking inventory of your abilities on paper is not a bad idea. Just what can you realistically handle physically and financially?

How much time can you devote to the project? What are your photographic goals? What expertise can you offer the biologist that will help him or her? These are some of the things you need to be thinking about prior to contacting the biologist.

Many of the answers to these questions are found in the publications you've probably already read once you've gotten this far. The journals and other materials can provide you with some insight as to what you might be up against. For example, let's say you've decided that you want to photograph a certain bat species. The literature will tell you whether the species you want to photograph lives under freeway bridges or in old mine shafts, or if you need to wear a hard hat or work in totally dark conditions. This information tells you whether you need to be a flash expert, have climbing skills, and whether you have time enough to devote to the subject.

From your reading you should also compile questions to ask the biologist. This is important for two reasons. First of all, you want to be as prepared as possible with appropriate photographic equipment before heading out into the field with the biologist. For example, if you're photographing a bat project, you need to ask if you will have to photograph in total darkness or if a flashlight can be used for focusing. If you find out that total darkness is required, then you know you need to come with a camera that has autofocus capability, and you need to know how to use the AF illuminator on your system. The other reason is that you want to demonstrate to the biologist that you have done some research and are trying to prepare for the challenges ahead.

Biologists don't expect any photographer to have all the answers. But being prepared by doing your homework and asking questions demonstrates your desire to be involved in research. Whether your goal is to collect data or capture a portrait, you're involved with research. You know your skills and your equipment, its strengths, and its limitations. Be honest with yourself and the biologist, and use your questions to establish a solid basis on which to build your relationship.

The final questions you need to ask relate to the type of working conditions you'll encounter. I'm talking about obvious stuff, such as whether you will be traveling on foot, by car, boat, or helicopter, or hanging from a rope. Will it be hot, cold, or somewhere in between? Will you be near civilization or in the middle of nowhere? How long will you be out for the day? Is there any electricity available for recharging batteries? Do you need to bring food and water? Think through your needs and ask questions to help meld your needs with the biologist's work. From the homework you do, the questions you ask, and the answers you receive, you can prepare yourself mentally and technically for the first time out.

Preparing Yourself and Your Gear

You won't impress the biologist with tons of gear but instead with tons of performance. The first thing you need to do is pack your gear, taking only what's necessary for the job. For some jobs this might mean taking every piece of equipment you own. For others, it might mean leaving most of it at home. Part of your decision regarding what to take is based on the working conditions you'll encounter. You need to transport gear in something that is functional and yet easy to carry. This applies whether you are traveling on foot, working out of your car, or both.

Traveling by car is the most common way to take your gear to the wildlife subjects. The car provides you with the luxury of being able to take every piece of camera equipment you own, which is a benefit not lost to many. However I'm always amazed at how some folks transport their gear, even by car. Most equipment failure, accidents, and damage come from transporting the camera and gear by car. Gear that does not

Field Tip

It can be valuable to find out whether the biologist has worked with other photographers before and what problems, if any, they may have had in working with them. Some photographers' unprofessional behavior may have soured the biologist to the idea of working with any other photographers. Be professional and you'll never have a problem; you'll have work for the rest of your life. It's a small world, so always put your best foot forward.

WORKING WITH BIOLOGISTS

This deer capture was one heck of a great project! I got to ride in the helicopter, handle the deer, and take shot after shot. I was airlifted to a location and then the deer was driven towards me so I could photograph the very moment that the net gun was fired. Without working with biologists, I would never have been able to stage such a scene to be photographed. The budget alone would have been prohibitive. Photo captured with Nikon F4e, 75-300mm f/4.5-5.6 AF at 200mm, on Fuji Provia 100.

function when you get to the site means photos not taken. And photos not taken means, well, why else are you there?

One of the leading reasons why I pack and carry my gear in the car the way I do is to protect it. Have you ever stopped quickly to shoot a subject only to hear your gear flying through the car? (Oh, does that hurt!) Ever been out shooting for a day, come upon a subject, and then not been able to find the particular lens you need because it's buried under everything else you've used that day? Or how about when you go to grab one piece of gear only to have another piece, lying hidden, go crashing to the ground? Have you ever unpacked your car full of gear and taken it into a hotel room, having that uneasy feeling that you're being watched and sized up to determine your net worth? These are important considerations to take into account when traveling to the subject by car.

I'm as guilty as anyone of taking everything when going by car. But with the above considerations in mind, I pack for success. My main carrying system for 90 percent of my gear is a rugged photo backpack. I recommend any large, well-built pack. My backpack sits

fully packed all the time in my office. I'm on call for many projects, and by having it packed and ready I know I can just grab it and have all the equipment I need to do the job. (Having everything in one bag makes going into a hotel room easy and discreet.) But its best feature is how easy it is to work with in the field.

Traveling by car encourages shooting from the car, and a large photo pack makes it easy. Though I typically travel with a camera and a 300mm lens in the seat next to me (for shooting out the car window), I inevitably need to use something out of the pack, which is stored in the back of the station wagon. By reaching back, and with one zip, I have access to everything, absolutely everything. The flap folds back, exposing all of my lenses and camera bodies. This permits quick access and often makes the difference as to whether I get the photo or not.

Many of my specialty accessories, the ones I don't need on a day-to-day basis, don't ride in my large photo pack. For those I take along one or two smaller camera bags filled with extra Quantum Turbos, a Shutter-Beam, Really Right Stuff Flash Arms, etc. (I recommend that you stick with one brand of carrying bags. If you standardize carrying systems, the dividers and accessories will generally be interchangeable and can be quickly swapped between bags.) Since these items are not used all the time, the bags containing them need not be readily accessible. The bags are small and nondescript though, so when I take them into the hotel, I'm not waving a big sign that says "photographer."

This brings me to a small side note. When traveling with my gear in a car, I always take a number of large, white towels (no, I don't take them from the hotel room!). I use these towels to cover my gear. I do this for two reasons. One is to keep honest people honest by removing the temptation of wanting to help themselves to my gear. But more important, the towels bounce the sun off my equipment. This simple, yet very effective, strategy keeps my

equipment cool in the hottest of California's deserts. And, knock on wood, I've never had equipment stolen from the back of my car.

I don't always stick with the car. I often drive to a locale and then take off on foot. By talking with the biologist in advance, I usually know whether or not I will be hiking. For these kinds of shoots, a smaller pack is handy to bring along in the car. They are more portable than the large photo backpacks. And if the biologist takes off across the landscape by foot, I need to be able to follow and function as a working photographer.

Typically it ends up that you must walk to close the final gap between camera and subject. Whether it's a short or long walk, you've got to get your equipment to the subject so you can shoot. Do you take everything with you? Do you take just one lens? What about carrying a flash and filters? Do you carry your gear in a fanny pack or backpack? You've got to take enough equipment with you to solve potential photographic problems, yet not so much that you are

unable to function. Here are the methods that I've found work for me. (Adapt these ideas to your own equipment and photographic style.)

The first part of the equation (and the basis on which I make all of my decisions) is the subject. I typically leave my car and take the gear I need to photograph the particular subject at hand. This might mean taking a long lens for perching birds, a 300mm lens for big game mammals, a wide-angle for scenics, and so forth. The subject dictates what equipment I take. And what equipment I take dictates how it is carried into the field.

One essential piece of gear for getting equipment into the field by foot is a vest. There are many different vests on the market, the best one being simply the one that works for you and your camera system. There are important features you should look for though in selecting a vest. The pockets are at the top of the list. You want pockets, at least a couple, that are waterproof and/or padded. One of these pockets should be big enough to hold a mid-range zoom lens. You don't want water splashing up and soaking the lens, which is why the vest should essentially be waterproof. The other pocket is for film, which also must be kept dry.

You'd best know what you're getting yourself into before stepping out your door. Airboats are a lot of fun, but they are also noisy, bumpy, and fast! In surveying for the endangered California clapper rail, I had the opportunity to both work and play. Photo of biologist captured with Nikon F4s, 20mm f/2.8 AF at f/8, on Fuji 100. Clapper rail captured with Nikon F4e, 800mm f/5.6, on Fuji 100.

When packing the vest it is important that you don't overpack it. You shouldn't try to empty all the contents of your photo pack into your vest. If you need that much equipment, you might as well just take the pack. A vest, lightly packed, is useful for a number of reasons: carrying ease, easy access to equipment, light weight, less back strain, stealth in keeping a slender and quiet profile in the field, and gear safety. For example, my vest is always packed with 20 rolls of Agfa RSX 100, a cable release, a 12-inch silver-and-gold reflector, a Leatherman Tool (an elaborate Swiss army knife), lip balm, filters, and gloves. That's all. If I want to fully load it, I might add a lens, flash, and cords to this, but no more. The vest is not meant to replace the camera bag, but allows you to carry a few items into the field and provides an extra hand when shooting.

The majority of the time when I take off on foot, I take along either the 600mm or 300mm f/2.8 attached to a tripod. When traveling less than a mile, I hike with the camera and lens attached right to the tripod and prop the tripod on my shoulder. If I must traverse more distance than that, I'll put the camera and lens in a pack and carry the tripod in my hand. Most of the time though, I use the over-the-shoulder method. More than likely, I'll have my Really Right Stuff Flash Arm set up with a flash and Better Beamer attached. My Quantum Turbo is attached to my Gitzo tripod via the Quantum QBC Mounting Clamp. And to facilitate quick shooting, I may leave the tripod's legs set to the proper length and opened up so all I have to do is set the tripod down and shoot. I've walked five miles in a day checking trap lines with this setup.

I usually carry a second camera body with me. I carry it via a neck strap on my left shoulder. Typically, my zoom lens is attached to it. In my vest pocket I'll either carry my 75-300mm, 35-70mm, or 60mm macro, depending on what I'm going to shoot. But my 20mm always goes along so I can capture any scene I might see. This includes scenes of the biologist at work. My favorite lens for this is the 20mm because it takes in the biologist, the project, and the setting. The reason I carry my gear this way is for quick operation and ease of transport. Since I'm primarily after wildlife, I need to be

This pair of young San Joaquin kit foxes looks cute and cuddly all on their own, but a polarizing filter removed the glare from their coats, softening their appearance even more. Photo captured with Nikon F4e, 300mm f/2.8N AF at f/8, on Fuji Provia 100.

ready to shoot at a moment's notice. I've found that this system works best in accomplishing this goal.

The things that many folks tend to leave at home or in the car are filters. To me, filters are one of the most important accessories available to help us communicate our vision to others. But because they are inconvenient to carry they tend to be left behind. I ran across this dilemma long ago, but I solved it in a hurry because I discovered I needed my filters in the field.

My solution was to select lenses that have identical filter sizes. For instance, the 75-300mm, 35-70, and 60mm macro lenses just discussed all take 62mm filters. This reduces the number of filters I need to take with me to about four, and I carry them all in my vest pocket.

I typically take a Nikon 62mm circular polarizer, a 6T close-up lens, a Tiffen .06 neutral-density filter, and one or more color-enhancing filters. For carrying ease, I screw all four filters together and use stack caps to protect the front and back sides of the stack of filters while they ride in my pocket. You can do the same thing even if your lenses' filter sizes aren't all the same. By using step-up rings, you can stack your filters for easy transport and always have them with you in the field. This takes a little thought at first, but after a few trips in the field it becomes second nature.

The other thing to do is to think through the photographic scenarios you might encounter in the field and prepare yourself for situations that might be new to you. This includes thinking ahead and packing your gear for easy access. This includes understanding how to use the AF illuminator and other specialized camera functions. Practice focusing on small objects that you've placed on the wall in a dark room. If you are going to be doing lots of macro work and need to use flash but are not sure of lighting patterns or setups, do some test shots prior to going out in the field. No one expects you to get every photograph. But if you look

prepared and professional, folks will be more forgiving if you don't get the photograph.

I've heard many horror stories from biologists about photographers. They tell me of all the antics they've been put through by photographers who didn't do their homework. It's not that a biologist will kick you off their research site if you don't get the photo (but they might), but they may not ever ask you back again if you come across as being unprepared. Go prepared to work as part of the research team, be self-sufficient, and be knowledgeable, and you'll do just fine.

In the Field with the Biologist

The first time out is like your first field trip in first grade. You're at once excited and nervous because you're going to experience something new. It's just grand!

The last thing you want to do is burst on the scene, cameras hanging around your neck in grand profusion, saying, "Where's the subject, where's the subject?" You'll scare the biologist to death doing this (and the subject, too)! Biologists are generally mellow folks who love to cherish each moment. Nothing is done in a hurry. So put on your brakes before you even leave your car.

I suggest that you start off with little or no camera gear at all. You're going to miss photos doing it this way, but you will capture better ones and more of them in the long run by taking this approach. The first thing you need to do is get to know the biologists and their methodology. I'm not talking about how they collect data, but when and how they work. Depending on the project, you might set off on a five-mile hike or sit back in a lounge chair and watch the clouds go by until it's the right time to shoot. Again, be prepared for the fact that you might miss photos in the beginning, but you'll be rewarded in the end.

Field Tip

While working with biologists and traveling by foot, I always make sure that my hands are free. I have my camera on a strap hanging from my shoulder where I can easily reach it in a hurry, yet it's out of the way. This allows me to help out the biologists, whether to open traps, carry supplies, or take notes for them.

Field Tip

Learn how the biologists collect data, and use it as the basis for setting the parameters on how to take your photographs. Their methodology is designed to have no adverse impact on the species being studied. The last thing you want to do is upset the apple cart by being in the wrong place at the wrong time or doing the wrong thing and causing them to lose data. But what's most important is that you not accidentally cause any harm to the species while you're taking photos or helping out. Be observant and you'll do just fine.

If you can't resist bringing your gear, start out with your vest on, film in your pockets, a camera body with a wide-angle or wide-angle zoom attached, and a longer tele zoom in your pocket. Other than possibly a flash, that's all you'll need. You want to be able to capture images of the biologist in action, general shots of the research site, and maybe a photo or two of the species itself. Most important, though, is that you observe what the biologist is doing and how he or she is doing it.

You must remember that initially you are a guest in the biologists' "home," figuratively speaking. They have certain ways in which they set the table, open the windows, and park the car. This set of informal rules defines how they collect the data that are so important to their work. If you violate these rules, you may not be asked back.

If your goal is to take a single portrait, you might have to start shooting on the first day, as the animal may present you with only one opportunity to get the shot you're going after. But I can tell you from my own experience, I've never gotten "the" shot, let alone

any shot, of my subject the first time out on a project. This is because at that point I haven't had enough time or experience to get to know the subject or terrain yet. It is important that you take time to get to know the biologist, the project, and the goals. I go knowing that I have to pay my dues in order to get the image I'm there to capture. So it's important that you go in with an open mind. Let me illustrate this with a story. (I have so many, I just can't figure out how to work them all in!)

The Palos Verdes Blue Butterfly

I once said with pride, "I don't do creepy-crawlies!" Shooting insects is just not my cup of tea—never really has been. I admire those who can do it and do it well. A few years ago, my wife and boys dragged me to an insect fair. Oh, you can imagine the excitement I felt for that venture (not)! Well, I really didn't go in the best of moods, but looked around with my boys trying to

There's much to be learned by working with a biologist in the field. The first is that they do no harm to their subjects. Much thought and care goes into placing a trap to safely and humanely capture an animal such as this Mohave ground squirrel. Photo captured with Nikon F4e, 20mm f/2.8 AF at f/16, on Fuji Provia 100.

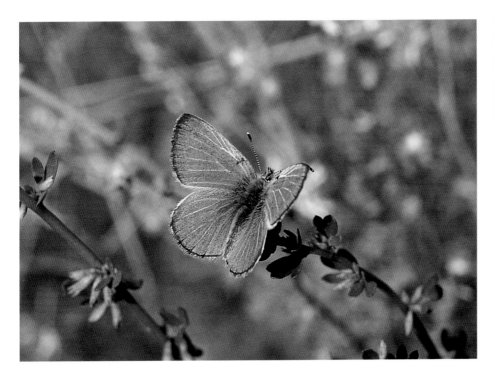

The endangered Palos Verdes blue: the little butterfly that taught me to be open-minded. "I don't shoot creepy-crawlies" was a bad attitude to have had. But luckily, with what photographic skill I had, I pulled off a big success. Photo captured with Nikon F4e, 60mm f/2.8 Micro AF at f/11 with fill flash, on Fuji Provia 100.

get excited about the bugs. I saw a posting of the guest speakers of the day. Two of the talks were on endangered species. That half-caught my interest, when I noticed one was on a fly I was curious about, so I thought I could save the afternoon by hearing this talk. By the time I got to the auditorium, that talk was over, but the next one on the El Segundo blue butterfly was just starting. Since it was an endangered species I knew a tad about, I stuck around.

I sat in my chair and started to watch the slides and hear the story about the El Segundo blue. The speaker and biologist (technically an entomologist) was a really good presenter. The point he was making reflected my own feelings about similar topics. His talk covered the need to protect habitats. All of a sudden, one of my photographs of a San Joaquin kit fox appeared on the screen. I listened to what he said, which I totally agreed with, and I rather enjoyed the way he incorporated my photo into his talk. After his presentation was over, lights were turned on, and questions were answered, I went over to talk with him.

I complimented him on his photog-raphy, and he admitted that many of the photos were ones he liked and had copied from magazines. I said that I especially liked the photo of the San Joaquin kit fox. He said that it was one of his favorites as well. I then said, "Thank you." He had a funny look on his face, then he turned red, bright red, as he realized that he had been had.

He really didn't know what to say or do—he thought I might go ballistic. But as I had said, the message he put with my photo was right on, so all I could do was tell him what a great job he had done. Well, he felt bad nonetheless and asked what he could do to make it up to me. I said maybe I could come down to his site sometime and photograph the El Segundo blue. It was fall, but he said to call him in the spring and we'd arrange a time to meet then.

Spring came, I called him up, and we made arrangements to meet at his research site. By the way, his research site is literally at the end of the runways of the Los Angeles International Airport. I went down there figuring I would get a few shots, learn a little more about our natural world, and then head home. The minute I got to the site and got out of my car, the biologist told me to get

WORKING WITH BIOLOGISTS

Later, after perfecting my system of photographing butterflies, I went back to photograph the subject we had intended to shoot that day, the endangered El Segundo blue butterfly. Photo captured with Nikon F4e, 60mm f/2.8 Micro AF at f/11 with fill flash, on Fuji Provia 100.

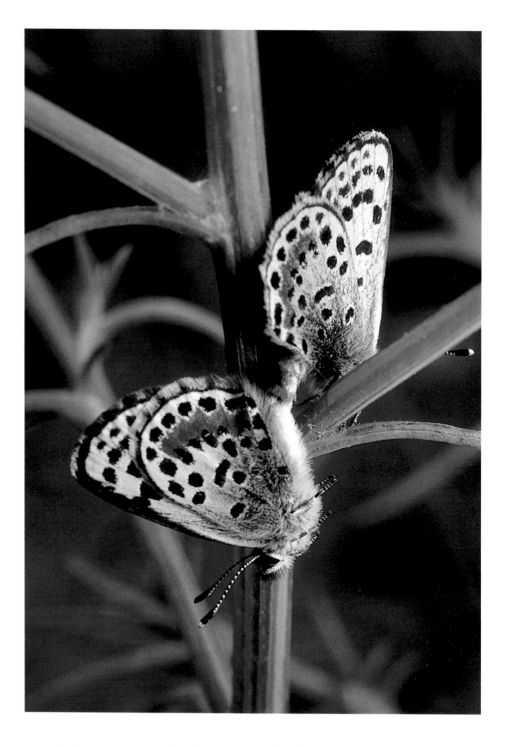

back in because we needed to drive somewhere. I didn't really think anything of it; I just did it. Well, as we were driving away from his research site (remember, we had never worked together before, only met that one afternoon), he asked me if I knew of the Palos Verdes blue butterfly. I said, "Yes, it went extinct ten years ago." He said, "I just rediscovered it yesterday and we're on our way there now." Have you ever felt fear and excitement at the same time? Well at that moment, I certainly did.

I was about to be the only photographer allowed to photograph this butterfly. And because I hadn't spent much time shooting insects, I was about as ill-prepared to photograph it as someone just starting out in photography. But

luck was with me that day, and I did get one shot, which was published more than 100 times over the next month. (I donated the photo; no revenues were generated from its use.) The moral of the story is: Go prepared and be ready for anything and/or nothing as you step out of your car to shoot!

What Can You Expect?

You can expect to capture the most fantastic photographs of your life! You can expect to use every technique I have offered, plus develop some of your own that I've never tried or even heard of. You can expect to shoot tons of film and be involved in some of the most exciting events known to man. And you'd better expect to be hooked for life.

After your first few trips out, you'll get a feel for how the biologist works. You'll understand exactly what equipment you'll need to have on hand at all times to capture the biologist and the species in action. Never forget to capture the progress of the project itself on film.

And what about the subject? Depending on what you're after, you could use any or all of the information I've provided to get those photos. But don't forget, the most important source of information you could have for learning about the subject is standing right next to you in the field—the biologist. As I stated earlier, my success is directly related to biologists. They have continually and generously shared with me the information I've needed to get the photograph. This includes when to be in the field (a very economical thing to know), where to look once I'm in the field, or when something noteworthy is about to happen. Biologists hold the key to helping us get the photographs we're after. Countless times they have alerted me ahead of time to an event that was about to happen so I could capture it on film. Please understand what I'm saying here, folks: They can help you get "the" photographs and at the same time

You'd better be prepared to have fun and shoot long after the sun goes down. This biologist is checking the weight of a giant kangaroo rat at 2:00 am! That was after starting out at 10:00 pm and working our way through 400 traps. Do I enjoy this? I consider myself fortunate to have been able to visit and work on this project for more than a decade! Photo captured with Nikon F4s, 35-70mm f/2.8D AF at 70mm with flash as main light, on Fuji 100.

totally protect the welfare of the subject. What more could you ever ask for?

Is There More?

Oh boy, I haven't even scratched the surface. Want that special little mouse for your photo tank? Want to know when a certain species of bird is going to nest? This is the type of assistance a biologist can offer you. Once you are tied in with a biologist, you won't have to read a book to understand the biology of the subject, it will be revealed to you in person. That's always been one of my fondest treasures, to witness the answers before they are ever recorded. It's a great thrill to be present when new research is being conducted, even more when you help write (and/or illustrate) it.

Do you have a budget for renting a helicopter to photograph bighorn sheep? Do you know where you could rent an airboat to survey a marsh? Do you have the key to unlock the gate to a back-country road to drive right to a subject's location? These are the side

WORKING WITH BIOLOGISTS

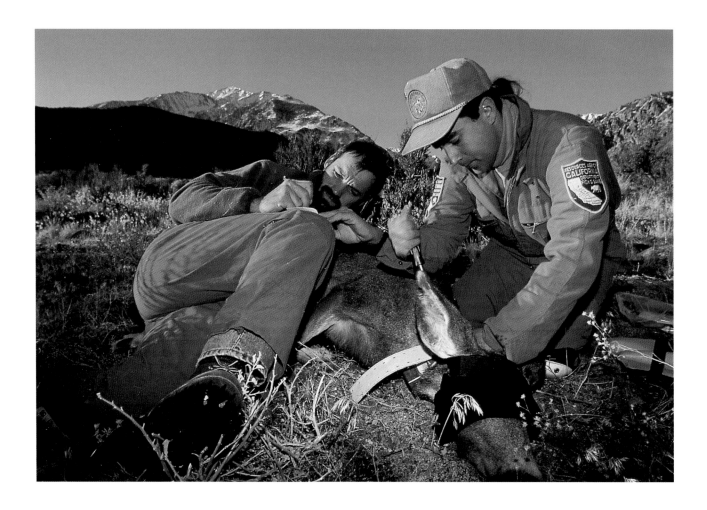

What couldn't be captured in this photo was the helicopter flight to this netted deer and my excitement of being able to work hands-on with wildlife. You can experience opportunities like these too when you work with biologists. Photo captured with Nikon F4e, 20mm f/2.8 AF at f/16 with fill flash, on Fuji Provia 100.

benefits of working with biologists that make the adventures so rewarding before the shutter release is ever pressed. But there is more!

Remember, you're a photographer, and once the excitement has worn off, you need to get to work. Once you've learned how to set a Sherman Live Trap and untangle a deer from a net, you must master doing these tasks while getting the shots! You have been given the unique opportunity to be there where the action is, so do your job as a visual communicator and capture the action on film. At times this requires putting the camera down and pitching in. I do that a lot. It's the best way I've found to get the photos, and the overall job gets done, too. For this extra effort, which is really one whole heck of a lot of fun, I get to do more projects!

How It All Grows

I could write an entire book just on my adventures with biologists. After you've done your first project with a biologist, you'll move on to the next. The effort and professionalism you demonstrated on the first project, never mind if you got the photos, will get you into the next. Now if you get the photos as well, you're golden, and many, many doors will be opened to you.

I don't know a single photographer I've turned on to working with biologists that has been able to go out just one time. Even if you never get a photo, it's one heck of a lot of fun. But you do get photos, and you can learn more than if you went to college and got a degree in wildlife management. You will find that your own personal

photography will grow from the lessons you learn while working with biologists. You'll find the quality of your images will grow as well. Most important, you'll find that the message conveyed by your photos will grow stronger.

In what seems like a matter of no time at all, you'll find you have a pool of biologists you've worked alongside, and the number of projects you're working on will be greater than you had ever imagined. You'll be getting photographs you never thought possible all while you're working a regular job. And I haven't even mentioned the financial opportunities (that's another book).

Want to be a hero? Want to have the ego boost of a lifetime? Want to be asked to work on other projects with other biologists? Simply provide the biologist with duplicate slides of the project. I have my own machine to make duplicate slides, and it's in constant use. Most biologists don't have budgets to conduct their own research, let alone pay for a photographer to document it. I never expect, nor have I ever asked for payment for my work. I have donated all of my time, resources, and duplicate slides for all the research projects I've worked on. Your duplicate slides help the biologists with their research. They help them share their work with their colleagues. And most importantly, they help them communicate to the public the importance of our natural heritage. There is no greater feeling than knowing that you were part of the team, you did your job and got the photographs, and that your photos made a difference.

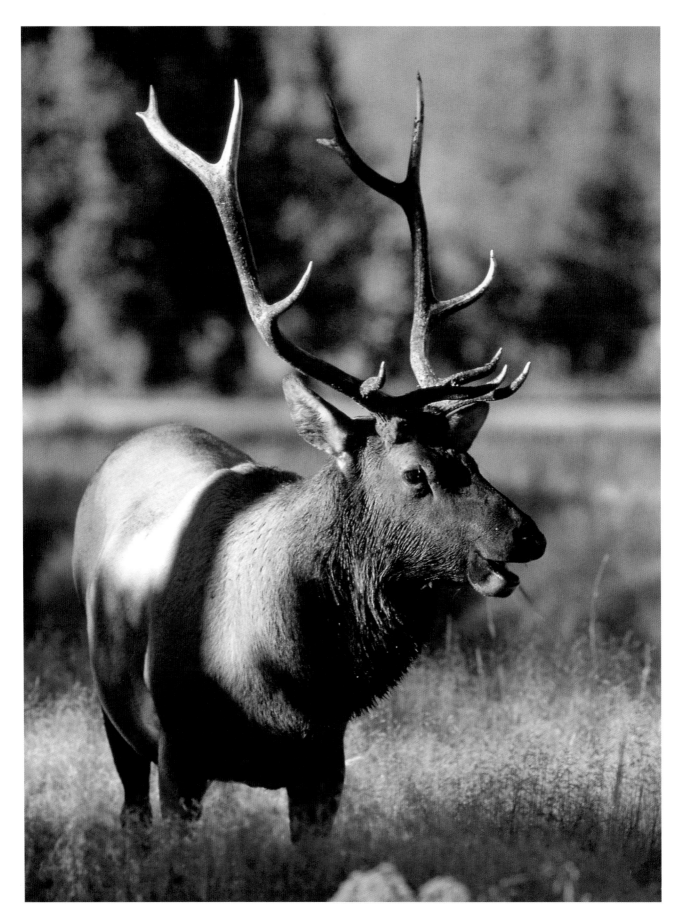

Telling the Biological Story

The nature of scientific research has changed over the years. Decades ago, a research project often lasted a minimum of five or ten years. Investigating a particular biological question, the reason for an evolutionary response to change, or simply how an extinct species once lived may have been a researcher's life-long work. This has changed in recent years, evolving into a focus on short-term projects, probably in response to economic factors. However, as these projects grow shorter and shorter in duration, scientists are increasingly recognizing the importance of long-term research projects. Typically, the shorter projects raise more questions than they answer. They don't demonstrate newly acquired knowledge, but instead reveal what we have yet to learn.

I've just recently recognized this same trend in wildlife photography. Back in the days when folks photographed wildlife with 4 x 5 Speed Graphics (oh, what a labor of love that was), they devoted years to capturing a particular subject on film. Part of this, I'm sure, is because of the format in which they were shooting. They weren't using an SLR camera with a rapid-fire motor drive. It was a painstaking affair, shooting one frame every five minutes. Then came along the SLR and a new generation of shooters with 9-to-5 jobs. The ease with which we could blast off photos of anything that moved within a limited amount of time brought to a halt the great photographic essays of days gone by.

Is this chapter about starting something new? No, it's about carrying on a tradition and advancing it using today's technology. Is this chapter full of advanced techniques? That all depends on how you look at it. My high school

photography teacher taught me much (not that I recognized it then) that shines through in my photographs today. But one thing he said applies to us all: "It's the person behind the camera that counts!"

You really smart readers will take what I have to offer in this chapter and apply it to the business of photography. Working with biologists over the past decade has not only influenced my style of photography, but it is also what has made me so successful in the business aspects of my work.

Training myself to question and understand the big picture to the best of my ability, whether studying a habitat, species, or camera system, is what has filled my mind with so many ideas, tips, and "trivia." I challenge you to tell the biological story by going beyond the single portrait, redirecting your thoughts to photographing the larger picture. This chapter is, in effect, a direct-mail piece that's intended to get you to focus on the whole story; that's the ultimate self-assignment, and it offers countless business opportunities. Suggesting this approach is also intended to get photographers more involved with their environment through photography. I want more photographers to use their talents and skills to evoke a response from those who view their photography. As photographers, we have the power to preserve and educate the public about our wild heritage. *YOU can make a difference!* As a friend recently reminded me, if I were to die in the next five minutes, would what I have done in my life change the world? I am fortunate that some of my photographs have had an impact. Yours can too!

In this chapter, I'm going to present

Field Tip

If you want to see the work of an old master who thoroughly explored a subject, place, or habitat with his camera and his soul, look at the work of Eliot Porter. Though some of his photos are a little "stiff" for my taste, his devotion to detail and the subject is a standard to which I constantly try to hold my work.

Yellowstone National Park offers many magnificent photo opportunities. This photo of a Rocky Mountain elk in rut was taken within two days' time of that on page 140. Photo captured with Nikon F5, 300mm f/2.8N AF (no exposure compensation), on Agfa RSX 100. (P)

ideas to start you thinking along these lines. These ideas and tips are more for the mind and soul than for the camera.

The Biological Story of the Seasons

Phenology

"There is a reason for the season." This slogan is written on a sign that I see when I drive home from Yosemite. Though the author of this slogan intended for it to have a different meaning than I have drawn from it, it nonetheless says it all when it's applied to wildlife and wildlife photography. I lived in the city for many years, and during that time this message was lost on me, though subconsciously I realized its ramifications. Living as I do now in the Sierras, I'm reminded daily of its meaning. For the past year I've been faithfully keeping records of the changes in the season and the changes that result. Understanding these patterns is vital to the success of a wildlife photographer.

Have you ever noticed that no sooner do you have your dream camera outfit but something new comes along that makes it obsolete? Is there anything old in this world that we can carry with us and use through all our years no matter what new technology might come along? There is for wildlife photographers, and it's called *phenology*. You're probably asking, "Who makes this marvelous technology? Agfa, Canon, Fuji, Nikon?" Well, it's none of those. In fact, it's made by the most prolific manufacturer in the world, Mother Nature.

Phenology, as defined by the *Cambridge Illustrated Dictionary of Natural History*, is "the study of the temporal aspects of recurrent natural phenomena and their relation to weather and climate." (That's a mouthful!) This age-old science is what the *Farmer's Almanac* relies on and is so good at reporting to us. It really involves no more than being aware of your environment and listening to what it's telling you every time you venture from your home. So just how can it improve your photography more than new equipment can?

Frank Craighead, Jr., in his book *For Everything There Is a Season*, recounts his decades of listening to Mother Nature in the Greater Yellowstone area. His book is a must for anyone who shoots in the Tetons or Yellowstone because it leaves no secrets untold about Mother Nature. Let me provide you with a quick example to get the show going. "With the peaking of scarlet gilia or blue penstemon, you can expect to see many species of young birds in the nest or just leaving it— black-headed grosbeaks, house wrens, American robins, tree swallows, mountain bluebirds, white-crowned sparrows, red-winged blackbirds, yellow warblers, prairie falcons, and long-eared owls." From observing a couple of flowering plants, Frank Craighead, Jr., knows just what these bird species are doing in the Tetons. This holds true no matter what the weather has brought that year, and it's all based on phenology.

Phenology, like anything in wildlife photography, takes time to learn and master before the big payoff comes. From the beginning though, it provides

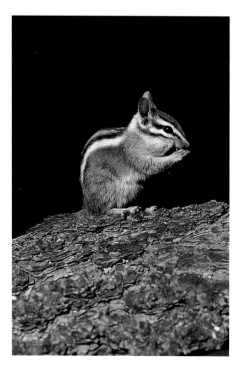

The actions of the yellow-pine chipmunk give me a clue as to what to expect for the winter. These chipmunks hibernate, and by noting when they go into hibernation and how much food they have stored, I have a good idea as to whether it's going to be a long or a short winter. Photo captured with Nikon F5, 600mm f/4 AF-I with TC-14e, on Agfa RSX 100.

you with insights into the lives of your subjects and your approach to photographing them. It all starts with your eyes, ears, and senses being in tune with your surroundings. It requires more from you than just watching for great photographic subjects, but looking for every little detail that might be different since the last time you ventured outside. And it demands that you to be a nature detective, able to solve a mystery by finding small clues that, when connected, are phenological events.

Think about what is so often referred to as the "web of life." The events you might witness in a day's time are all related in some way, often in ways unbeknownst to us. Weather, climate, altitude, hurricane, drought, or flood—all these factors contribute to the biological events that come to pass on a certain day. This is all part of phenology, just a fancy word for better understanding and being keyed into our environment.

The basic tools required for using the phenological approach are ones you should already have: a pencil, notepad, binoculars, and some field guides (those on birds, mammals, and plants are the most useful). The goal is to be observant and write down your observations when you're in the field (a micro-cassette recorder works well too if your hands are full of equipment). In practice, note the date, including the year, the weather (overcast, cloudy, sunny, etc.), and anything else you might see, such as a plant that's flowering, insect activity, or wildlife. Note such things as a flower species blooming or going to seed, a bird collecting nesting material or flying with a fecal sac, or a deer in velvet or with no antlers at all. All these are clues as to what is happening at that moment in time. This collection of information forms the basis of phenology and your entry into better and more rewarding photography.

Now, we know that birds normally do their thing every spring and that leaves fall from trees every autumn. But the specific timing of these events can be predicted to the specific day by rain, temperature, and altitude. Climatic events change every year, influencing the progression of life in nature. It's impossible to say that on every July 1, the great horned owls will fledge their young. But by understanding all the indicators associated with the fledging of great horned owls in your area, you'll know when they should be fledging that particular year. These predictions are normally accurate within a week or two, as long as good notes are kept of past events.

A great example is predicting the great fall color climax. Ever wonder

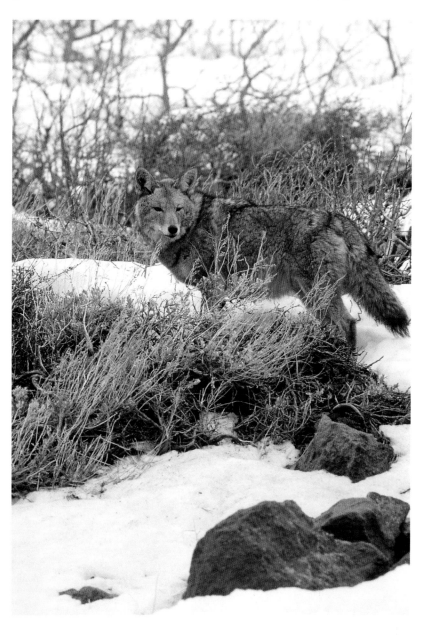

Does she have a thick coat or a thin coat? Watching such things as the density of winter coats on animals can clue you in as to whether it's going to be an early spring or not. The coat on this backyard coyote is dense, but not super thick, telling us that spring would be arriving around the normal time. Photo captured with Nikon F4e, 300mm f/2.8N AF at f/8, on Agfa RSX 100.

TELLING THE BIOLOGICAL STORY

why some years there is a great show and other years there's zip? A combination of rainfall in the spring and a cold snap in the autumn are the major factors. Generally, a severe cold snap is needed to send all the trees into changing the color of their leaves at one time to get that big, grand, fall show of color that film was made to capture. Keeping notes on these contributing factors can make all the difference in being prepared to capture it all or being disappointed with the autumn display.

The growth of most plants and wildflowers is linked specifically to climatic events. For example, some years poppies can carpet the California landscape to the horizon in the spring, while other years (normally dry ones) none can be found. This is an indicator of the severity of the temperature and the amount

of rain that has fallen over the past winter. It foretells of other plants' success or failure during the spring. It also foretells the fate of animal life. For example, when there are few poppies it is likely that small mammals will also be few in number, and that in turn tells us that raptors might have a tough spring raising young. The young will be in the nest earlier in this scenario than in a good year. All these hints regarding what will unfold in spring came from observations made of one plant.

But how can all this detective work and note-taking benefit your photography? There are many, many ways, depending upon where you are in your photography. How many of you work a regular job all week and must plan your vacation time way in advance? Ever plan your vacation around a certain event, such as migrating cranes or fall color, only to find when you arrived that the dates you selected six months earlier were too early or too late? How about planning simple events for the coming weekend? Should you mow the lawn and watch football or is now the time that warblers are moving through the area on their southward migration? Or is the favorite plant of that butterfly you've always wanted to photograph blooming or still just in bud?

What if your thing is nesting birds? Unless you spend lots of time in the field, you probably won't know when the birds have come back from migration to nest. Furthermore, you probably won't know if they're on a nest or feeding young without actually spending hundreds of field hours watching through binoculars. But just as Mr. Craighead illustrated, knowing what's happening by noticing a couple of environmental indicators can make the difference. It helps assure that your time spent in the field looking for a nest will be rewarding. And if you've done much work photographing nesting birds, you know that economizing on the amount of time spent in the field is a big factor in your success. Having a better understanding of the timing of these events each year cuts down on field time

This Yellowstone bull moose was photographed as it was walking through a meadow near a creek. We had seen him hours before and knew that he would eventually walk up the creek. So we went upstream and waited for the moose to come to us. This is an example of how you can use your understanding of basic biology to get close to wildlife. Photo captured with Nikon F5, 600mm f/4 AF-I, on Agfa RSX 100.

dramatically! (Of course, you still have to know where to look for a nest to find it. Check out Chapter III.)

Does all this take you away from being a photographer and make you into a biologist? No, quite the contrary, it probably makes you a much better photographer because you'll know and understand basic biology. I had an English teacher who always said, "In order to write about a subject, you must first know it well." Nature photography is no different, as the greatest rewards come from putting in the time to really get to know your subject.

This does not have to make you a paper junky either. I write my field notes in a diary format in my computer. Some just keep notes in a well-used, water- and sweat-stained, tattered notepad, while others have made elaborate computer data base programs to keep track of all the data they collect. You can make phenology as simple or as complex as you wish. (Keep in mind that after a decade or two, you too could publish a book of your observations like Mr. Craighead did and not only share your knowledge, but also get paid for it!)

Phenology can be applied to any new equipment that manufacturers might dream up and tempt us to buy. That's because it's not the camera that takes the photograph, but the person behind the camera that counts! Phenology makes us better people and better photographers, because instead of chasing down nature with our cameras, we're part of it as we tell its story. Without knowing there was a term to describe it, I've used phenology in my work ever since I started more than a decade ago. It's an integral part of my everyday life and could very well account for what many say is my natural karma with wildlife. Whatever it is, isn't it nice to know that in this day and age when technology grows by leaps and bounds, we can rely on old standards such as phenology to carry us through no matter how the winds of change may blow!

I have no doubt that many of you are already shooting species and/or topics based on the seasons. Fall color and wildflowers are probably the first examples of this that pop into everyone's mind. But I would also guess that you have missed, even if just subconsciously, many seasonal events in your own backyard.

Is it gathering food or nesting material? Part of knowing the answer is understanding the subject's habits and its biological cycle. This greater sandhill crane was photographed at Bosque del Apache National Wildlife Refuge, New Mexico, its wintering grounds. Nesting will occur in the spring when it migrates to the tundra. Researching the subject's biology helps you be in the right place at the right time for shooting the behavior you want to capture. Photo captured with Nikon F4e, 800mm f/5.6 at f/8, on Agfa RSX 100. (P)

TELLING THE BIOLOGICAL STORY

We have visited this enchanting Pacific loon on many occasions, although she is usually just sitting on her nest. We'd spend only ten minutes with her each time, and even though we got the same photo on every visit, we couldn't stop ourselves from going back. And just when we thought we'd seen it all, she stretched her wing, capturing our hearts and triggering our shutters. Photo captured with Nikon F4e, 800mm f/5.6 at f/8 with plus 1/3-stop exposure compensation dialed in, on Agfa RSX 100.

Seasonal Biological Stories—Birds

Birds are our best example and easiest subject for such a conversation. In the winter, the forests, meadows, grasslands, and gardens are quiet except for the few resident species that tough out the cold. Here the story starts, with these small little balls of feathers braving the elements. If you live in snow country, you'll want to photograph the birds in the snow. You can capture them scratching seed out of your snow-covered feeder. You can photograph them at your bird bath, which might have icicles hanging from the edge. If you're really lucky, you'll catch them with a large snowflake atop their head. (I've tried to get that shot; it's not an easy one.) This is the start of your winter bird story.

You have a solid start now. Spring is in the air and on the way. The snow has melted, the weather has turned pleasant, and the songs of birds fill the air. Time to go out and find the nest of the bird you photographed in winter. It's time to find those singing posts that the males use to attract a mate. It's time to find as many nesting birds as are needed to tell the story. Chapter III provides you with all the info necessary to make this happen. (But there's a challenge here that is greater than that presented in Chapter III. Whereas finding and photographing the nesting bird is the entire challenge in that chapter, in this chapter it is only part of the challenge. In that chapter the nest is the sole focus; in this it is only part of the story, a key element but not the main one.)

Summer comes, the spring growth now looks older, colors are not as defined. Baby birds are now out of the nest and exploring the world on their own. They're doing those things that juvenile birds do. Young birds often beg from their parents for a long period after leaving the nest. They do all sorts of things to get their parents' attention for a free meal. The young at this stage are more than capable of providing food for themselves, but when a parent shows up, they just can't help themselves. Typically, the young still have a slight yellow cast at the corners of their mandibles. So as you're out looking for more elements to tell your biological story, watch for birds with this yellow coloration, follow them, and be ready. I've seen much more action and comedy watching these little dudes than I've ever photographed. They can be seen hanging upside down, jumping up and

down from a lower perch over and over again as if on a trampoline, their wings flapping, doing just about anything to get their parents' attention and a free handout. These are all well within your photographic grasp.

Summer then moves into fall, leaves change color, temperatures drop, and birds react. The pace quickens as they fatten up for migration or winter's cold until this activity becomes a full-time pursuit. Hummingbirds are the first to head south (in my region) and slowly disappear. Of those species that stay, some start to aggressively protect their turf. Against the backdrop of orange, yellow, and red leaves, life changes. In the telling of the story, these fall signs are just as important as the birth of new life in the spring. We know that many of the birds leaving to go south

I was very fortunate to have had a couple of days to photograph this northern pygmy owl. Despite its being smaller than a dollar bill, this little dynamo can take prey the size of a quail. Over the course of two days I was able to photograph many aspects of its behavior, which provided me with an excellent photo essay on its daily life. Close-up captured with Nikon F4e, 800mm f/5.6 at f/5.6, on Fuji 100. Photo below captured with Nikon F4e, 300mm f/2.8N AF at f/5.6, on Fuji 100.

will not return. Be it due to age, inexperience, or bad luck, many of those you've focused on during the spring and summer will not be back.

The first dark clouds of winter roll in and the ballet of snowflakes again begins its dance among the trees. Life has come full circle and you've photographed it all. If you've done your homework and followed through with good plans, you saw this entire circle of life transpire in your own backyard.

I've glazed over a lot here, but you get the idea. Life travels through season after season, presenting us with incredible photographic opportunities if we just take the time to see them. Looking at the whole story as opposed to the individual events brings a whole new realm of possibilities to our photography, and with it, new meaning. But birds don't have to be your focus, there are plenty of other animals to keep your camera clicking.

Seasonal Biological Stories— Mammals

It takes a little more effort and a higher degree of expertise and commitment, but you can do the same thing with mammals as well. Select as a subject a small mammal that hibernates or stays underground with a cache of food. (I wouldn't recommend trying this with a mountain lion, if you get my drift.) Your best bet of course is to use a tank in which you can watch the animal's activity, or lack thereof, and take photographs when the opportunity arises.

Here's the secret of doing this. You need to provide your little critter with a home in which it can hibernate or sleep. Typically, these little dudes live in a burrow or tree hollow of some sort. You can make your own, though, one that they can feel safe in and be used for photography at the same time. Start with a balloon that, when blown up, is the appropriate size for the critter (you'll have to do some homework to determine the properly sized home for your subject). Then take a cardboard tube (a paper towel roll will do), and cut two 3-inch sections. Tape them to either end of the balloon. These function as entrances to your artificial den. Now if your little critter lives in a grass home, cover the balloon with dried grasses. If it makes a nest of leaves, cover it with leaves, and so on, depending on the required habitat. Cover all

Nestled in for the winter, this great basin pocket mouse has it made. It's in an artificial home I made for it, tucked away safe and warm in my garage, out of the snow and out of harm's way. Photo captured with Nikon F4e, 60mm f/2.8 Micro AF at f/11 with flash as main light, on Fuji Provia 100. (C)

but a small portion of the side of the balloon with plaster of paris. The plaster will keep the grass or leaves in place. The uncovered portion will be your window for photographing into your subject's home, so make the opening no smaller than the filter size of the lens. When the plaster is completely dry, pop the balloon and remove it from the artificial burrow. You now have a picture-perfect home for your little critter. Place this inside the tank, with the picture-taking opening next to the glass, and you've got it!

Place the tank in an unheated but sheltered location (such as a garage or barn) where the animal can react naturally to the changes in temperature and day length. This will ensure that its hibernation begins and ends as nature intended. Not only will you get great pictures chronicling your critter's life during a stage that most people never get to witness, but you can also read the little guy's behavior and foretell the season's changes.

Photographing life in this way during the winter is the easiest way to capture it on film. Some might find holding such a little critter captive all winter to be cruel (check with local wildlife laws before doing this). But the odds that the little critter awakens safe, warm, and with enough fat reserves to start off healthy in spring after being kept in captivity puts it way ahead of the rest who braved nature on their own. Once you release your little critter after its long winter sleep is when your work really begins.

With the warmth and new growth of spring come the annual mating rituals of most small mammals. The combination of their small size, outrageous energy levels, exuberant love of life and fun, and the driving motivation of mating, makes for a subject that never, never holds still. Looking out my office window I have watched chipmunks run miles in just a minute's time while never leaving my front yard. Then, all of a sudden, two come together seemingly from nowhere. They burst up a tree and out onto a branch, their tails twisting and waving as they tell each other something. Then they come together for a mere second, touch noses, and wag their tails in young love delight. I haven't captured that part of their biological story on film yet. As you can imagine, it's a real challenge.

With spring growth well established, some of the squirrels, chipmunks, and other animals disappear. They're off giving birth. Where are you? Well, being a smart photographer who has done your homework and fieldwork, you should know exactly where new life has begun. Another key element of the story is at hand. If you're lucky, the chipmunks have denned in one of the special birdhouses you've put out that you can photograph through the sides (and not in your log pile, as happened to me this year). If you're even luckier, the chipmunks are in a natural cavity in a hollow log you've hung out for their use. Of course, you've modified this cavity for photography (not an uncommon practice).

Whether you're privileged to photograph the young in their nest or not, you're prepared for when they first emerge from their home into the big bad world. Then you watch and photograph them during the summer and fall as they grow and put on fat for the coming winter. For those species that build up a cache of food, photograph the process of them filling their cheek pouches and running back to their burrows to tuck away their prize. You're there with your camera to capture and tell their biological story. Perhaps you catch the first flakes of snowfall resting on the heads of your little friends. It signals the time for them to go into their safe, warm homes and another year gone by for us.

These are just some examples of telling the biological story through the eyes of one critter over a year's time. There are many more ways to tell this story. For those who live where there is no snow, fall color, or obvious change in the seasons, your challenge is to find other ways of capturing the seasons of life. That is really a greater and grander challenge.

Field Tip

During true hibernation, mammals do not eat or drink, but rely on stored fats to make it through their sleep. Prior to hibernation, though, they consume incredible amounts of food, putting on fat for the winter. If you have a small mammal in captivity during this time, you must provide it with simple foods, such as generic bird seed. Put a pile of seed and some water in the tank with the critter and keep an eye on it. When the food disappears, keep replacing it until one day, it doesn't disappear. Then you know it's time for the critter to start its long winter nap.

TELLING THE BIOLOGICAL STORY

It's moments like this, when you see your subject's life unfold, that are the most rewarding, whether you catch them on film or not. Photo captured with Nikon F4e, 800mm f/5.6 at f/8, on Fuji Provia 100.

The Story of My Foxes

Until recently, I lived in such a land, a land of no seasons. Time seemed to pass slowly, with seasonal changes made apparent only through observing the surrounding wildlife. Maybe that's why I was first drawn to my friends, the San Joaquin kit foxes. Doing my homework before ever photographing them at a den was a depressing task. This endangered species had traveled a hard road that was only getting more difficult with each passing day. Despite the pressures and negative publicity associated with the fox, the species persisted to survive to some extent right along with man. This was the status of the San Joaquin kit fox when I first began working with it in 1986.

The San Joaquin kit fox, just slightly larger than a house cat, lives in the grasslands of California's central valley. This is a desert habitat minus the cactus, but not without the heat or lack of water. I had seen one or two here and there, but never one that could be photographed, as they were busy avoiding confrontations with man. While working with biologists, I was introduced to my first den site. It was springtime, the only indications were a slight green tinge to the grasses and a mild temperature of only 85° rather than 105°. While staring through my 800mm lens, I saw my first kit fox pup peer out of the den entrance. Those big eyes took in the world as if it were a grand and glorious place that belonged to no one but him. I was hooked.

Recording the biological story of this critter on film is a challenge that is taking me into my eleventh year. Photographing life at the den, when new life is exploding with youthful energies, is the easy part. Communicating that it's wintertime in a world of brown dirt is

Sensing a movement in the grass, the young pup imitates its mom to see what's there. Every waking moment is a learning experience for him, which, if not mastered, could mean death. These foxes must face many obstacles while growing up. Photo captured with Nikon F4e, 800mm f/5.6 at f/8, on Fuji Provia 100.

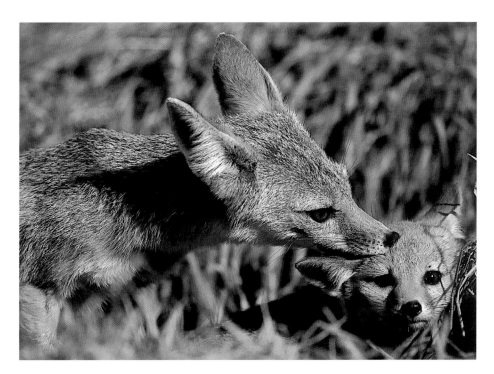

"Aw mom, do you have to do that now? He's taking my photograph." The interaction between young and old is what I wait to see unfold before my lens. This window into these foxes' biological world is not only a great photo op, but a sign that they accept my presence. Photo captured with Nikon F4e, 800mm f/5.6 at f/8, on Fuji Provia 100.

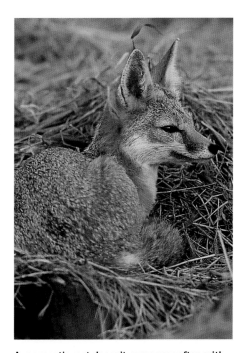

A moment's rest doesn't come very often with pups around. This endangered San Joaquin kit fox vixen rests near the entrance of the den to watch for predators and to nursemaid her young pups while they are out playing in the fleeting sun. Photo captured with Nikon F4e, 800mm f/5.6 at f/8, on Fuji Provia 100.

not too difficult because the foxes are adorned in their warm, thick coats. But all the parts in between are the real challenge. During the year, these foxes might visit each of their 40-some-odd den sites only twice. They're nocturnal, so the majority of their hunting is done under the cloak of darkness. And they are an endangered species, trying to eke out a life while their very homes are being displaced by those of man. Some of the foxes' story is amusing and heartwarming; the death of a pup or the destruction of a den site, depressing. All of it makes up the larger life story of the San Joaquin kit fox.

This biological story is just one of more than two dozen that I have started and worked on over the past decade. I have captured so much and yet so little. The rewards are greater than can ever be expressed in words, the challenges greater than any others I've put before you. And the best part is, it's not over, because with every passing moment, with every season, come new challenges and chapters to add to the story. These lessons that I'm trying to express to you here are what this little fox has taught me. It's a challenge from nature, to which we owe so much.

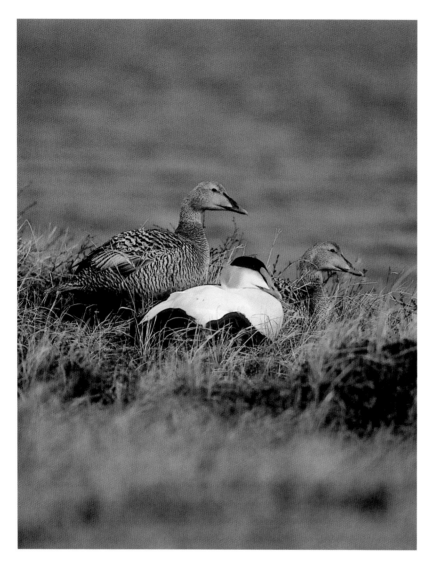

These "tugboats," common eiders, ride the tides back and forth on the Churchill River. During the nesting season they gather in groups to attract a mate. Most of all, they like to stay away from photographers. But this male and two females were so involved with courtship that they let their guard down and let us get close. Photo captured with Nikon F4e, 800mm f/5.6 at f/5.6, with plus 1/3-stop exposure compensation dialed in, on Agfa RSX 100.

Luck by Design

Focusing on just one subject or species to tell a biological story just might not be possible. Be it your occupation, location, or any number of other possible factors, it's not always feasible. But that doesn't mean you can't focus on smaller snippets of the biological story and capture them on film. The challenges of telling locational biological stories are just as difficult, if not more so, because they're not right outside your door. There are thousands upon thousands of examples, most of which I still have not personally photographed. But this doesn't mean we can't have them in our sights. For example, I've yet to witness or photograph the spectacle of the

magnificent grizzly on its annual fishing trip standing in the rushing water of an Alaskan river. This is just one example of a locational biological story still looming on the horizon for me.

There are two examples I'd like to propose here to get your gears in motion. They are more typical of situations that most photographers find themselves in these days, traveling to a new (or old) locale for a week of intense photography. These trips are commonly photographic workshops like the ones I conduct around the country. Workshops are typically held in glorious locales such as Yellowstone National Park, Wyoming; Churchill, Manitoba; or Bosque del Apache National Wildlife Refuge, New Mexico. I want to start you thinking about your next workshop or week-long destination with a slightly different slant, exploring prospective photo locales with a different perspective than you might have had in the past. It all has to do with telling the biological story. Let's start with Churchill, Manitoba.

Churchill

What was the biological story I wanted to tell about my trip to Churchill? Deciding on that was the easiest part. When I told folks I was going to Canada, they always asked, "What part?" When I said Churchill, they said, "For the polar bears, eh?" Although I was able to hug a live, wild polar bear on my trip, I actually went to Churchill to photograph its nesting birds. The one thing I wanted to come back with was a body of images that showed that Churchill was more than just a place for bears. Churchill is unique in that it is the southernmost breeding area for some bird species, the northernmost for others, and the only breeding ground for a couple of others. The amazing thing and the hardest concept for folks to realize is that the "flat" tundra, with all its water and mosquitoes, is the most biologically conducive habitat for many birds to raise their families in.

What a spectacle of bird life! During the time we were there (the month of

June), we saw 70 species of birds and photographed 40! In being able to tell the biological story of the Arctic nesting bird, we couldn't have asked for more. But before venturing to this land of Oz, some homework had to be done.

First I went on-line and read all the information I could find on the subject of Arctic nesting birds. Then I talked with some friends who had had limited shooting time with these birds. I also went through my video library and viewed programs on the Arctic that I had taped off the television. This is very useful for seeing what the conditions could be and understanding a little better what to prepare for, environmentally and photographically. And finally, I started reading all the books I could on the topic.

I knew I would be seeing and photographing birds I had never seen or photographed before. I was excited because I was heading to Churchill with the goal of telling a story. The photographic opportunities were endless, not limited strictly to photographing nesting birds. When your goal is to tell a story, you go out on location each day focused on particular topics—chapters of the story you want to tell. This places you in situations that might never be encountered merely by stepping out of the car and shooting whatever comes in front of the lens. It's luck by design.

I was fortunate that I was able to spend three weeks in Churchill. This small window of time was the most critical for some of these birds. By the time we arrived, most of the birds had already been at Churchill for a week or more. They had already selected mates, mated, and some had even built a nest. Most were just laying eggs. It was amazing that just three weeks later birds were already congregating to migrate south. Three weeks—that's mind-boggling! If you want to spend just a little time to tell a bird's biological story, this is the place to go.

On our first week, we traveled about exploring the different habitats and looking for nests. It was interesting that during the first week, some birds

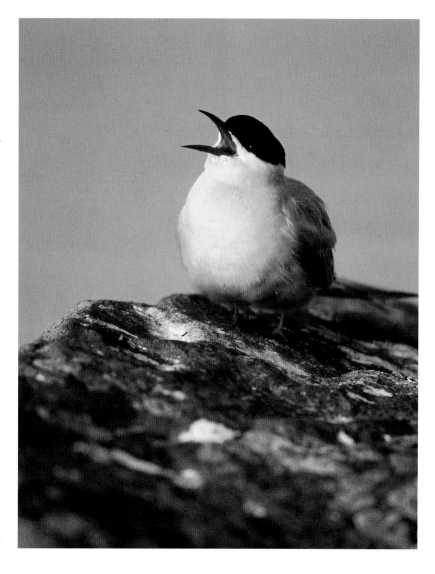

that I thought would be common and easily seen were actually hard to find. The best example of this was the willow ptarmigan. During the first week we saw one or two, but never had any photo ops. The second week, the place was crawling with them. We shot them up, down, sideways, and any other way we could. The third week we saw none. We weren't traveling to different places, nor had the weather gotten any better, they just were not out.

Our photographic setup for shooting during the three weeks really wasn't all that complicated. I usually shot with my 800mm f/5.6, Nikon F4e, and at times with a Speedlight SB-24 flash with a Better Beamer attached. Sometimes, when I wanted to photograph different

Mouth open. This is oh-so-typical for Arctic terns. They call all the time—in the air, on the nest, with a fish dangling from their bills— they never shut up. But that's part of their charm, and plus, after a day or so, you're deaf and can't hear them anymore, anyway. Photo captured with Nikon F4e, 800mm f/5.6 at f/5.6 with plus 1/3-stop exposure compensation dialed in, on Agfa RSX 100.

TELLING THE BIOLOGICAL STORY

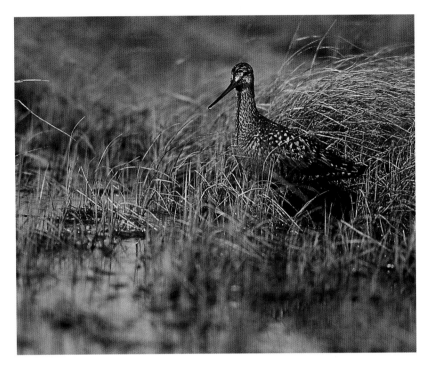

I felt fortunate to have gotten this photo of a female Hudsonian godwit on a trip to Churchill, Manitoba. However I didn't get the much-prized photo of the male. That just gives me a good reason to go back. Photo captured with Nikon F4e, 800mm f/5.6 at f/5.6, on Agfa RSX 100.

aspects of the story, I used different lenses. I shot the entire time with matrix metering, except when I used an 8mm extension tube. (The camera automatically switches to center-weighted metering with it attached.) And depending on the subject, lighting, and elements I wanted to include, I dialed in the appropriate exposure compensation.

What follows are some examples of the lens choices I made. We were privileged to photograph a magnificent parasitic jaeger's nest (see pages 63 and 65). I captured beautiful head shots, flight shots, and wing stretches with my 800mm. The pair tolerated our presence with ease, so obtaining these shots was really a matter of being at the right place at the right time. But I wanted more; I wanted to communicate the grace and care with which these birds tended their eggs. So I worked my way up to the nest until I was a mere three feet away. The female, who was incubating the eggs at the time, just sat there as I approached. My goal was to get photos of her softly landing at her nest, with her eggs in the photos as well. Now the very nature of jaegers is that they are in the air often, so I knew that to get my shot I wouldn't have to

do anything other than wait. And just a few seconds later, the female was off the nest chasing away a herring gull. She came back in a short time and softly landed on her nest, my 35-70mm f/2.8 set at 35mm capturing every graceful wing beat as she settled into place.

The Arctic terns are another fine example. These characters are just that—characters. Considering their long migration from the Arctic to the Antarctic, it's a wonder that these little puffballs do it. As they dive-bomb you and pound your head as you get near their nest, their fierce determination to defend their young is startling. And when you see them hover in the afternoon sun and breeze, their simple elegance is truly inspirational. Documenting all of this on film took more than just being by a nest site for awhile. It required photographing all that I've just mentioned and more. It meant photographing them feeding as they wrestled with the jaegers to keep their meal and capturing their simple elegance in the day's last rays of sun.

How did I convey that it was spring in my photos? Plumage. In spring birds always dress in their best colors to impress their mates. Shorebirds especially get all duded up, and the parade of color in Churchill was staggering. To make sure this was clearly communicated, though, I had to have photographs of these birds in their fall plumage as well, otherwise someone who didn't know birds might think they look this way all the time. So some of the story of Churchill's nesting birds wasn't taken at Churchill.

Other ways that communicated that I was there in spring were the lack of snow, which was easy, the presence of wildflowers (in profusion), and the baby birds (hard as heck to photograph). Shorebirds have young that are precocial. This means that as soon as they hatch and are dry, they are out of there. They kind of hang with mom and dad, but otherwise they are on their own. Heck, mom and dad don't even wait to migrate with the kids, they head south

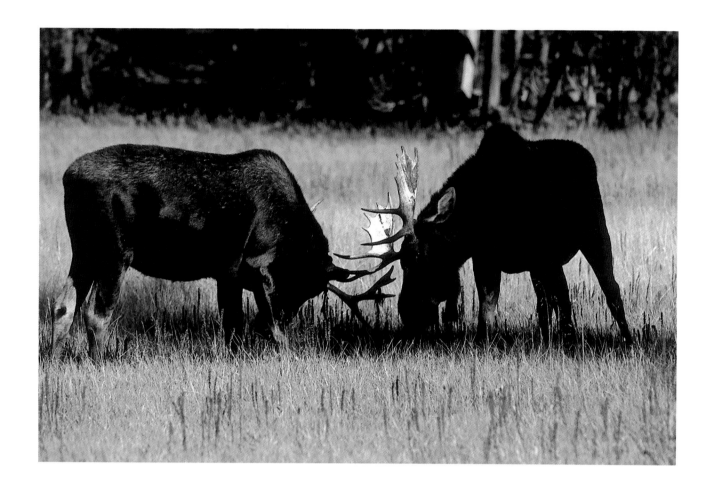

weeks before the kids do. Well, these little guys are so well camouflaged that we saw them only on a couple of occasions. And when we did see them, they zipped through the tundra so fast we couldn't catch up with them. (That's OK though, as it gives me a good reason to go back and finish the story.)

So after three weeks and shooting 200 rolls of film, did I get the biological story? Not the whole thing. I did accomplish much of what I was after, but I missed all the young that ride on their parents' backs, such as the Pacific loon and horned grebe. I also missed the first wave of birds that show up in Churchill in the spring when there is still ice everywhere. Many of these birds are there only briefly before heading farther north. However, I did capture much of the biological story on film, enough to accomplish what I set out to say, that Churchill is much, much more than a home for polar bears.

Yellowstone

I honestly don't think that any place on Earth is as visited by cameras as Yellowstone National Park, Wyoming. While we photographers can recognize a Yellowstone photo as such, there is still a magic, a presence that draws us back over and over again. I have seen some documentaries on television that do an excellent job of telling the Yellowstone biological story, but they seem to fall short in those 53-minute segments. But I haven't yet seen excellent still photo coverage of Yellowstone. Granted it's a huge place, and some of the most incredible images I've seen were taken within its borders, but I haven't yet seen the complete story or coverage of specific stories.

When folks think of migration, they typically picture birds flying overhead. They don't think of the bison and elk herds that move out of the Greater Yellowstone ecosystem and head south to Jackson, Wyoming. Most folks are

Yellowstone has so much to offer photographers, especially the ones that use their knowledge of basic biology to find their subjects off the beaten path. These young bull moose are taking out their fall aggressions on each other. This mock battle had no winner, except for me, who, thanks to "luck by design" was in the right place at the right time to catch the story as it unfolded. Photo captured with Nikon F5, 300mm f/2.8N AF (no exposure compensation), on Agfa RSX 100. (P)

TELLING THE BIOLOGICAL STORY

Places such as Yellowstone National Park provide us with the opportunity to capture on film biological phenomena that most people never get to witness. Here a Rocky Mountain elk stands with velvet dripping from his rack. Photo captured with Nikon F5, 300mm f/2.8N AF (no exposure compensation), on Agfa RSX 100. (P)

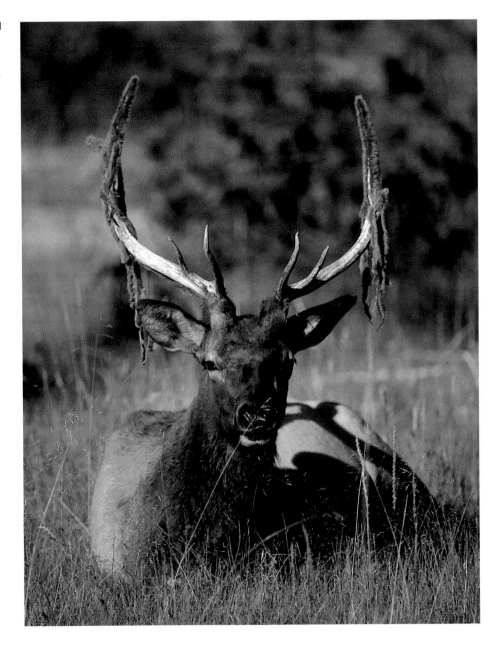

under the impression that the entire park's population of these species just hang around the geysers and hot pools all winter. I've seen and taken magnificent photos of the Rocky Mountain elk that call the park home. But I haven't taken or seen their biological story on film. Here's a species that is normally completely wary of man, but in this park setting, they come up and kiss your lens. Imagine having the opportunity to capture one year in the life of a bull elk!

Start in the spring when the calves are first born. The young bull calf has

no idea what life has in store for him or the rites of passage he must endure. He lives for a number of years, growing, gaining stature, and finally taking his place in the ranks of the herd. During this time, he has probably had to endure the hardships of a few Yellowstone winters, an attack by a wolf or grizzly, and the harassment of tourists' cameras. Then comes the spring when the bull has come of age and he starts putting on fat for more than the hard winter to come. At this same time, his rack is growing back after being shed, bigger and wider than ever. He grazes

in the same loose bachelor group with which he has always spent the spring and the summer, but there is something different. By mid to late June, his rack has gained considerable size, but is still wrapped in its soft velvet sheath. Then comes fall when he must strut his stuff.

On a cold, frosty fall morning, he announces he is ready to join the mating ritual. Lit by the sun against the shadow of the pines, his breath can be seen in the morning light. As he bugles, he looks and sounds like a dragon. And in a short time, he is doing battle with another bull, pushing and shoving, trying to command the high ground for the reward of having more cows in his harem. This whole life sequence is but a part of the biological story played out year after year in Yellowstone literally right outside your car window. With a topic this grand and remote to most folks, it is impossible to plan on capturing it all in one visit. But it can be done in segments over time.

This is barely a drop in the geyser when it comes to photographing Yellowstone. Strictly from a business standpoint, just imagine the photographic files you would have if you had all of Yellowstone on film: coyotes catching voles in the snow-covered fields with Old Faithful blowing in the background, pikas on a talus slope with their mouths full of grasses they are storing away for winter; trumpeter swans floating on Indian Pond with their young on their backs; plus the bighorn sheep, pronghorn, eagles, ospreys, and every other small critter that makes Yellowstone its home. Think of this story still waiting to be exposed, on film, in print, and to the public! All this, and we haven't even mentioned geysers!

The Habitat Story

If I have a forte, it's including the species' world in a photograph. This comes directly from my desire to communicate through my photography that wildlife has a unique home on which they depend. Without that home, there is no wildlife (and that's the reason there are endangered species around the globe). The definition of the word "home" in biological terms is "habitat." And the habitat story is a complicated, beautiful web of life in which anything you might focus on is an important element. And we're not talking landscape photography here, folks.

In *NWP*, I devoted a whole chapter to getting physically close to the subject. This might lead some to think I'm an "eyeball" photographer, striving to capture only head shots. Actually, the goal and style of my photography is to relate the subject to its world, communicating those qualities that make it unique. What some might label as landscape photography, including the world that's home to the wildlife adds a new dimension to the plop-down-the-tripod scenic. This shouldn't be misconstrued as a cop-out for not getting close-ups of wildlife. This is a style of wildlife photography rarely thought of and even more rarely pursued. It's a style of photography that requires every ounce of talent and equipment one has!

Environmental portraits are just as challenging to take as tight portraits, if not more so. There are more elements to deal with in environmental portraits. Mammals and birds tend to always be on the move, causing composition to be, well, frustrating at best. And since the wildlife is an element of the photograph and not the main subject, making it pop can be a tremendous challenge. Some of the greatest rewards for the viewer though come from those photographs in which the wildlife is so much a part of the scene that finding it is a grand surprise. What elements make a wildlife photograph an environmental portrait? Can one pursue this type of wildlife photography and be successful in capturing those "once-in-a-lifetime" portraits? Indubitably!

Actually, any lens one has in a camera bag can be the perfect one for this type of photography. But most tend to use either wide-angles or telephotos, which are my preference as well. These two extremes of picture angle can

Mule deer are easy subjects to photograph in Yosemite. When you have the chance, practice or perfect your technique of capturing more in a photo than just a head shot. When working with wide-angles, you need to get physically close to the subject and be careful to exclude undesirable or distracting elements. Don't think that just because you're not capturing head shots that environmental portraiture is easy. Photo captured with Nikon F4s, 20mm f/2.8 AF at f/16, on Fuji 100. (P)

communicate totally different messages about the same scene. Understand that the wide-angle lens (in the range of 18-35mm) creates a visual space between elements in a photograph, separating them by distance. The telephoto, on the other hand (200-800mm range), visually compresses elements in a photograph, stacking them on top of one another.

When we think of photographing a scenic, wide-angle lenses automatically pop into our heads. They have the majestic picture angle that takes in our entire world. And while taking in so much, they also reduce the physical size of every element in the final photograph. Every element takes up a very small percentage of the picture frame area. This can put our subject on the same visual level as any other small element, reducing its impact. So with wide-angles, getting physically close to increase the subject's size relative to its

surroundings can make all the difference in the world.

Photographing mule deer in Yosemite Valley with a wide-angle lens lends itself to environmental portraiture. Yosemite Valley is a place where even a 13mm cannot capture all of the valley's magnificence. Photographing mule deer in a meadow at the base of the valley's granite walls screams for a wide-angle lens. Like wildlife in most state and national parks, these deer permit one to get closer than normal. (They're still wild, though, and should never be approached within ten feet.) They tempt one to get out the telephoto for those extreme close-ups. But by getting down low and close with a wide-angle you can capture the deer grazing in the warm morning light while giving height to the massive granite walls in the background that say, "Yosemite!"

A wide-angle can have an angle of view of 94°, a telephoto, just 6°! With a

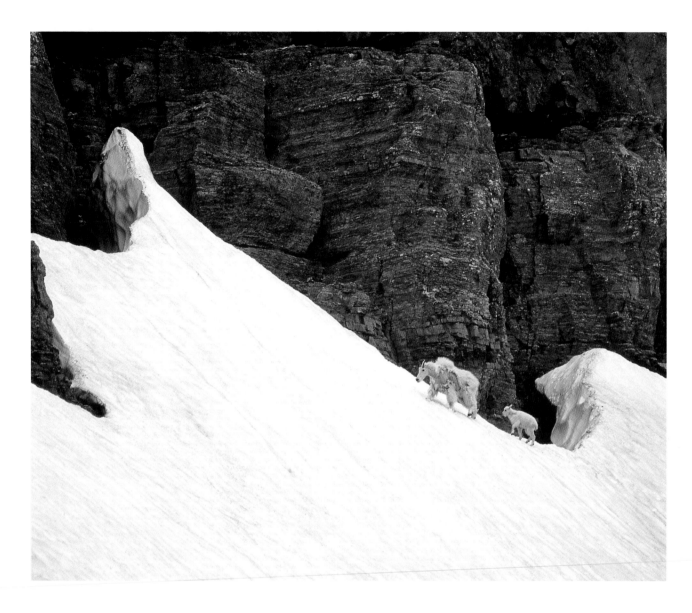

telephoto, the slightest change of the lens either left or right, up or down, can radically alter the composition of a photograph. This incredible tool gives you the ability to take the exact same scene, but in one instance place the main subject in front of mountains and in another in front of the vast expanse of the prairie. This gives you the ability to completely change the message of your photograph. Understanding angle of view is important; using it to better communicate is imperative.

The choice between using a wide-angle or telephoto lens is governed in large part by the subject and its environment. There are too many rules of composition to write here—so many

that they normally scare folks off. Those rules are important, but like all rules in photography, they are meant to be broken. They're best broken when the elements of lighting and background combine to make the subject *pop!* The successful combination of lighting and background creates visual depth and drama in a photograph, two winning elements. This quite often determines which lens should be used.

The mule deer in Yosemite are a great example. The tan color of the deer helps them stand out from the green grass while tying them to the warmth of the light. Color contrast is one of the main ways we have of making subjects pop away from

Wildlife constantly strives to seek better conditions in the basic struggle of daily life. Wildlife photography is no different. It can be seen as a trudge up hill or an ascent to better lands. We learn something every day while working to improve our craft. Photo captured with Nikon F4e, 800mm f/5.6 at f/8 with plus 1/3-stop exposure compensation, on Fuji Provia 100. (P)

backgrounds. When we see dark elements in front of light or light elements in front of dark in a photograph, our eyes are automatically drawn to these contrasts. It's important to understand that these contrasts need only pertain to the subject and not the entire photograph. It's also important to realize that we're not discussing exposure contrast, but color and tonal contrast.

This brings us to the importance of the background. Environmental portraits need backgrounds that provide visual depth, conveying a sense of space. Bringing visual depth to the photograph through fore-, middle-, and background; adding drama through lighting, both ambient and flash; using filters; and applying many other techniques have not even been discussed. But as one masters environmental portraiture by meeting the challenge of perfecting these beginning techniques, a whole new world of wildlife photography unfolds—a world that's as grand and unlimited as the wild heritage that is ours to enjoy and capture on film! Through our photography we are uniquely able to preserve and reveal to others just how grand our wild heritage truly is!

The Technical Stuff

Looking for the technical info to capture this all on film? Within this and my first book, *Nikon Guide to Wildlife Photography*, I have provided you with all the information you need to accomplish everything I've talked about here. With the tools I've provided and others that are available to you, there is nothing you can't do. It's time to pack it all up, load it in the car or plane, and hit the ground running. The only thing left for you to do is experience it and capture what you see on film for others to enjoy.

Is There an End?

Hell no! Every time we step out of our front door, camera in-hand or not, the challenge is laid down before us. In the introduction I wrote that the one thing that makes the greatest difference in your success as a wildlife photographer is passion.

As you might imagine, during the process of writing this book, I learned more new tidbits to share with you at a future date. New techniques, equipment, biological knowledge, and passion filled my adventures and these still must be revealed. And likewise, you have your own path to forge.

I'm often reminded by a close friend just how fortunate we photographers are to be able to do what we do. The challenges, experiences, rewards, and photographs that await us are beyond our imagination. Grasp your camera, throw open that door, and venture out. Let the wonders of our natural world fill your viewfinder and your heart. May all the rewards these passions bring fill your day!

Appendix A

Resources

Reference Books and Periodicals

Birder's World
44 East 8th Street
Suite 410
Holland, MI 49423-3502

The Bird's-Eye reView
National Bird-Feeding Society
P. O. Box 23
Northbrook, IL 60065-0023
(847) 272-0135

Bird Watcher's Digest
P. O. Box 110
Marietta, OH 45750
(614) 373-5285

The BT Journal: The Wildlife and Technical Journal for Wildlife Photographers
B. Moose Peterson/Wildlife Research Photography
P. O. Box 3628
Mammoth Lakes, CA 93546-3628
(760) 924-8632

The Complete Birdhouse Book
Donald W. and Lillian Stokes
ISBN 0-316-81714-7

Complete Guide to Bird Feeding
John V. Dennis
ISBN 0-679-75052-5

Conservation Biology
Blackwell Science Inc.
238 Main Street
Cambridge, MA 02142-1413

Ecology
The Ecology Society of America
2010 Massachusetts Ave, N.W.
Suite 400
Washington, D.C. 20036

For Everything There Is a Season
Frank C. Craighead, Jr.
ISBN 1-56044-187-9

A Field Guide to the Nests, Eggs and Nestlings of North American Birds
Colin Harrison
ISBN 0-82890-532-0

Life Histories of North American Birds Series
Arthur Cleveland Bent

National Geographic Field Guide to the Birds of North America
ISBN 0-87044-692-4

Natural History
American Museum of Natural History
Central Park West at 79th Street
New York, NY 10024-5192

Peterson Field Guides
Roger Tory Peterson
(Such as *Field Guide to Eastern Birds*,
ISBN 0-395-36164-8; and
Field Guide to Western Birds,
ISBN 0-395-51424-X)

Readers' Guide to Periodical Literature
ISBN 0-685-73473-0

APPENDIX A

Journals in Which You Can Find Biologists and Biological Information

American Midland Naturalist
Department of Biological Sciences
University of Notre Dame
Notre Dame, IN 46556

AUK
Condor
Journal of Field Ornithology
Wilson Bulletin
Ornithological Societies of
North America
P.O. Box 1897
Lawrence, KS 66044-8897

BIRDING
American Birding Association, Inc.
P.O. Box 6599
Colorado Springs, CO 80934

California Fish and Game
California Fish and Game
4001 North Wilson Way
Stockton, CA 95205-2486

Canadian Field-Naturalist
The Ottawa Field-Naturalists' Club
P.O. Box 35069
Westgate P.O.
Ottawa, K1Z 1A2
Canada

Endangered Species Bulletin
School of Natural Resources
and Environment
The University of Michigan
Ann Arbor, MI 48109-1115

Great Basin Naturalist
Brigham, UT 84602

Journal of Mammology
American Society of Mammologists
c/o Department of Zoology
Brigham Young University
Provo, UT 84602

Journal of Raptor Research
The Raptor Research Foundation, Inc.
14377 117th Street South
Hastings, MN 55033

Journal of Wildlife Management
The Wildlife Society
5410 Grosvenor Lane
Bethesda, MD 20814-2197

Living Bird
Cornell Laboratory of Ornithology
150 Sapsucker Woods Road
Ithaca, NY 14850

Pacific Seabirds
Pacific Seabird Group
Oregon Institute of Marine Biology
University of Oregon
Charleston, OR 97420

Southwestern Naturalist
The Southwestern Association of
Naturalists
Department of Biology
Southwest Texas State University
601 University Drive
San Marcos, TX 78666

Western Birds
6011 Saddletree Lane
Yorba Linda, CA 92686

Wildlife Information Web Sites and E-Mail Addresses

Audubon Society
http://www.igc.apc.org/audubon/

Birdlinks
http://www.phys.rug.nl/mk/people/wpv/birdlink.html

Ecology Channel
http://www.ecology.com/index.htm

EcoNet Endangered Habitats & Species
c/o IGC: Habitats & Species: Internet Resources Collection
http://www.igc.org/igc/issues/habitats/

Endangered Species Recovery Program, San Joaquin Valley
http://arnica.csustan.edu/esrpp/

EnviroLink
http://envirolink.org/

Facility for Animal Care and Treatment
http://www.csubak.edu/FACT/index.html

National Parks and Conservation Association
http://www.npca.org/

National Wildlife Federation—Endangered Species
http://www.nwf.org/nwf/about/species.html

Natural Resources Defense Council
http://www.igc.apc.org/nrdc/

The Nature Conservancy
http://www.tnc.org/

B. Moose Peterson/Wildlife Research Photography
Email: moose395@qnet.com
http://www.av.qnet.com/~moose395/

Sierra Club
http://www.sierraclub.org/

WindStar Wildlife Institute
http://www.lightlines.com/wildlife/

E-mail Journal

WILDLIFE ECOLOGY Digest
kingfshr@northcoast.com

Appendix B

Equipment Sources

Better Beamer
Arthur Morris/Birds As Art
Dept. MP
1455 Whitewood Drive
Deltona, FL 32725
(407) 860-2013
Fax: (407) 574-5584

Nesting Boxes
Avian Habitats
4678 Almond Drive
Templeton, CA 93465
Phone and fax:
(800) 585-BIRD (585-2473)
Email: avianhabitats@tcsn.net

*Bogen Magic Arm/Bogen Super Clamp/
Gitzo Tripods*
Bogen Photo Corp.
Gitzo Products (imported by Bogen)
565 East Crescent Ave.
P. O. Box 506
Ramsey, NJ 07446-0506
(201) 818-9500
Fax: (201) 818-9177

Canon Products
Canon USA, Inc.
One Canon Plaza
Lake Success, NY 11042
(800) 828-4040

Birdhouses and Birdfeeding Supplies
Duncraft
102 Fisherville Rd.
Penacook, NH 03303
(800) 593-5656

Lite-Link
Ikelite Underwater Systems
50 West 33rd Street
Indianapolis, IN 46208
(317) 923-4523
http://www.ikelite.com

Drop-In Polarizers
Kirk Enterprises
107 Lange Lane
Angola, IN 46703
(219) 665-3670
(800) 626-5074
Fax: (219) 665-9433
http://www.kirkphoto.com

Super Trekker/Mini Trekker
Lowepro, Inc.
2194 Northpoint Parkway
Santa Rosa, CA 95407
(707) 575-4363

Promax SoftBox
Lumiquest
P. O. Box 310248
New Braunfels, TX 78131
(210) 438-4646
Fax: (210) 438-4667

Nikon Products
Nikon Inc.
1300 Walt Whitman Road
Melville, NY 11747
(800) NIKONUS (645-6687)
http://www.nikonusa.com

On-Camera XTC II
Photoflex Inc.
333 Encinal St.
Santa Cruz, CA 95060
(408) 454-9100
(800) 486-2674
Fax: (408) 454-9600
http://www.Photoflex.com

Turbo Battery/QBC Mounting Clamp
Quantum Instruments Inc.
1075 Stewart Avenue
Garden City, NY 11530
(516) 222-0611
Fax: (516) 222-0569
http://www.qtm.com

*Flash Arm/B89 Extender Post/B90 Dual
Strobe Bar/Lens Plate*
Really Right Stuff
P.O. Box 6531
Los Osos, CA 93412
(805) 528-6321
Fax: (805) 528-7964

*Benbo Tripods/Domke Backpack/
OutPack ScopePACK/
Stroboframe Ballheads and
Flash Brackets*
The Saunders Group
21 Jet View Drive
Rochester, NY 14624-4996
(716) 328-7800
Fax: (716) 328-5078

Sto-Fen Omni Bounce
Sto-Fen Products
P. O. Box 7609
Santa Cruz, CA 95061
(800) 538-0730
Fax: (408) 423-8336

TreePod
TreePod Inc.
P. O. Box 7548
St. Cloud, MN 56302
(320) 240-2362
Fax: (320) 654-1549

Shutter-Beam
Woods Electronics Inc.
14781 Pomerado Road #197
Poway, CA 92064
(619) 486-0806
Email: WoodsElec@aol.com

NOTES

From Silver Pixel Press

Nikon Guide to Wildlife Photography
By B. Moose Peterson

Peterson's first book on photographing wildlife discusses the equipment and techniques necessary for photographing wildlife like a pro. It covers lighting, lenses, depth of field, and filters as well as how to track and lure subjects to your camera's lens. He also shares the secrets of how to locate and photograph a variety of species, both birds and mammals. With extensive use of photos, clear explanations, and an emphasis on field ethics, this book is sure to increase your success at taking superb wildlife images. More than 140 full-color photographs.
Softbound. 8-1/2 x 11". 176 pp. ISBN 1-883403-06-5

Nikon System Handbook,
4th Edition
By B. Moose Peterson

Peterson's magnum opus, the *Nikon System Handbook* covers the entire Nikon SLR system from its introduction in 1959 up to the release of the F5. Every Nikon camera, lens, flash, and accessory is described in detail from a photographer's point of view. This book is packed with detailed charts and descriptions, including dates of production, significant features, and design improvements that distinguish each item. Fully indexed, this book is a must-have for every Nikon aficionado. More than 130 duotone illustrations.
Softbound. 7-1/2 x 10". 176 pp. ISBN 1-883403-32-4

Magic Lantern Guides
...take you beyond the instruction manual.

Magic Lantern Guides offer complete operating instructions in an easy-to-understand format with tips on how to use the equipment's features and take better pictures. Written by top photo writers such as B. Moose Peterson, Peter Burian, Paul Comon, and Bob Shell these quality users' guides help photographers get the most from their photo equipment. *Magic Lantern Guides* have sewn bindings and laminated covers for long life. Fully illustrated in color and black and white.
Softbound. 5 x 7-1/2". Approximately 176 pp.

Magic Lantern Guides are available for most popular cameras and accessories.